The Wash

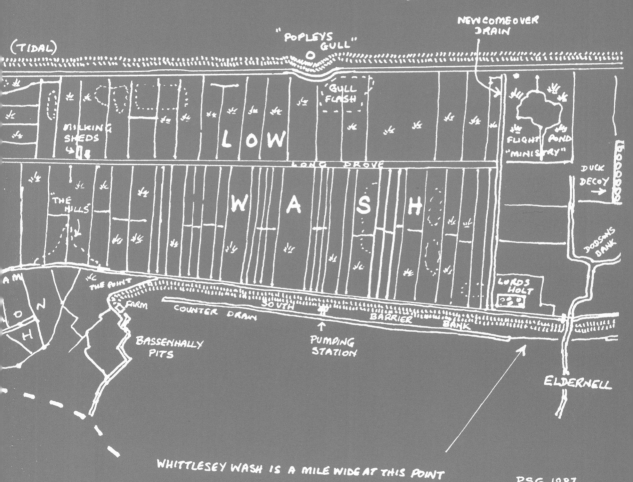

BASSENHALLY MOOR

NEWCOMEOVER DRAIN

(TIDAL)

"POPLEYS GULL"

GULL FLASH

LOW

MILKING SHEDS

LONG DROVE

FLIGHT POND "MINISTRY"

DUCK DECOY

"THE MILLS"

WASH

DODSONS BANK

LORDS HOLT

THE POINT

FARM

COUNTER DRAIN

SOUTH

BARRIER BANK

AM

O N

O H

BASSENHALLY PITS

PUMPING STATION

ELDERNELL

WHITTLESEY WASH IS A MILE WIDE AT THIS POINT

PSG. 1987

THE WASHLANDERS

BY
PHIL GRAY

Overleaf: *The author in his gun punt on the flooded Whittlesey Wash during a successful wildfowling expedition.*

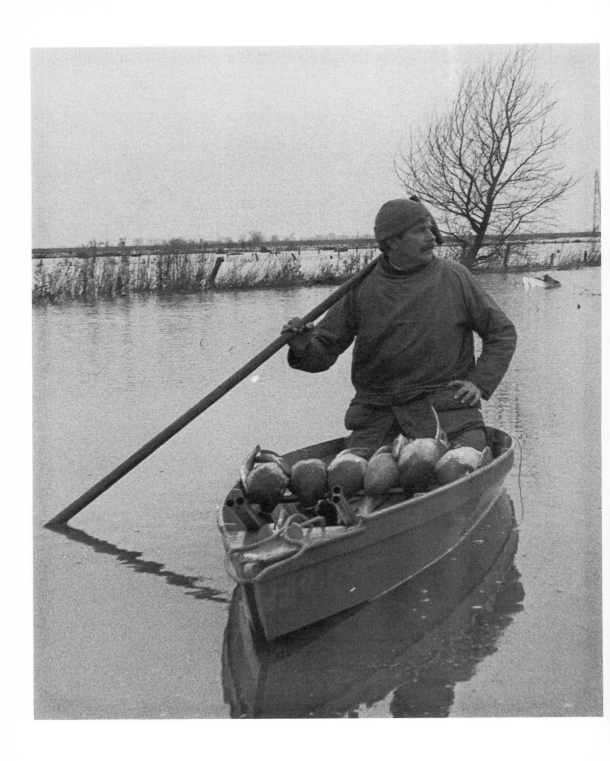

THE
WASHLANDERS

Tales of the wildfowlers, shepherds and eel catchers of
the Nene Washes

PHIL GRAY

TERENCE DALTON LIMITED
LAVENHAM, SUFFOLK 1990

Published by
TERENCE DALTON LIMITED
ISBN 0 86138 071 1
© Phil Gray, 1990

Dedicated to the Washlands
and those free spirits that love them

Text photoset in 10/11 pt. Baskerville
Printed in Great Britain at
The Lavenham Press Limited, Lavenham, Suffolk

Contents

Acknowledgements

My grateful thanks are due to Mr C. Hailstone, Mrs G. Hailstone, Mr J. W. Hilliam, Mr and Mrs E. A. James, Mrs S. Page, Mr R. Sallabanks, Mr H. Smart, Captain N. M. Thornycroft, Mr B. Weldon, the librarian and staff of Wisbech Library, and to Wisbech Standard Newspapers for permission to reproduce material from their files.

I must also thank those who provided the photographs for this book: The Whittlesea Society, Lincolnshire Museums, Dr M. Anderson, Mrs O. Erhart, Mr and Mrs E. W. Guess, Mrs L. Hilliam, Mr R. H. Gray, Mr A. Neal, Mr S. Rooke, Mrs W. W. Watson and Mrs E. Easton; and my thanks are due to the *Peterborough Evening Telegraph* and Sharman Newspapers for permission to reproduce certain of their photographs.

Foreword

FOR CENTURIES the low-lying fenlands of which Phil Gray writes lay as an all but inaccessible area fought over by the salt tides of the North Sea and the floodwaters from higher inland; sparsely inhabited by a hardy and independent breed of men who existed, by their own efforts, off the wildlife which surrounded them.

In due course the search for wealth led to the reclamation of these large areas of waterlogged land. Barriers were erected to restrict the tides, and the floods from inland were controlled by directing them into channels that stand and serve their purpose to this day, creating the washlands Phil Gray describes. Some of the richest agricultural land in the country came into production, but the curtailed independence of the fenmen was part of the price paid.

Even within living memory a hardy handful still gained their livelihood by the ancient crafts—fowling, plover netting and eeling in their seasons; wonderful characters many of them were, wise and knowledgeable in their ways.

At this period it was regarded as a right that any local—and even some outsiders—could shoot over most of these washes for the asking. Fowling today is no longer a means of livelihood, but the instincts of generations still flourish and the sheer romance of being out alone in dawns and sunsets and often bitter weather, the sights and sounds of the wild birds that are one's quarry, and the effort and understanding and study of their habits needed to bring success within reach give rise to a satisfaction not easily understood by those who have never had the privilege of experiencing it. Pointing a gun and pressing a trigger is in many ways the least absorbing part of the thrill, yet without it fowling would become as meaningless as a sentence without punctuation.

Today another factor is entering the washland scene. With the disappearance of many of the world's wetlands, safe wildfowl habitat is shrinking. Appreciating this with admirable foresight, a band of devoted men have obtained control of considerable areas of washland, lightly flooded them where needed, and turned them into ideal sanctuaries for bird life. Welney observatory is a classic example, where wild duck in their thousands and a swelling wild swan population feed in full view of any who wish to study them. Following on this undoubted success, the RSPB have also

bought up large sections of washland and turned them into areas strictly preserved for birdlife. Ruffs, godwits, avocets and the like are returning to breed there again.

But here once more, much of the burden falls on the local, who finds his liberties still further curtailed. One result of this is that in some districts fowlers have banded together and themselves bought up or leased stretches of wash for the continuation of their sport. This could be to the overall benefit of the birds, for these washes will now be jealously protected, and any breeding pairs there will be carefully looked after.

All the same, there are two separate, though not entirely conflicting, interests here. Both wish for birds in plenty, and the toll taken by fowlers is an infinitesimal percentage, but goodwill and understanding are needed from both sides or there could be friction—friction which could do good to neither, and least of all to the birds themselves.

All this and much much more is the background to Phil Gray's writing. Being of fenland stock himself, he writes with authority and love and understanding of his subject. I can only say how honoured I feel at being asked to write the foreword to such a book, which could well be classed as a saga of the Fens.

February, 1988 Nigel Thornycroft,
 Marandellas,
 Zimbabwe.

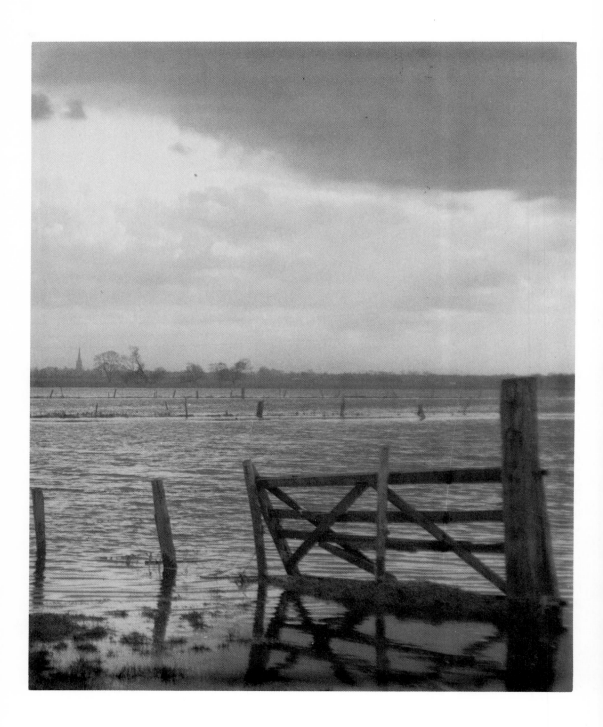

Wigger's Tale 1

OLIVER HAILSTONE watched tensely as his son, lying prone in the long, low punt, stealthily glided through the water. The muzzle of the great gun was, he hoped, still bearing on a pair of unsuspecting mallard which were feeding some eighty yards ahead. George Hailstone was experiencing for the very first time the heart-stopping excitement of punt gunning.

The boy killed his pair of duck and, elated, bore them in triumph to his father waiting on the bank. Oliver beamed at his son. "Now, boy, you are a gunner," he said. "They always say that if a man can kill a pair with a big gun he can kill a good party, but if he cannot kill a pair he may as well give up, for he will never make a gunner."

Now, that's a true Hailstone reminiscence. From an early age I have listened to the stories of the old 'fowlers and eelmen; I have never tired of hearing them, however often they are repeated. Though some will try to spin you a tall story, that can be recognized as such and treated as a bit of fun. The true stories are better. Most of the tales in these pages are from kindly people who, recognizing a kindred spirit with a genuine interest in their experiences, respond with genuine tales and derive pleasure themselves because, of course, they live it all again.

This book is the story of men like the Hailstones, men who have always taken pride in a hardy way of life, either for a living or for sport, on the washlands. These low-lying wild lands between the River Nene and Morton's Leam, like the waterways themselves, were the product of the draining of the fens. Whittlesey, the immediate locality of this book, got its name, which means literally Witel's island, when it was an island amid the vast swamps of the Saxon fens, and it retains some of the character formed a thousand years ago as it basks beneath the wide, wide East Anglian sky today.

The Washlanders were wildfowlers and fishermen who found their livelihood and their sport in this wild waste of reeds and tall grasses. They were men who were always opposed to anything that might curtail either their business or their sport, and in the old days things were apt to become quite lively whenever their interests were at stake. To give just one example, there was hostility in Whittlesey to the enclosure and drainage movement in the early eighteenth century: in 1703 one George Goulding and seventeen others were accused at Soham of unlawful assembly, breaking into

Opposite page:
Looking across the flooded wash towards Whittlesey. The spire of St Mary's Church can be seen on the horizon.

1

the close of Francis Keate and overthrowing a windmill or "dreyning engine". They were, says the *Victoria History of Cambridgeshire*, found guilty of their crime; history does not go on to record what sentences were handed out.

I had heard George "Wigger" Hailstone's stories many times. When the old fellow was ill, a few months before he died, I went to his house to cheer him up a bit. His wife Gladys met me at the door saying, "Stay as long as you like, but he is very depressed, I don't think you'll get a lot of chat today." Now George had a stuffed bittern, which incidentally still stands in its case in Whittlesey Museum. After a while I brought the conversation round to this bird, and asked if he would tell me once again the story of its capture. So here you have it, and the other tales that poured out, as George told it. The old chap had a smile on his face when I left. For a glorious hour the years had rolled away, and "Wigger" had been back in his element.

Waiting for duck on Whittlesey Low Wash, with Eldernell Decoy just visible on the horizon.

"Bittern?" began George. "It were in 1927, just after Christmas. Father, he'd had a shoot at Eldernell Wash. He picked up eighteen duck, but another four had, being wounded, got to the scradge bank before he could shoot them with his hand [ie

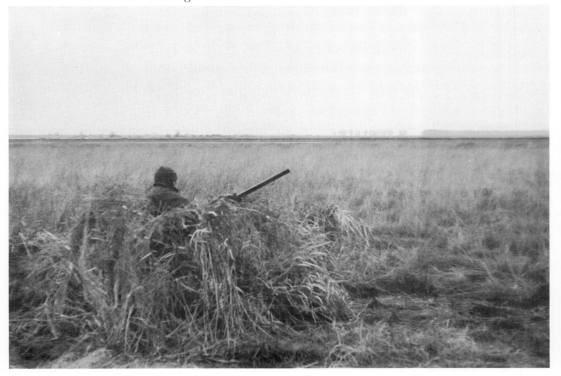

shoulder] gun. We went along the scradge bank to see if we could happen on 'em.

"Now, two days beforehand I'd had a shot at some geese. A couple had got away, so I was also on the lookout for them. Well, this old bittern clawed up, and I naturally thought that it was one of my crippled geese, it were long in the wing. It got up at about forty yards, and flew out into the wash. I nipped the gun up and tippled him over. We'd left the boats further back down the wash, but I got out to it all right without getting wet. It weren't dead. He stuck his old neck out and ruffled his feathers round his neck, as though he were going to take a peck at me. I held his neck down with my gun barrels while I got hold of his legs.

"When I picked him up I hadn't seen a bird like it before. I brought it to the bankside and asked father what it was. He said, 'I don't know, I've never shot one like it. Mind you, I think old Billy Brown killed one in Lord's Holt. I can't tell you the name on it, but it were a bird featuring that one.' Later, at home, father said, 'You want to take that to Mr Rowell, the chemist on the Market Hill. He used to bass [ie stuff] birds. He'd know what it is.'

"I took the bird up to Mr Rowell's shop the next day. He got out his bird book and looked it up. That's how we found out what it were. I asked if he would set it up for me. He said, 'I'm sorry, I've done away with all the tools for the job. Perhaps Francis's Gunmakers at Peterborough will set it up for you.' So I took it over there and they done it, case and everything. Mind you, they told me I was wrong to shoot it as it was a protected bird. That's lasted well all them years, ain't it?"

I agreed, and cast another fly: "Was that the same day you shot all those plover?" I asked. Rising to it, my old friend went on, "No, that were a foggy day. I were coming along the drove to where I kept my boat on the headlands, poled along the river and branched off just yon side the Hills, somewhere agin the point. I were going over the drove when I heard some plover whistling. I laid down and started stalking the sound.

"When I got opposite this dykeside I could just discern one or two getting up and shifting along like, for more feed. I pushed the punt into the dyke and went nice and steady. I knew that in the fog, as soon as I could see 'em I were in gun reach. All I wanted was to find the bulk of the birds. I crept on along the side of the dyke, hoping they wouldn't jump. They were on both sides of the dyke. I chose the thickest side, shot right along the dykeside and killed fifty-eight."

Duck or plover falling to the fowler were despatched to Reads of Leadenhall Market, London. The birds were smoothed over, heads tucked under wings, presenting them nicely, then sewn into sacks for transportation.

George demonstrated how he picked up the birds and twisted the legs under the body, so that the knees were outwards, like a trussed chicken. "That's how we used to send them to market. They look more compact, and plumper, you see. Anyway, I gathered them all up and thought, what a lovely shoot. I'd never heard talk of anybody getting more than twenty-five to a shot. I pushed back to the drove to a nice bit of island to re-load the big gun.

"While I were doing this I could hear someone coming along, splash, splash, up the drove. When he come out of the fog I could see it were Harold Pickering. He said, 'I've been down since first light but had no luck. Now, if you want another shot, there's a lot more plover down agin the "Gull", 'cos I've heard 'em.'

"When I'd got the old gun loaden up, I went shoving orf down. I found the birds, 'cos when I heard anything I knew just where to strike out for 'em. To bring 'em either into the wind, or how I wanted them, you see. That's the art of gunning, Phil. That's to get in what we used to call fair winded, and that's head wind. I got up this here dyke, and I thought, I'm going to have another do here. There looked to be more birds here than in the first lot I shot at. I tell you, I shot there and killed another sixty-two. I gathered them all up, cleaned 'em and put them in the front of the boat. Father finally stalled that night when I told him I'd brought home one hundred and twenty!

"Mother had one of them big old kitchen tables. We stroked the plover down and laid them all out on the table ready for packing. Father had been threshing with the tackle all day, and I don't think he thought much to it, me getting all them birds. Anyway, it came next morning, a Sunday, and do you know, he got up afore me so as he took the shoot away from me! He went between the Hills and Blunt's Holt. There's a high dykeside along there. If you notice, that's always the last to go under the floods."

The Hills is an extension of a gravel seam that runs out from the "island" of Whittlesey. The highest part is perhaps fifteen feet above the rest of the land, and when the waters are out it becomes a triangular island, with sheltered bays whichever way the wind is blowing. My cousin and I were pleased to land there one day when our boat was sinking.

"Ducky Benstead, he were catching plover at the Hills, but these plover all came off that high land at the back of Bassenhally. A man named Clegg had it then. They'd come off there, but didn't go to Ducky, 'cos that dykeside gave them a good feed of worms, and they could wash all the muck off their feet.

"Father, all he'd got to do was go to the little island of high ground near Little Bridge, where the gunners left their punts upside down, with the big gun underneath them. He turned his

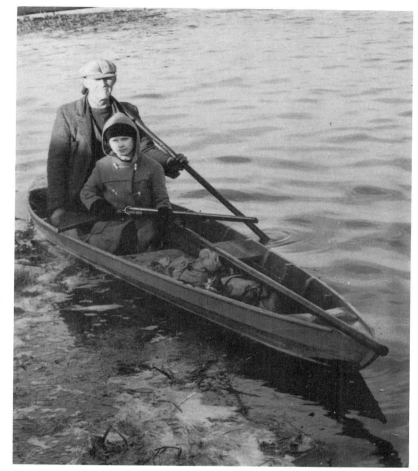

boat over, went trundling down the river, and happened on these plover straight away. All he had to do was steer into the dyke, lay down and stalk. He didn't stalk above a chain before he shot, and do you know, he killed sixty-five."

I inquired at this point if honour was then satisfied. "Yes," chuckled George. "When old Ducky saw father next, he said, 'You'll kill all them plover, so as there won't be none to catch with a net. I've never seen so many killed to one shoot in all my life.'

"Years ago these old gunners used to reckon twenty-five plovers was a good shot. So it was to get eighteen wild duck, never mind about twenty-five. I've killed several twenty-fives of duck, and I killed thirty-nine wigeon with one shoot. That was the biggest shot in wildfowl I ever had.

"I happened on them when I left old Peakey [William Peaks, a professional wildfowler] at the stile one night. He said to me, 'I think I've had enough for one day. I think I'll turn the boat over and get off home. I'll get where it's a bit warmer, we're had a cold old day out here again.' So I said, 'Well, if you're going I'll make my way towards Whittlesey.' When I struck orf I thought I'll make straight across to the drove, then if there's birds either side of the drove I shall be able to go to them.

"Well, do you know, I never see a bird not to shoot at, not till I got between the Hills and Blunt's Holt. There's a biggish field, it was somewhere in there, Phil. At a distance, 'cos it were drawing dusk, I thought, what the davil's that? I've never seen that afore. That water across there was as though a dyke had been done out. It were one black streak right across the field. Then, as I drawed nearer, I could see the movement, bobbing this way and bobbing that, feeding and going in. Then I got near enough to hear—Wheeo . . . Wheeo! I knew then that it was a lot of wigeon. I thought, if I lay down I might get a crack 'ere. So I laid down, and started stalking to 'em.

"I shall remember always, there was a gateway into the field, it had wings to stop cattle getting round the dyke end. I drawed up aside one of these wings, and looked down the gun. Lord above! I never see so many wigeon before. There must ha' been a thousand! I laid there and thought, what am I got to do? Am I got to wait? Some, the nearest to me, were leaving the field to come to the dykeside to feed on the grass. It was panny. I thought, I shan't be in line if they all come over, I've got to move, and I've got to go steady. So while they were edging and edging towards the dykeside, I started edging and edging to get myself into position ready for them. I got so as them nearest me was in line with those in the field. I tell you there was a nice few.

"I shot just at the top of them nearest to me, so all the shot told. When I got cleared up it were dark. I shot the few hand-gun cartridges away at cripples, but I got most on 'em. Thirty-nine when I counted up."

I interrupted George here to comment that that was quite a bit above the average bag for a punt-gun shot.

"Yes", came back George, "I don't think there has been another thirty-nine killed on this wash. I don't remember a bigger shot at geese than my eighteen. Herbie Smart of Coates watched me from off the bank. He had a team of hosses there. They used to graze them floors, him and his father. He were a young man then, Herbie was.

"There weren't enough water for me to get so as I could get them all lined up, else I would have killed a lot more. There weren't half a company of 'em."

I suggested that the bag he did make was still a very good one.

George went on: "I were once down in Eldernell Wash right close along the side of the scradge bank. It were all rough, with water among it. I found a little bunch of teal, about sixteen on 'em, in there. I just shoved the boat's nose through the reeds and watched these little old teal. They were bibbling about all over. I watched them for half an hour, more than long enough to sort myself out. Wanting to find out just what did happen when the gun was pulled and the shot got there, I took my time. I looked down the old gun just as they bunched together. She was lined up on 'em lovely, I knew she was right. I lifted my head as I let drive. You never seen nowt like it in all your born days. They went down like mown thistles. All were killed bar one!

"It was just the same shooting on ice. When you shoot on ice, you want to shoot right down at the feet. The lower shot bounces up off the ice and they'll tipple up on their backs, and that's all they'll do. I've killed no end on the ice. I have seen it in 1917, when that sharp weather were about during the first Great War. I'm seen where you could walk out on the ice and pick 'em up. They were so poor, they hadn't got strength to get up."

I asked if this was the time they would fit the gun punt on to runners. "Well no," replied my friend. "We had a frame with osiers and reeds all round for a bit of cover. The gun was laid on that, and we'd lay behind the gun just like you would in your boat, you see. We'd take some rib bones of a bullock, three on each side of your sledge. You'd be surprised how easy that shoved on them broad bones, Phil, you could shove it as fast as a boat."

I guessed that the recoil of a punt gun would cause such a sledge to slide backwards a fair way on ice. George agreed that this was so. I then brought us round to the topic of eeling, and what it was like in George's youth.

"The dykes that time a' day, Phil, they used to run into the tide river. The tide used to run up the dykes and partly flood the wash, so you'd got a good flow of water all the while. That's the reason we used to catch so many eels that time a' day. Worth making your nets for."

Casting another fly, I reminded George of a story of a "borrowed" boat.

"Oh Ar! That were old Charlie Jones's," laughed George. "I got three stone of eels that night, totting with one bunch of worms. I laid in the Leam, between Blunt's Holt and the Hills. Old Bill Billings and his sons came by me that night, in two boats. They asked me if I was having any luck. I told them I was getting a few, but I didn't tell them how well I was really doing.

"I see their lamb net in the boat, and I knew they hadn't got two boats. They'd pinched old Charlie Jones's. He had his hives [eel

traps] between the bathing bridge and Gravel Dyke; that stretch along the haling bank. He left his punt close agin the bathing bridge in a dyke end. Bill Billings and them used to keep their boat further along in one of them 'Tomkin cuts' where you could pull it out.

"As they were starting out they took old Jones's boat 'cos they needed two for the job. One dumps the river while the other holds the lamb net in the water. The net is held open by a hoop, and it's fixed to a pole. The mouth of the net is about six foot across. They drive the fish and eels into it.

"Anyway, I was totting (or babbing) and busy pulling up eels four and five at a time. Never catched so many in my life, not in such a short spell. I'm been in the tide river hundreds of times, but I've never pulled eels in like I was pulling 'em in that night. It was as though that river were full on 'em!

"As the night drawed on, you could hear them come right to the top of the water, you could hear them sucking at the weeds. I tell you, I'd only just got my lead in the water, and all I'd got to do was just keep chucking these eels in. When I started to fish first off, I were fishing with four or five foot of line. I finished up, as I say, with only a little bit in the water.

"There were eels as thick as your thumb, and a lot thicker

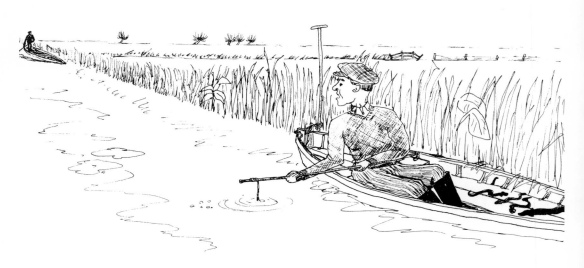

some on 'em; they were a lovely sample. Well, I had a rare old set to, then suddenly I thought I heard someone spritting along; I heard a splash, you see. It were old Joney. 'Course I'd pulled up my mooring stakes, he didn't see me fishing in his water. He used to hire that little river right from Gravel Dyke to the New-Come-Over, all that stretch. By the time he saw me I was poling up the river towards him. When I drawed up to him he said, 'You've got my boat!' You see, all our punts looked alike; they were all made by the same man. Old Dewsbury, of Hammonds and Dewsbury at Peterborough, he made 'em.

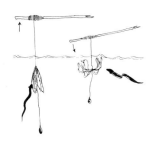

Totting or babbing for eels.

"I said, 'Charlie boy, this is my boat what I use for gunning every winter.' He said, 'Well, if that's not mine, who has got it? Ha' yer seen anybody goo by in one?' Well, I had to tell him a lie. I didn't want to give anybody away, and I didn't want him to know that I'd been fishing his water. He'd got closer by now, and he said, 'Cawd, look at the eels you're got in there.' They were all over the bottom of the boat, you know. He said, 'You're been fishing here!' I said 'I know I een't. If you want to know where I've been, I took a pair of guns down to Eldernell Stile. Ducky and my brother Charlie were waiting for them, to go rabbit shooting. They'd biked round there and didn't want to expose the guns by road.' I said 'I left the guns, and stopped yon side of the New-Come-Over (where he didn't hire it!), and that's where I got my eels from.'

"He didn't really believe me, and I daren't tell him old Billings and his son had passed me in his boat. Anyway, I couldn't fish no more, so I came up to Little Bridge with him. 'If there's a policeman up here', he says, 'I'm going to let him summons you!'

"Sometimes two policemen would meet on the bridge; it was the boundary of their area. But there wasn't any on this night. Old Tom Hemmaway was there, though. He was looking after his hosses like, to keep 'em off the road. 'Course, there weren't the motors about, not then. He allus used to be a late owl, Tom did.

"Charlie Jones had come down in Tant Hillum's boat. That were a gunning boat, too, but Tant used it for going alongside the river, in summer, filling all the cattle tubs with water, and for plover catching in winter.

Eel scissors.

"As we went under Little Bridge, Joney says, 'Lend us your tot', and I take my oath, there was only just a few stragglers of worm left on the crochet cotton; we used to thread 'em on crochet cotton. Anyway he staked the boat down, put the tot in the water and started to catch eels like styxo. That shows there must a' bin some eels up that river that night.

"When he'd caught a bate he pulled up stakes and gave me back my tot stick. While he had been messing about I'd been picking up my eels with a pair of eel scissors. It don't take long with a pair of them.

"When I got home I equalled them out into a big bath tin and a pantion. You mustn't get 'em too thick else they'll smother themselves. When father got up the next morning he said, 'Wherever have you got all them from? You've pinched them out of somebody's trunk!' Do you know, it took him all his time to believe that I'd catched all them on that one tot of worms. There were about three stone.

"It was just chance I happened to be there that night, and if I could have stopped long enough, and had enough fresh baits, I reckon I could have catched ten stone of eels. I don't know how old Billings got on. I never heard any more about it. They took Charlie Jones's boat back. I don't think he ever did know who had it; I didn't tell him, I daren't, he'd have known straight away that I'd been fishing then. As it was, I got away with it."

I commented that there had been a rare flow of traffic using the Morton's Leam that night.

"Yes", said George, "We used to have some ups and downs, what with gunning and one thing and another. There would have been more birds killed if they'd have kept it like it used to be. If two or three gunners went together at one lot of duck, they'd share whatever they made. They were making part of their living out of it, you see.

"Billy Benstead went and bought a gun [punt gun] from Welney orf one of the Smarts. He let his brother Tom have his father's gun. There'd be one in one place and one in another. They used to go afore it broke daylight, stalk out and see if they could listen 'em. Then they'd see if they could get near enough before they flew away when it got light. They'd shoot at a pair, or two or three pair, and you could go somewhere else for your'n!"

I reminded George that Bill Peaks had had a big old punt gun, some eight inches across the breech but very short in the barrel. George agreed.

"That gun were all right, but you'd got to get well up to the birds. I could always shoot another twenty or thirty yards further away than he could with that, and get a day's work when he couldn't. If that had been another three foot longer in the barrel that would have been a fine gun.

"I've heard father say that the best gun as he see come on the wash was owned by a Captain Vipond. He used to come on this wash some winters in a big two-man punt. He had a man to push him about while he laid behind the gun. Father said it were a lovely gun, a breech-loader, on a swivel. It would kill anywhere up to a hundred yards away."

I asked George if he knew where this Captain Vipond came from. It would have been in the eighteen-nineties.

"No", said George, "I don't know where he was from. Father

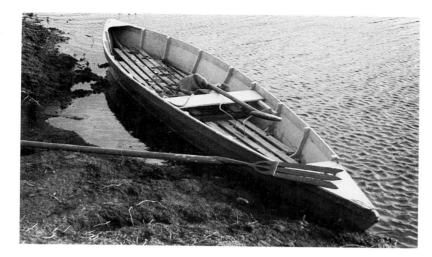

An eel catcher's gleave ready for work. The punt is typical of those used in the Whittlesey area, entirely open and undecked.

didn't see him on the wash above once or twice, that's all. We had nicknames for some of the punt guns. We used to call old Peakey's the Trunk end of a tree. Jack Benstead's gun, they called her Lady Lambkin, 'cos they reckoned the metal were soft! The one old Bill Brown used, she had dented marks all up the outside of the barrel, so they called her the Small Pox. Father's gun was Black Prince, and mine was old Hornigold a' Lynn. That's where I bought it, from an old man at King's Lynn named Hornigold. When we went to buy it orf on him he said, 'If it had been a few years agoo, you might as well have come after the teeth out of my head 'cos you wouldn't ha' got it.' He were a man over seventy then, you see.

"It had a slipper for the recoil, and it were like central fire [a post gun]. When you pulled, the shot were there. I had it changed to pan and cap, so you got the flush. Up they'd jump, just lift as the shot got there."

All the local punt guns had large horsehair pads nailed on to a crude shoulder stock, whereas most punt guns are roped, or in some way fitted to the punt, so that the punt takes the recoil. I asked George if the old gunners of Whittlesey ever used a breeching rope. From his answer I can only assume that they used light loads.

"We took it all on the shoulder," said George. "It used to give you one, but not too bad. It depends how you load. Now if you wad 'em up tight and put that extra powder and shot in, then they'll give you a master one! I got a bit angry one day. I'd shot and never touched a bird. I thought, I'll bet you'll hit some next time, and I put extra stuff in her. Lord, she jumped and hit me in the mouth. I had a pair of lips like my thumbs, in less than three seconds. She

11

put me out flat in the boat. When I came round I just stopped the gun from rolling off into the water. She hit me that hard I thought I'd broke my collar bone. I never had a blow like that afore. It were like that Sugar Ray Leonard hitting Boy Green when he knocked him out!"

Remarking that it was a wonder there weren't more accidents, I reminded George of the time one of the Hilliams and Jack Benstead came upon the same lot of fowl in the fog, but from different directions. With neither gunner aware of the presence of the other, Benstead fired, and a stray pellet hit Hilliam in the corner of the eye; luckily he was not blinded.

"Yes, I remember that," rejoined my friend. "That same thing nearly happened in the twenty acre, between me and Ducky. I was going to these ducks from the drove end. When I left Little Bridge his boat were on the Island. From the Hills I came across to the drove dyke, and along there to the twenty acre. There were some ducks in there, so I started to come down to 'em. The twenty acre was always a favourite place, so were the thirties, a wonderful place for duck. If there were nowt in them two grounds there weren't much in the wash.

"Well, I were getting well up to this lot. I was soon thinking about shooting. There was rough cover in the water but I just happened to see something move. That were Bill yon side on 'em, meeting me head on. He were getting close to 'em an all.

"Wor! I thought to myself, there's something going to happen here if we don't mind. I thought, well, the best thing I can do is frighten 'em up before he shoots. I believe he perhaps didn't see me even though I could see him. I got hold of a stalking stick, clawed up on my knees and hit the stick on the beam of the boat. Up jumped the duck, and up jumped Ducky. He said, 'What the B . . . ing Hell do you think you're adoin' on?' I said, 'Ar, and what the B . . . ing Hell do you reckon you're doing? Your boat, when I left Little Bridge, laid there, and your gun underneath it. I didn't know you was out!

"He had a pair of glasses, you see, and he'd been watching me coming along the drove. He could see the birds in the twenty acre, and knew he could come along the Leam with the run of the water harder than I could come along the drove dyke. That's how he got that bit in front of me. He thought he was going to pip me to the post, but he didn't 'cos I scared 'em up!

"I said to him, 'Do you know we could have killed each other there?' Wor! I shouldn't ha' bothered a bugger if we had ha' done! He didn't like it 'cos I frit the birds, but I weren't going to lay there and let him shoot me!

"Still, I used to love it. There was no one who loved that wash more than me and father did years ago."

The Washlands 2

THE SUN was at last going to bed, after doing its level best to scorch us all day. The evening air was pleasantly cool. As I gazed downriver along the tidal Nene from the bridge at Dog-in-a-Doublet the tide was still ebbing. The wide shelves of mud shone with the moisture they retained. Three or four herons, spaced at intervals, patiently stalked their evening meal of eels.

As I stood there, I recalled the same scene some twenty years before. Then there had been another fisher out on the muds with the herons: Tom Thrower, the pumpman, staking out his wing nets for eels.

In these days when anything that is not bolted down is more than likely to "go missing" it is hard to imagine that it was common practice for wildfowlers to leave their punts lying upside down on the river banks. The big punt-gun would lie sheltered underneath. Sometimes twelve-bores would be left there, too. Miles from home, yet nothing was ever stolen.

Similarly, when eel catchers netted a dyke mouth, they would "claim" the dyke by sticking a willow rod up at the drove end of the dyke. Other eelmen respected this, as it saved them making an unnecessary and wasted walk down the half-mile-long fields, only to find the dyke already netted. On finding a rod erected they merely moved on until they found an unclaimed dyke. The old-timers might have been rum old boys, but they were honourable among themselves in their codes of practice.

Long before most of the major drainage schemes undertaken in the fens, Bishop John Morton, lord of the manor of Wisbech and notorious for his two-pronged taxation methods, supervised the cutting of Morton's Leam from Peterborough to Guyhirn in 1490. He is reputed to have viewed the operations from a raised scaffold in order to ensure that the drain was keeping to a straight line.

Some 300 years later the River Nene at Peterborough was diverted by means of a straight-cut channel direct to Wisbech, and thence to the estuary at Sutton Bridge. This cut was called Smith's Leam when completed in 1726, but eventually it became the main river. The old Nene still meandered a more sedate way across the fens. Smith's Leam, running parallel to Morton's Leam, created a more direct route for upland waters to the sea. The land between the two rivers, thirteen miles long and up to a mile wide, became washland.

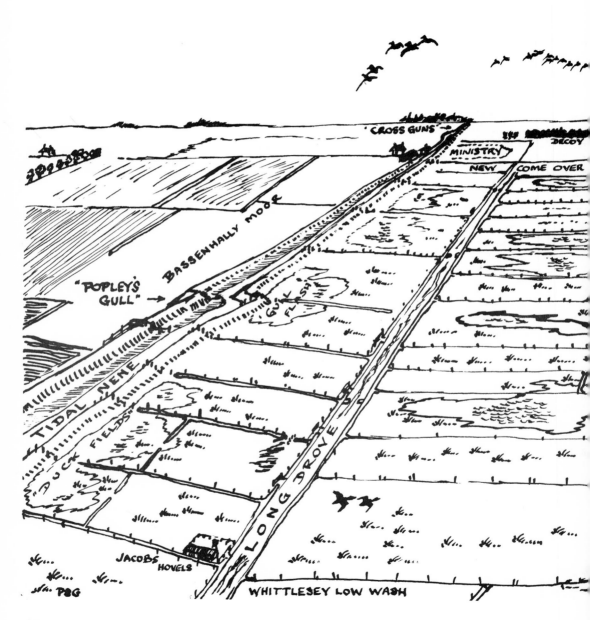

A bird's eye view of
Whittlesey Low Wash
showing some of the
landmarks mentioned in
the text. In the
foreground are Jacobs'
Hovels (the milking
sheds) and the Hills, an
area of land that is some
six feet higher than the
rest of the washland.

15

The South Barrier Bank seen across the waters of Morton's Leam.

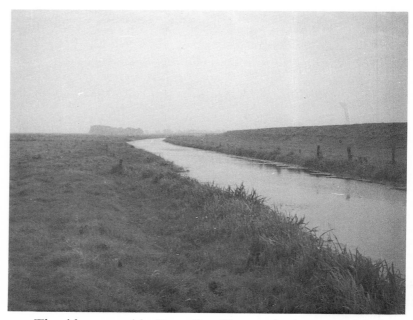

The idea, as with Cornelius Vermuyden's successful Ouse Washes, is that the outer walls of the two rivers are strong, high barrier banks, while the inner walls, known as scradge banks, are much lower. Normally the waters are contained in the river and dyke systems. With the arrival of floodwater from the higher lands of Northamptonshire, the excess water simply overflows the scradge bank and "washes" out on to the land designed to hold it, instead of bursting banks or flooding out over valuable farmland and villages. It is stored here until levels drop and it can be discharged at leisure into the Nene and carried away to the sea.

There are three main areas of washland in the fens, Cowbit in Lincolnshire and Welney and Whittlesey in Cambridgeshire. Similar places in other parts of the country are the Derwent Ings in Yorkshire, the Somerset Levels and the vast cattle marshes of east Norfolk and Suffolk. Of all these, it is Whittlesey Wash that will feature strongly in these pages.

At the widest part, Eldernell, a duck decoy wood was planted perhaps eighty years ago, but it was never worked as a decoy in the accepted sense. The practice became illegal before the wood was mature. The pond was used for duck shooting, from a hut I am told, but that is all. It would be interesting to know if this shooting was carried out on the old French "Huttier" system. Nowadays the 'coy is a thirty-acre roost for pigeons, rooks, herons and game.

A mile to the west is the New-Come-Over Drain, which cuts

right across from Morton's Leam to the base of the Nene bank. At the junction of the drain and the Leam there is a smaller, older wood, Lord's Holt. There is a heronry here of a dozen pairs. The big grey birds have a ready supply of fish right on their doorstep.

From the New-Come-Over Drain, running west along the middle of the wash, is a drove exactly two miles long. It divides at its western end, its two arms shooting off north and south to give access from the main Whittlesey–Thorney road. The land between these arms, a fifty-acre block, once belonged to the Town Charities and is still known to some as the "Town Fifties". From this block back to the New-Come-Over Drain is Whittlesey Low Wash. Further west lies Whittlesey High Wash and then Stanground Wash. East of Eldernell the sequence ends, roughly five miles on, at Guyhirn Wash, near Wisbech.

Before the Second World War the dykes ran through the scradge bank into the tidal Nene, and in consequence the highest tides spilled out on to the marshes, the whole lot being semi-tidal. The eastern end of Whittlesey Wash, right through to Guyhirn, was a wild waste of reeds and tall grasses, grazed off to some extent in summer by horses and bullocks. The rest, except for another rough area known as the Reed-Bush, was grazed or cut for hay.

The only human beings to be seen, apart from the haymakers in July, were the wash shepherds (though their charges were cattle and not sheep), eel catchers and wildfowlers. Often all of these "trades" were combined as a way of life. Apart from a few attempts at cultivation, this has been the pattern until the present day.

Once upon a time the actual ownership was in several hands; people kept a few grounds, as the fields were known, for hay for their own use. Later, grazier and butcher F. W. Brown owned large blocks of washland which passed to his sons, one of whom, Peter, expanded the holding by buying out many of the smaller owners. Eventually, the Browns' Low Wash land, along with another large acreage owned by Ted Saunders, was the first land to be bought by the RSPB for a new reserve.

Peter Brown still grazes several head of cattle on the High Wash, along with John Holland, another farmer who thankfully retains an interest in beef cattle. He is aided by his old henchman, Jack Searle. The shepherds on the High Wash these days are Mack Bottomley and Jack "Muster" Hailstone, so up to a point the pattern continues.

A former owner of washland was John Smith, father of Whittlesey's most famous son, Sir Harry Smith, the Hero of Aliwal. In Sir Harry's autobiography is a letter to him from his father, dated 13th July, 1815, in which John Smith congratulates him on his part in the Battle of Waterloo. Later in the letter the topic changes to horses . . . "Your mare was put to Cervantes, a horse of

17

Lord Fitzwilliams, She is very well and lying in my Wash Ground with my mare and foal. I think the hansomest I ever saw. . ."

The tide once flowed up as far as Peterborough, but for fifty years now the tidal limit has been the sluice and locks at Dog-in-a-Doublet. Now there's a name for you! It is actually the name of the public house which stands on the bank nearby, but the bridge and the sluice as well as the inn are all known by the one collective name, sometimes shortened to "The Dog".

The road across the wash to Whittlesey provides a pleasant access to the town, passing as it does through an avenue of shock-headed pollarded willows. These trees, which lend character to the scene, are a feature of marshlands in many regions of Britain. Here they were planted around the turn of the century to indicate the whereabouts of the road in times of flood. In later years a narrow bank was raised alongside the road for pedestrians. The walkway has several gaps to allow the passage of water, bridged by hefty timbers which are still known as the "baulkers".

William Billings has plenty of custom for his ferry across the wash in this nineteen-thirties scene.

Before the raising of the bank, passage across the flooded wash was provided by a couple of ferry boats, used mostly by folk travelling to and from work. One of the boats was owned by a giant of a man called "Blucher" Hilliam. The Hilliam family have long

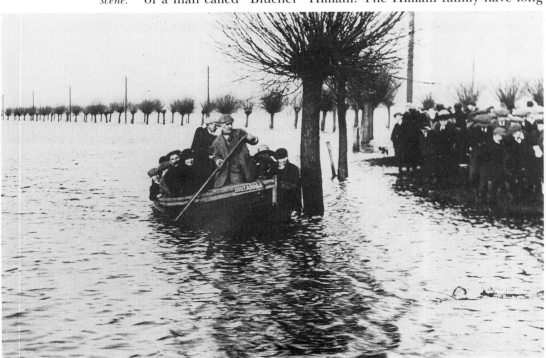

been associated with Whittlesey Wash as shepherds, fowlers and the rest, and at least one of the family, "Blucher's" great-grandson, enjoys a bit of duck shooting to this day. "Blucher", or "Big John", as he was also known, was some years ago mentioned in the local press. His grandson, Mr John W. Hilliam, kindly loaned me the cutting, which I set down here in full:

1910 Incident Recalled

The present state of the Wash recalls to mind in many of Whittlesey's older residents an alarming and exciting incident. When it was in a similar condition on December 2nd, 1910, a party of eight members, and a youth, were going to work at six in the morning, and to do so had to cross the water which was about four feet deep. The men were in a boat with the owner, the late Mr J. Hilliam, or Big John as he was popularly known, as skipper. It was quite dark but all went well until the party reached a point near the opposite bank.

Presently the boatman felt the boat sinking. It did not capsize, but just sank under its load. The water was up to their chests, and although a second boat was just behind, it was also heavily loaded. The second boat was in the charge of Mr W. Brown, who today resides in the Delph, Whittlesey. In order to rescue the party from the water, a journey to the bank, about a quarter of a mile distant, had to be made. In the mean time the men in the water were having an unhappy time. The youth was in the greatest straits, the water being up to his chin, even when standing on the seat of the boat. He had to be supported by the other men to prevent his total collapse.

When the second boat returned empty, it was found to be too small to carry all the party. So three, of whom Hilliam volunteered to be one, had to remain a further period in their precarious position, until the boat came back again. The men were cut off and could not wade to land because of the rivers and dykes. They were exhausted by the cold and could not have held out much longer The pluck of the late Mr Hilliam, whose cheery words did much to encourage the men, and the manner in which Mr Brown came to the rescue, was deservedly praised for many a day afterwards.

The waterways in years gone by provided transport for cargo and passengers. In 1839 folk wishing to travel into Peterborough could board the packet *Water Witch* when she called at the Dog-in-a-Doublet on her voyage from Wisbech on Wednesdays and Sundays, or arrangements could be made to sail direct with Mr F. Stallebrass from his moorings in Delph Dyke, Whittlesey, where the wash enters the town; he made the trip on Wednesdays and Saturdays. Alternatively, Mary Harris's boats departed from Delph Dyke every Saturday, bound for Wisbech, while on Tuesdays and Fridays the *Water Witch* called again at "The Dog" on her way to Wisbech. In those days, and until 1937, Delph Dyke ran directly into the Nene.

Notable washland landmarks of the old timers were Dodson's

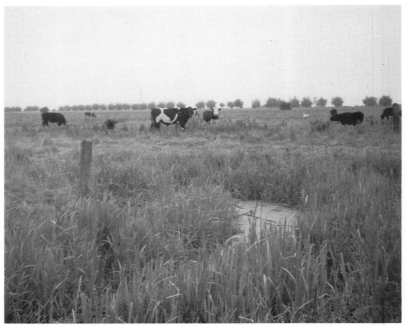

Bank, Headland Ten, Snushall's Plover Hole, Peak's Plover Hole, The Hills, Hughes's Hole and so on. The plover holes were low marshes that could be artificially flooded by means of a slacker, or sluice, through the river bank, enabling the plover catcher to carry on his trade in dry spells when there was no natural flooding. The other locations were places that remained above most floods and were therefore popular gathering places for resting fowl.

One of the earliest ways of making a living in the Fens before the land was drained was the keeping of huge flocks of geese whose feathers went into the stuffing of feather beds. They were plucked alive when their feathers were loose at the moult, and as most folk had feather beds there was quite a demand. It did the geese no harm; they grew a new lot of feathers, which in due time became next year's crop. In the summer much of the fen dried out and vast areas could be grazed by the birds.

Old Bert Snushall, whose plover hole took his name, must have been the last man in the Fens to keep geese on a large scale. He had over a thousand geese on the wash in what was the wild region, east of the Duck Decoy. I was fascinated to learn that this practice of grazing geese on the fens and cropping their feathers was carried on almost until the Second World War.

George Hailstone told me that when he was a youth twenty-five tame geese suddenly arrived at the Whittlesey Wash. George

told his father, who said "They'll be Bert Snushall's down at the Guns" (the Cross Guns public house, three miles away on the Nene bank). "You'd better take them back to him." George's father helped him to drive the geese into the Nene, then left the boy in his gunning punt to herd them downriver. After a mile or two he was beginning to wish he had never mentioned the geese, when a man on horseback rode over the bank and nearly turned the birds. George shouted at him to get off the bank. He did, and then rode up behind. The rider turned out to be Mr Snushall, so together they herded the birds the remainder of the way to the pens. When all were safely penned, their owner said to George "Have you got a shilling?" George replied in the negative. "Oh," said Mr S, "I've only got a two-shilling piece, I suppose you'd better have it." That remark still rankled with George all those years afterwards.

Some attempts were made at ploughing and cropping parts of the washland, but not many farmers have found it worth while. There is so much uncertainty as far as flooding is concerned; it must be very frustrating to have a good crop flooded just before harvest. One syndicate of farmers still cultivate their land, however, reckoning that one good year in five will keep them going.

Between 1965 and 1980 Eldernell Wash and more than half of

The Hilliam family at home at West Delph, Whittlesey. Father had died by the time this photograph was taken and the head of the family was "Big John" or "Blucher" Hilliam, who at twenty-six stone was the town's heaviest man; he is framed by the doorway.

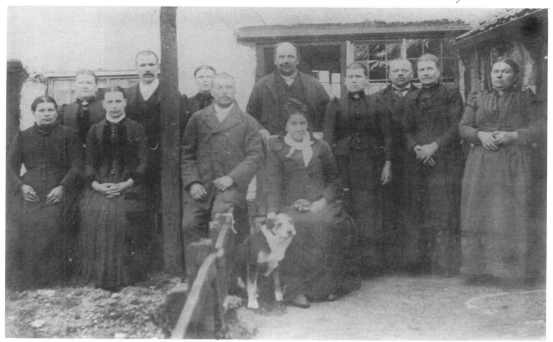

Whittlesey Low Wash had been cultivated. Had the weather settled into a dry cycle it would not have been long before the wash as we had known it would have been lost to the plough for ever. As it was, a series of wet springs disheartened most of the Low Wash farmers and as a result much of the ploughed land was allowed to return to nature.

Being wetter than the fens to the north and south of it, the washland with its undrained peat is quite a bit higher. The adjacent Thorney Fens are so much lower that the bed of the River Nene is above the level of the land; the water level is at times twenty feet above!

An interesting point about the cultivated parts of the wash is

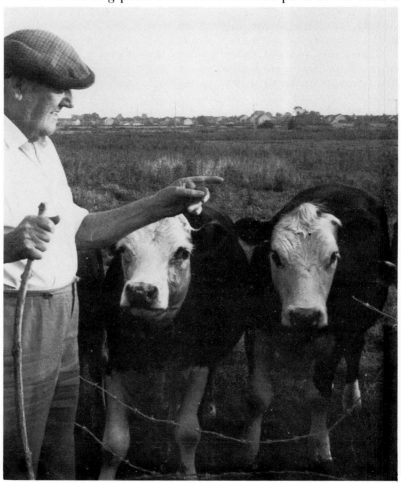

Wash shepherd Jack "Muster" Hailstone counts heads.

that once the land was ploughed the dykes were kept dry by dams, and in consequence the land shrank. It sank rapidly, as much as four inches a year, so that before long these areas became significantly lower than the undrained fields, which naturally meant that after a flood the water stayed on those ploughed fields the longest and often required pumping off. Mr Roy Fisher, who farms the Town Fifties, has a permanent pump house on his land. This few acres is worked with some success, due possibly to the comparatively easy access to the pump from the road.

Conservationists are very concerned at the speed the few remaining wild places in our countryside are being lost to developers of one sort or another and there have been moves to retain at least some before it is too late. Wetland such as our wash is now increasingly rare, so when farming there was at a low ebb and most owners of a mind to sell, the Royal Society for the Protection of Birds, with grant aid from the Nature Conservancy Council, began to purchase land on the Low Wash. At the time of writing the RSPB owns almost all the land between the New-Come-Over Drain and the Town Fifties. There is no doubt that this purchase has saved that part of the wash. It is being returned to grass, and will be grazed and cut for hay as before; the water levels will be kept higher, thereby retaining and increasing the natural wetland flora and fauna.

Possibly because of past confrontations and sometimes bitter exchanges in other parts of the country some, though not all, officials of the RSPB have adopted an arrogant attitude which has not endeared them to local people, who sometimes feel that they are being forced to accept various restrictions and changes. One thing a Fenman will not tolerate is being pushed, especially by outsiders. The conservation bodies are very powerful and have the financial muscle, should they desire to use it, to get what they want regardless of people's feelings.

Some degree of ruthlessness is to be expected when, at the other extreme, you get people ploughing up valuable natural habitat for the sake of an extra grant, with little or no care for the future. At the end of the day I feel that a reasonable compromise must be reached to keep local goodwill and to make the reserve areas workable. There ought to be room for all the traditional users of the washlands.

Though it would be sad to see all the washlands drained and ploughed, it must be said that the existence of some arable land that floods is an asset to certain species. On Whittlesey Wash the numbers of pintail increased dramatically when potatoes had been harvested and the land then flooded. The feeding pattern of the fowl was so clearly defined that a wildfowler in the nineteen-seventies could in times of flood choose his hiding place with some

certainty, depending upon which species of duck he wanted. If it was wigeon, he'd go to the grass marshes, for pintail or mallard, to the flooded arable land.

Some folk from the cities and from the vast sprawl of suburbia will often, through ignorance of the ways of the wild, support proposed bans on country sports, yet they will tolerate those aliens to the countryside, the twitchers, who rush around in their clamouring mass competing for the most ticks in their birding logbooks. Then there are the TV-inspired urban naturalists who descend by the coachload on organized nature trails. How can anyone appreciate true closeness to nature when out in such a crowd? Surely enjoyment of the countryside stems from being alone to take in the peace and solitude of one's surroundings?

I accept that it takes all sorts, and that safely signposted artificial reserves and country parks at least give townspeople a small taste of the real thing. I do not grudge them that. But wildfowlers and, I suspect, many proper ornithologists need to be on the marshes actually among the wild creatures, at one with them as part of the scene and not as spectators from afar.

It seems to me that the true countryman is becoming an endangered species in today's materialistic world. We need the freedom of a wild habitat almost as much as the birds. Perhaps the time is coming when positive discrimination should be practised in our favour!

So long as anglers, wildfowlers and interested village children are reasonably unfettered, and the landowner doesn't feel too hemmed in by restrictions, and everyone takes an open minded, tolerant attitude, there is no reason why the whole situation at Whittlesey shouldn't work out to the benefit of the wash. I am quietly optimistic for the future of the Nene Washland, its traditional users and its wild inhabitants.

The Seed Sown 3

ONE'S EARLY YEARS are the formative years, we are told. The way one is raised, and the environment in which that raising is done, must surely have a bearing on the interests that attract one later in life.

The late Ted Easton, an eel catcher of note, told me that when he was a small boy he was coming across the Whittlesey Wash when he saw a man standing in a gunning punt wielding a long-shafted eel gleave. That man was Charlie Jones, an eel fisher of a still earlier generation. Ted watched him stabbing the spear into the bottom of the river, catching an eel or two between its tines, and years later recalled "I wished with all my heart that I could be in that boat with him."

There is no doubt that the seeds sown at that moment germinated, for Ted became a proficient catcher of eels. Indeed, the same Charlie Jones later taught Ted the art of knitting eel nets. Ted followed Charlie's method of joining flat sections of net until he was shown by a Dutchman how to knit "in the round" (ie, tubular netting). "It doesn't catch any more eels, but it looks better," was Ted's comment.

Another example of seeds falling on to fertile ground comes from wildfowler Roy Whitwell: "I would have been about nine when father packed up shooting. I can remember going with him once or twice. When I was younger I used to love it when Dad and George [Roy's elder brother] came home. They didn't have proper game bags then, they had a sack. I would be waiting for them and they would let me fish into their sacks, bringing out the birds one by one. I really enjoyed that, seeing the different sorts of bird."

The sacks mentioned by Roy Whitwell were ordinary hessian potato sacks. A cord knotted on to one of the bottom corners, with the other end of the cord tied on the neck, enabled the sack to be slung like a proper side bag. One merely opened the neck end to add extra game. I have used such a sack, and so has Roy. They hang well around the small of the back and hold a lot of stuff. So, you see, that is how it all starts. A seed blown here and there . . .

Let me tell you of my own early life, and of how the attractions of the open-air sports and pastimes grew on me.

While my father was away serving in the Second World War I

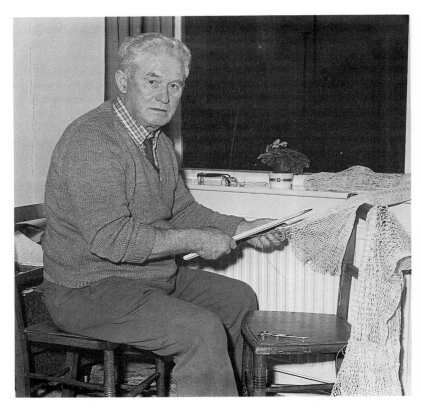

Eel catcher Ted Easton knitting an eel net. It was the sight of Charlie Jones wielding a gleave that set him on his path in life.

spent a lot of time at my grandparents' home, Micklewaite Farm, Glassmoor, in the Fen just out of Whittlesey. Grandfather was the horsekeeper and their house was right on the bank of Bevill's Leam, the drain which carried away the waters of the mighty Whittlesey Mere when it was drained in 1851. The mere was famous as the largest lake in southern England. Some of my very earliest memories are of being taken around the yard at Micklewaite by my grandfather to "look the eggs up". There would at times be a dozen, perhaps twenty, corn stacks in the yard, and the hens, up to a hundred of them, ran free, laying eggs anywhere and everywhere. I was lifted into the manger to walk along it searching for eggs, sometimes while the horses were at their feed. Big old gentle-eyed Percherons, grey and dappled, with nostrils of pink. Shires, too, with white-blazed faces. It was all a great adventure.

Later, after the war, my nearest cousin in age and I would take turns, week and week about, to stay "Down the Fen" with our grandparents during the school holidays. I used to like to go with Grandfather of an evening when he took the horses along the bank

26

to a grass field for the night. The horses loved this run, free of inhibiting harness. One summer evening one of them became a little too excited and broke back towards us at the gallop; I was scooped up and dropped over a wire fence with fierce instructions to "Stay there, and don't you move!" Grandad ran back in time to turn the stray into the right direction.

We would stand for a while at the field gate while Grandfather lovingly watched his charges settle down to graze. They would trot to the gate instantly if he whistled, however, for that love was mutual. While we stood at the gate Grandfather would point out all sorts of things such as the partridges, as the coveys "creaked" to each other, settling down as the day closed. Grandfather shared the happenings of his everyday life with me, and I have always valued that. How important it is for adults to spend time with children.

Uncle Bob and Aunt May lived on the same farm, not above a couple of hundred yards along the bank, and my older cousins, Tony and John, were usually about somewhere. There was an old square boat, a raft with a rail fence all round, which was hauled across the river on a continuous chain and from which Tony used to fish.

When they were younger my mother and the two eldest of her five sisters used to cross the river in the boat to walk along the far bank to Angle Bridge School. In winter they often had to break the ice first. Their uncle, Jack Cowling, who was about the same age, lived on the bank opposite the school and also crossed to his lessons by boat.

The waters provided a few meals. Grandfather gleaved eels and bream from the river, and used night lines and trimmers, too.

Sometimes the men would stick a clothes prop into the thick "cott" weed, twisting it round and then running up the bank with it. Eels would be brought up with the weed and there would be a mad scramble to catch them before they made it back to the river.

My grandmother's name was Cowling. Her family had lived in the Mereside/Glassmoor area of the Whittlesey fens at least as far back as my great-great-grandparents. She used to tell us of how a barge would come upriver loaded with turf for sale as fuel. The boatmen, possibly from Woodwalton Fen, offered these peat blocks at so much a "thousand", but Grandmother found out that just a few hundred made the boatmen's roughly reckoned thousand! The turf was stored in a little hovel with wattle walls and a roof thatched with sedge and rushes. The wattle allowed the wind to blow through, thus keeping the peat well dried out for the fire.

To get to the town from Micklewaite one either crossed the river in the boat to the hard road atop of Glassmoor Bank or went along three gravel droves to Turning Tree Bridge. After the traction engine had hauled its train of threshing tackle down the droves in January the surface was cut up so badly, and turned to mud by the rain, that it was the bank or nothing for cycles.

Eventually, of course, changes came about. My uncle and aunt moved to a foreign land called Doddington, eleven whole miles away, to Ransonmoor Farm, where Uncle Bob became foreman. I was twelve when Grandfather died, only into his early sixties. Grandmother and my two youngest aunts had to move "up town". That was the end of our association with Micklewaite.

My father's parents owned a hardware, sweet, tobacco and toy shop in Whittlesey, and my great-grandparents had run various businesses in the town back into the nineteenth century. At one time the family tried a very early attempt at self sufficiency farming: they kept bees, goats, hens and other livestock and grew

Harvesters returning home from work across the flooded wash road in 1912.

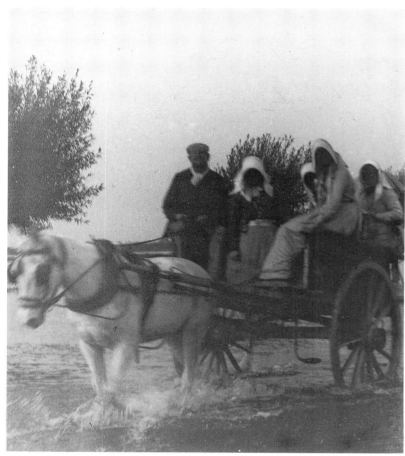

their own produce. Something didn't work out, however, and the scheme died eventually.

My father remembered skating with his parents along the frozen "Briggate River" from Whittlesey to Peterborough, Grandfather in Homburg hat and Norfolk jacket, Grandmother wearing a long dress and a muff. The Edwardians always wore the correct dress for the occasion. Father became a good skater when he grew up. He was always the outdoor sportsman, a keen swimmer and cyclist, and a regular player on the cricket field.

When still a small child, I'd be rushed outside by my mother to see the wild geese fly over. Lines and vees of magnificent birds often flew right over the house in winter; the sound of pinkfeet calling makes a lasting impression.

Another seed was planted at home in Market Street. Our

sitting room upstairs, over the shop, had a bay window which overlooked the street. I was standing in the bay late one afternoon when I saw our neighbour, grocer Len Hart, draw up in his old van. Len and his pal Charlie Patman emerged and, from the back of the van, took double-barrelled guns and bags; bags in which could be seen wild duck and pheasants. The sight triggered off something in me. I was perhaps seven years of age at the time; I didn't know why, but how I wanted to be like Len and Charlie, bringing home the game!

In March, 1947, I would be a month away from my sixth birthday. The snow and ice of that epic winter had melted, and the result is a well-known Fenland story. Luckily, "our" local water had been contained within the washlands designed for just that purpose, but it was the highest the water had been in living memory, and I was taken down to the Hare and Hounds (now the

The flooded wash road, from a postcard dating from about 1910.

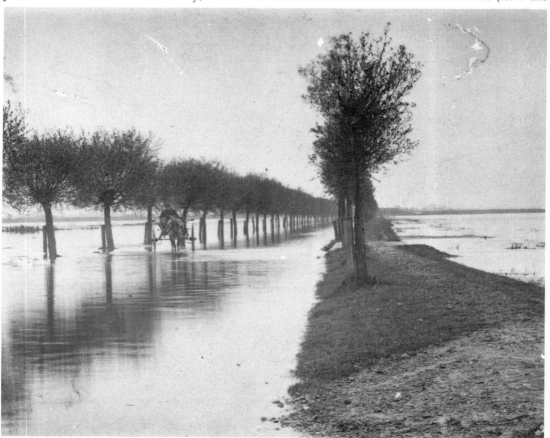

Morton Fork) to see the spectacle. The water was up beyond where the "island" of Whittlesey begins to rise out of the fen. It has never been so high since. Not yet.

What really impressed me at that time was being told how men in boats went out there to shoot duck. Another seed was planted, though it was to be another seven years before I was to discover the magic of that place for myself.

My youngest aunt married a farmer. Some of my cousins and I were allowed to "help" with the harvest: riding the binder, getting half choked with dust; watching for the rabbits when the last swathes were cut; stooking up the sheaves in rows to ripen off; shaking barley awns out of your sleeves; then carting—being allowed to drive the old Fordson Major—days when small boys walked ten feet tall!

Later, I was allowed to walk round the hedges with an air rifle, hunting sparrows and starlings. Once I looked through a gap in the hedge straight into the eyes of a cock pheasant. I don't know who was the more surprised, but he didn't stay to consider it.

Around this time I "found" four or five boxes of pre-war shotgun cartridges in my grandfather's bookcase-bureau. I would give my eye teeth to have them now, for they were collector's pieces: "Bonax", "Smokeless Diamond", "Special Stowmarket", all in their boxes. I still have a couple of empty boxes, and a few cases. At the time, however, cartridges were cartridges. Roland, my farmer uncle, had a cousin called "Nipper" Doughty, who obtained an old twelve-bore from somewhere, and I provided the ammunition. We lay in wait in an old barn for starlings to muster on a pile of corn we had scattered on the snow outside. What an unsporting practice, but boys do not study such niceties.

When I progressed to a twelve-bore of my own (I would have been about fifteen at the time), I was given the freedom of the farm, which I have to this day.

Another uncle tried to teach me to swim. Regretfully I would not co-operate. I don't suppose matters were helped by the fact that when we were toddlers at Micklewaite the house stood on a steep bank, only yards from the river. My poor Grandmother was naturally worried that we would fall in, so she instilled into me that if you went too close to the river the nasty Bogeyman, who lived therein, would leap up and drag you down under the water. I still can't swim! But there's no Bogeyman . . . is there?

At intervals through the summer two or three lots of relatives would converge on Sunday afternoons on the farm near Doddington where another uncle and aunt lived.

Uncle Bob has a dry sense of humour and a mischievous twinkle in his eye. He is knowing, too. Taking me aside one of these Sundays, he said, "I know you won't want to be stuck round the

house all afternoon. Why don't you take this, and go and shoot some of them blinking old woodpigeons for me?" So saying, he thrust into my hands a most beautiful little 28-bore gun and a double handful of cartridges. The gun was a double, Damascus barrelled, hammer, underlever by Holland & Holland. It was given to Uncle by his boss for pigeon and crow scaring! Today you would perhaps need £2,000 to buy one like it. Be sure I went off delighted, returning a couple of hours later proudly carrying nine woodies.

My cousin Martin is only six months older than I, so we were more or less constant companions when exploring the various swamps, old gravel pits and scrub areas around the town. We found one very interesting swamp, in Yardy's Pit, I think. When we walked across a certain stretch of rushes it "gave" like a trampoline; it was obviously a thick skin of vegetation over water. We had great fun jumping up and down on it. God knows what depth lay beneath the rushes.

Almost as hazardous was watching blacksmith George Nelson. We'd enjoy hanging over the half-door of the forge in Station Road watching the sparks fly from hot metal being beaten into shape. I liked to see him fitting pitchfork heads on to shafts, because that caused a lot of smoke and a woody smell. Sometimes we would see Mr Nelson nip across to the small paddock opposite to shoe a carthorse, amid clouds of white, acrid smoke from the hoof.

If things are not going right, not many people can tolerate an audience of small, sniggering boys. We always knew it was time to

leave when a piece of metal thudded into the door closely followed by a string of curses.

When we were about twelve Martin went fishing with a mutual friend of ours in the tidal Nene. He was so taken by the place that he soon passed on his find to me. At first we spent our time walking the jetsam line of the previous high tide to see what treasures we came across, and we would play in the flooded fields or in the two milking sheds that stood on the wash. The Hailstone brothers, Jack and George, had the asbestos shed near the Nene bank, but this was demolished several years ago; the other shed, which is still standing, is owned by Ron Jacobs, farmer and one-time England Rugger International. These old sheds, known as Jacobs' Hovels, were hired twenty years ago by Harold Lilley. He and his employee "Darkie" Wright milked their herd down there and delivered milk round the town. Health inspectors might throw up their hands at the thought of milking there these days, but our milk always "kept", even in summer if stood in a bucket of cold water, because it was fresh.

One day we were approaching the sheds when we noticed a lot of rooks taking an interest in the place. Going in, we scared about forty of them out of a small outbuilding which was a store for cattle cake (three-quarter-inch cubes of compressed food). With the intelligence of the tribe, these rooks had pecked open the bags, and each came out with a cube in its bill. If they had been at it all day, they must have eaten a considerable amount of the stuff.

Eventually, every Sunday morning would find us along the tide line of the Nene. What a curious collection of rubbish we found: driftwood, bottles, broken chairs, dead hens and seals and drowned sheep; broken toys, rope and timber; new timber, fallen from the ships in Wisbech. And ladies' handbags; always ladies' handbags. Being young and innocent, we always dreamed of the day when one of these soggy bags would disgorge wads of five-pound notes. Silly boys; later we would find out that ladies carry everything in their handbags except money! Oars we found, and made use of. Once a wooden clog, from a Dutch ship. Lifebuoys, too; the cork from these made good floats for the headrope of an eel net.

Many of the bottles contained scraps of paper, usually bearing the address of a boy or girl in Wisbech. One day though, I found a more interesting one, with a note which read:

"This bottel are thrown in the Wisbech cannel by J. v. d. Jagt, Chief Engineer, mv *Naerebout*". Then the date, and an address in Vlaardingen near Rotterdam. I took the paper home, put it in a safe place and forgot about it, only to come across it again some three years later when throwing out some rubbish. On impulse I wrote to Mr van der Jagt at the Vlaardingen address, and in due

course I received a reply from his wife. She wrote to say that her husband was now chief engineer aboard the Dutch whale catcher *Thomas W. Vinke* with the whaling fleet in the Antarctic, and promised to send my letter on.

A couple of months later a postcard dropped on to the doormat from Johan van der Jagt, franked by the Antarctic Post Agent. The picture showed a whale catcher complete with harpoon gunner in the bows. Thus began a sporadic correspondence, mainly at Christmas. In 1962 four of us were going over to Holland for a holiday, so I arranged a visit to the van der Jagts. By that time Johan had retired from the sea but was still working as engineer aboard a crane ship, the *Albatros*, in Rotterdam harbour. We visited him at his work one day, and then at the weekend paid a call on him at home, meeting the whole of his considerable family. We stayed for tea, and that evening Johan invited us to meet some of his friends. It turned out that most of these friends were barmen. We shipped a considerable amount of Oranjeboom, Heineken and Amstelbier. We also heard tales of our host's whaling days, of how they would allow their beards to grow untrimmed for the whole voyage; by the time they returned home they could tuck their beards into their belts—as Johan said, it was as good as an extra shirt! My cousin Martin was able to meet the family some years

Lord's Holt can be seen on the horizon in this view of the Low Wash.

later when he was working in Holland. It just goes to show what can result from a scrap of paper in a bottle, washed up along the muddy old Nene.

On our Sunday-morning walks we could not fail to notice the different kinds of birds, several of them new and strange to us. We bought bird books to help us to identify them, and the following Christmas Martin received a pair of binoculars. Gradually the beachcombing took second place in our priorities.

During these years I had acquired a twelve-bore gun and began to see if I could get some shooting on the wash. Martin did not shoot, and at first he took rather a dim view of my designs upon the wildfowl. I am glad to say that it did not result in a serious rift, however.

While in our early teens we purchased a Canadian-style clinker-built wooden canoe which cost us the astronomical sum of seven pounds—for us it was astronomical, even though we shared the cost between us. We took over the vessel, which we christened *Windhover* after the many kestrels, on Peterborough Embankment and brought it home along the Nene one day in 1956.

It opened up a new world for us. From it we saw the washlands, the rivers and dykes from a different angle. There is a small spinney of eight trees, known as Blunt's Holt, not far into the wash, and from Harold Lilley, who then hired the grazing, we obtained permission to leave our boat in the dyke there. Sixty yards in from Morton's Leam the first tree had a freak bough; broken early in life but growing on, this bough came out horizontally across the dyke, leaving a gap just wide enough for our boat to pass. Once through, she lay moored right alongside this natural jetty. The field was bounded on all sides by water, and the only access was by a gateway to the drove, a quarter-mile away. We called this our "island" and were for ever making plans to save up to buy it one day.

At that time the dykes were clean. Frogs were abundant, and as a result so were grass snakes. It was nothing to spot three or four snakes crossing a dyke as one walked its length of a sunny day. I saw five fourteen-inch pike within five yards one day, most likely a family hatch.

One could hardly call Blunt's Holt a holt today, for the ancient willows have nearly all blown down and are wrecks. In 1956 most still stood, though two of them were beginning to go even then. One of them which we called the Broken Tree was hollow; this was our secret cupboard, in which we hid canoe paddles and such. A little owl nested in there most years. On the other decaying tree a massive bough had crashed during a storm, leaving a torn and jagged rupture high up on the bole; here a kestrel brought off her young for several years—naturally this became the Kestrel Tree.

We spent a lot of time during the summer holidays at our "island", sometimes camping in a small ridge tent and heating up tins of baked beans over our cooking fire. Herons roosted in Blunt's Holt then, and in the mornings their raucous pre-breakfast discussions would rouse us better than any alarm clock.

If the nights were lit by a full moon we might take the boat for a run up the Leam. One such night we ran up to some swans. Usually they would swim away until able to take off, but one of this

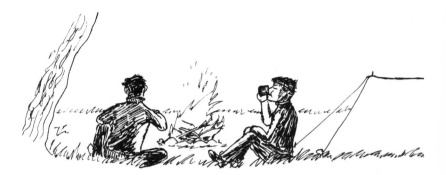

group thought it could get enough lift to clear us and came thundering along towards our boat. It was still running along the surface when only yards away. We ducked as the huge bird, looking to us like a bomber, just scraped over us.

We were walking across a rough, reedy swamp on Eldernell Wash about one in the morning on a glorious moonlit August night and telling each other ghost stories when we walked right into a party of jukking pheasants. Black shapes rocketed up from all around our feet amid a whirlwind of noise, making our hair stand on end!

Sunday morning walks are often the way that country boys learn about their surroundings and the wildlife therein. So it was with us. We picked up a lot from our bird books, but much more from poachers, shepherds, wildfowlers and naturalists.

We began to meet on winter Sundays a schoolmaster from Thorney, a Mr Driver, who was a keen birdwatcher. Next appeared Mr Douglas Ellicott, who until then had used the High Wash and Yardy's Pits as his territory. From these men we learned a lot about the birds of the washlands, about different geese, duck, swans and waders, for example. Later on a boy younger than us was occasionally seen; it was Robin Jolliffe, in years to come to rise to prominence in RSPB circles.

In March, 1958, Peter Scott, who had just opened his new Wildfowl Trust Gardens at Peakirk, held a lecture evening at the

Embassy Theatre, Peterborough. This evening was to give the venture a public send-off. Mr Driver arranged to meet us at the theatre, and we were thrilled when he introduced us to old Billy Williams, the decoyman at Borough Fen Decoy. Here, in the flesh, was someone out of Fenland history!

Mr Ellicott took us about in his long-bonneted Alvis open tourer, a sporty car which would be much prized by enthusiasts today. Doug Ellicott was an all-round naturalist who aroused our interest in the various plants and herbs and in butterflies. Things that we would have ignored as just part of the scene we began to recognize instead as comfrey, purple loosestrife, meadowsweet, large tortoiseshell and so on.

It was Doug Ellicott who one day pointed out the lesser whitefronted geese among the mass of grey that made up the main gaggle of geese. We saw more than fifteen, maybe twenty. We did not know at the time that the record then stood, I believe, at eleven. Being unaware of records we just enjoyed the geese for their own sake.

Mr Ellicott emigrated to Australia at the age of sixty-eight. He is now in his eighty-eighth year and has only just retired from a part-time job in a museum.

While learning from the naturalists, we learned at the same

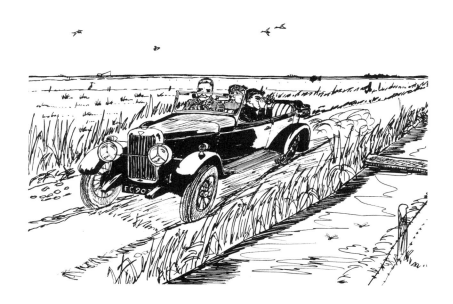

time the ways of the poachers. Shooting seasons meant little to some folk, and many a stubbling mallard was put into the bag in August.

It was 1957, June in fact, when that well-known, likable rogue Jack Gilbert and another were caught shooting duck out of season; you cannot get much more out of season than June! They had shot two wigeon and a shelduck near Popley's Gull, driven back to the milking sheds and plucked the fowl therein. They didn't get away with it, though, for when they drove out on to the main road the ever-vigilant Police constable Bailey, who had heard the shots, was waiting for them.

Nine months later, in the March of '58, Police constable Bailey struck again. This time three local brothers had been shooting; again, it was out of season. The two eldest had cycled out on to the road, having instructed their fifteen-year-old brother to bring home the bag, two shelduck, two wigeon and a pheasant, once they were well clear. Unfortunately for them he didn't wait long enough, and cycled up as the constable was interviewing his brothers. The upshot of this was that as well as being fined the elder brothers had their guns confiscated by the court. I had seen the guns when we had shot together earlier in the year, brand-new single-barrel Webleys; it was quite a blow to lose them.

While on the subject, I might say that there are enough poachers around Whittlesey to man a good-sized pirate ship. Though they are a rough and ready crew, most of them are good hearted characters who are as good as their word. I'll limit myself to one little tale of a swan, told by the main character's daughter, so it ought to be authentic.

A noted poacher in the Forties was "bolting for his earth" one night with the law in hot pursuit. He rushed into the back door of

The Gull Flash on Whittlesey Low Wash, a favourite place for duck and for poachers.

his bungalow carrying a freshly-shot swan, and almost at once the bobby hammered on the front door. His missus was able to cause a few moments' delay by "having trouble" unlocking the door. In steps the constable, eyes scanning the room, but the poacher, though a little breathless, returns his gaze calmly enough, gun and outer garments having been stowed away seconds before. After a search reveals no evidence the frustrated constable is forced into a reluctant withdrawal.

As soon as the policeman has gone, wife and daughter descend on the poacher. "Where on earth did you hide that swan?" is the chorus. He leads them into a bedroom and, with a grin, turns back the quilt. There lies the huge bird all serene. "He looked a bit

tired", remarked the poacher, "so I thought I'd let him get his head down for a while!"

The wash was at that time a sort of Tom Tiddler's Ground for local gunners. Some had permission to shoot, others did not; nobody cared much either way. Don Payne was a regular then. He always wore his Paratrooper's red beret, complete with winged cap badge, which impressed me. It was also impressive that he had managed to survive so long with his terrible old crock of a twelve-bore. It was a hammer gun, and the underlever was so shaky that it was bound up with tape. Nevertheless, it was deadly in more ways than one. I can still picture us talking on the drove; a pigeon approached; Don swung up the old underlever and fired.

"He's a dead 'un!" said Don. The woodie flew on, seemingly unscathed, then suddenly crashed. A dead 'un sure enough.

The wash shepherds, Sam Hilliam on the Low Wash and his

brother Len on the High Wash, were very kind people, under-
standing and tolerant of us boys. I think that they saw that we had a
genuine love for the place and were not out to make mischief. We
would watch Sam top up the cattle drinking troughs from the dyke
with his jet (a long-handled bailer). We would help him get a beast

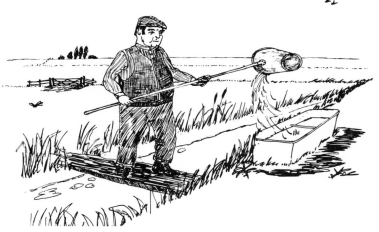

out of the dyke or move stock to a fresh pasture. Sam would tell us
of the old days, when he was a small boy, of how his father showed
him the nest of a ruff, or perhaps it should be reeve. None of us
could guess then that in a few years' time the ruff would again nest
on our washlands.

Sam knew our grandfather, "Saturday" Smith, and com-
mented on his fine singing voice. Sam remembered him winning a
piglet by singing with it tucked under his arm.

Sam was a big man; most of the Hilliams were. When he was
counting bullocks he would stand on the drove near the gate and
dob his finger at each beast as he counted it. Viewed from half a
mile away, his silhouette looked just like someone conducting a
choir!

In August '57 I first set foot on the wash with a gun. I had no
idea where I could go. It was Sam I asked. "You can go in this field
here," he said. "I saw an old hare in there earlier on." It was one of
the high fields in the wash, known as "The Hills".

I did not find the hare and so ambled down to the Leam right
on dusk. I had a shot at a moorhen and was most impressed by the
flash of the gun but didn't make any sort of impression on the
moorhen.

After a month I had explored right to the end of the drove,
but was still very green. I stood there one September night when
another gunner appeared out of the gloom and had a few words.

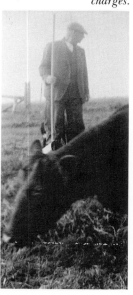

*Len Hilliam, High Wash
shepherd, with one of his
charges.*

Before he left he said "You'll never get a shot standing there. Look, be at the top of the drove next Saturday and I'll put you on the right lines."

You can depend on it that I was waiting at the appointed time. My tutor duly arrived in his van and we bumped our way slowly down the drove for two and a half miles. My friend told me his name was Don Anthony, and that he had been shooting for several years.

At the New-Come-Over we walked along the drainside to the Nene Bank. We passed en route another gunner ensconced in the reeds, puffing out clouds of smoke from his pipe in an effort to keep the gnats at bay. He also wore a trilby hat, probably for the same reason; I don't think I have ever seen a trilby down the wash since.

On reaching the tidal river Don and I turned east along its bank. To my amazement there was a large expanse of rushes and water, some thirty acres of swamp spread out before my eyes. This piece of permanent marsh was known locally as the Ministry Swamp, as it had been taken over by the Air Ministry at one time for a bombing range. We boys hadn't explored this far down and I was delighted with my new "find".

Don, I noticed, had a old Tolley hammer ten-bore, with a duck painted on the stock; this all added spice to the romance and excitement for a youth of sixteen. Don put me near the dyke which bounded the swamp while he and his dog moved on a couple of hundred yards.

We didn't see a great deal. Heard a few wings whistling and some muffled quacks. I think I had two misses with my single-barrelled twelve-bore, then a lone duck approached from the south. It turned across my front, swinging downwards, one wing tilted higher than the other. I swung too, and fired. Somehow that unlucky duck flew into the shot, folded up and dropped like a

stone, hitting the water with a mighty splash. I couldn't believe it; I was elated. Don's black labrador was already swimming back with the bird. It was dark now, so Don walked up with the duck, a mallard.

As we made our way back to the van I was told that the correct way to carry my prize was by the neck. The drove was grass in those days and on the way home we became stuck. I was dropped off near my cycle, at the top of the drove. After Don had driven off I discovered that I had a puncture; I didn't mind walking home, though.

Every now and then I'd feel in my bag to see if the mallard was still there, and that I hadn't dreamt it all! I really had got my very first duck, the one you always remember. I now know that it was poached. I wasn't aware of that fact at the time, and at that age I don't suppose the knowledge would have made much difference!

I had made friends with Tom, the youngest of the Hailstone clan. He grew celery plants on his land in East Delph, on the very edge of the town, and I used to watch him sprinkling soot along the rows to prevent worms working during the night. While he was sooting Tom told me tales of the old days of punt gunning, plover catching and eeling.

At his home he showed me a great chest crammed full of fowler's impedimenta: powder, shot, reloading tackle, flasks, caps,

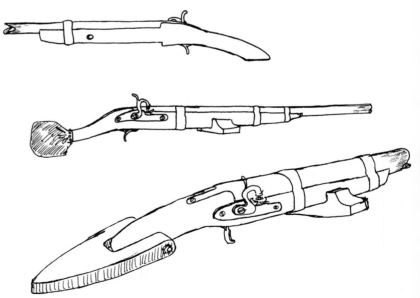

Fenland punt gun stocks, showing the local variations. Top is a type used on the Ouse Washes at Welney; the recoil was taken either by a rope or by lodging the stock against a thwart. In the middle is a pattern used on the Nene Washlands at Whittlesey; the horsehair pad enabled the recoil to be taken on the gunner's shoulder. At bottom is the bootjack or slipper used on the Welland Washlands at Cowbit; the recoil is taken by a punt floor, against which the slipper is wedged.

and a bag of large swan shot; then dyke nets, gate nets, and eel hives. Two massive punt guns hung from loops on the wall, and in a greenhouse yet another punt gun reclined on the roof trusses.

This third gun Tom said I could buy for £4.

The gun had no lock. We searched through a box full of gun locks, but found only one that was anywhere near the correct shape and size. I took this while Tom promised to look for the original lock. The gun was a muzzle loader of 1½ inches bore with a barrel 7 foot 3 inches long and the local stock with its horsehair pad. Proudly I carried it home.

When I had been able to obtain some black powder I loaded the gun, powder only, to test it in our garden. It did not fire. Using the worm on the ramrod, I drew out the rag wadding, and with it came some of the powder, spilling on to the tea chest on which the gun barrel was resting. My brother Duncan, who would have been twelve at that time, asked if he could light the surplus powder. Foolishly I agreed. He put a match to the small mound. It flashed up, catching that which had trailed to the muzzle of the gun; it flared, full bore, like a blow lamp until it reached the bulk of the charge still in the chamber. There was an almighty roar and a cloud of thick white smoke filled the garden. The Lord knows where my five-pound canister of gunpowder was, but I'll bet it wasn't far away! Our mother rushed out to see what was going on. By now my brother was in his usual refuge when trouble loomed, up the pear tree.

I got to know old Bill Benstead, known as "Ducky", who showed me all his tackle, and a wad of bills of sale for the birds he had sent to Leadenhall Market in London. He even had a bag of new flints for flintlock guns. Bill was more or less finished with big gunning then and offered me his boat and punt gun, the complete outfit for £20. I could not afford that, for I was still at school, and eventually it was sold to someone from out of town.

Occasionally I went flighting with Tom Hailstone. I learned from him to keep one ear into the wind, thus leaving the other one free to hear approaching wings. It's a good tip and one I use to this day. Tom also stressed the importance of letting a duck get a fair way by before firing, allowing a larger shot pattern. Tom pulled off some fine shots, and didn't waste many.

We carried his father's heavy old gunning punt down to the East Delph land, intending to use her, but alas, she was too far gone and rotted there.

Naturally I met others of the fraternity of the marshes during this spell, including the Parnell brothers Sid and Ted. Sid, another gunner who didn't waste shots, was a very patient fellow. One of his favourite occupations was to lie in wait at dusk for pheasants and partridges as they flew over the bank from the arable lands to

spend the night in a cosy patch of rushes on the wash. It was not unusual for Sid to bag fifty to sixty birds a season like this.

Then there was Ivan Hart, a legend even then, who lived in Claygate. Many were the stories of his prowess with a gun and of his heavy bags of fowl and game. He was a sort of a hero to the younger gunners. It was from Ivan that I first heard of places like "The Coy" or "The Guns" (The Cross Guns pub area). I bought from him a mighty single-barrel four-bore with eleven cartridges for £15. The cartridges alone would cost that today.

Our local GP, Dr Logan, had a stepson, Patrick St Leger, who now lives in South Africa. Patrick and I were around the same age, so we joined forces during the school winter holidays. Patrick had such difficulty in rising early for flight that he would set three alarm clocks in a biscuit tin—they must have shaken the whole house.

Another friend made at this period was Tom Thrower, the pumping station operator at Dog-in-a-Doublet, a man with some interesting stories to tell. Tom made his own nets for eels, which he caught from the drains and the tidal River Nene, and—ssh!—for other things as well. We would watch him setting his wing nets out on the mud shelves at low tide.

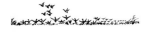

We tried our hand at eeling. I bought a trap from Tom and made a not very good copy of it. We also ledgered for the slippery fish, amusing ourselves for hours.

Since my "discovery" of the Ministry Swamp beyond the New-Come-Over we always headed there. A clap of hands from the bank would usually be followed by a hushed silence, then a roar of wings as anything from sixty to three hundred ducks, mainly mallard, thrashed skywards. Mallard were definitely in the majority. Other duck using that swampy haven were teal, some shoveller, and, one famous day, sixteen garganey, eight pairs; I've never seen a larger number to this day. We often came across the odd pair, the rattling cry of the drake being so very distinctive.

We had seen signs of the presence of otters, especially on the low tide mud of the Nene. Five-toed footprints and slides in the mud were unmistakable evidence. We longed to see these secretive creatures, but were lucky only twice.

When I was at work and Martin was away at university we still spent our holidays on our beloved wash, and I still accompanied Mr Ellicott on some of his Sunday-morning rambles.

So our youthful adventures carried us into the beginnings of manhood. The seeds sown over these years had indeed germinated. We had entered the fraternity of the Washlanders.

A Washlander's Year 4

AS THE fowling season ends on 20th February I suppose it could be said that the Fenland sportsman's year begins in March, so let us begin this chapter at the springing of the year, when the ice rarely holds long enough for skating, for already the sun is gaining in power by the day.

The land and the air warm beneath it. The birds feel the change and are making preparations of their own. The herons in Lord's Holt already have their nests, easily seen through the still-bare branches of the ancient trees.

Snipe drum, swooping down like little dive-bombers, pulling out, climbing up, up, flipping over at the peak to sweep down once more, all guns blazing! Redshanks appear now in greater numbers, flying in from the saltmarshes of the Wash, perhaps eighteen miles away as the 'shank flies.

Until the mid-sixties, March was the month that great gatherings of pinkfooted geese collected at Whittlesey Wash prior to migrating to their Icelandic nesting sites. My diary records that on 23rd March, 1958, three thousand pinks could be seen from the milking sheds. Spread out on all the tussocky fields to the south of the drove, a thousand here, two hundred there, three hundred over there, and so on, like so many flocks of sheep, they were tugging up the grasses, grazing themselves fat for the long flight north.

It was thrilling to watch a great skein fly in, perhaps 200 yards high, then, seeing some of their clan feeding below, whiffling straight down, spilling air out of their wings, to drop in a tumbling, twisting mass of birds. Dropping perhaps fifty feet at each twist of the body, but all levelling out to land head into the wind in a most orderly fashion, showing complete mastery of the air.

It was far more normal to see skeins circle warily before gliding in on set wings, the stance Peter Scott has captured in so many of his paintings.

Perhaps the most geese I ever saw on our wash was on 9th February, 1958. Mr Ellicott drove us round to Eldernell, where the three of us were soon making our way to the decoy. We gained access to the 'coy via a fallen tree over the dyke, and walking past the pond, with its island shrouded in mist, we stealthily approached the western edge of the Decoy wood.

On the fields beyond were the geese we had come to see, a huge crowd of them. The fringe of the nearest birds covered a stretch of shallow water 300–400 yards long; the depth of birds was unknown to us. All the time more skeins and little parties arrived to join the grey mass; it seemed that there could be very little room for any more to squeeze in! We picked out about a hundred whitefronts, but they were pinkfeet in the main. We estimated 4,000 to 4,500.

After we had been watching them for an hour a crow-scarer over on the farm land went off with a loud bang. All the forest of necks went up, like reeds. A moment of total silence, then they jumped; the roar of wings was like a deafening roll of thunder. Once on the wing they found their voices again. Most of the geese came right over us, a truly magnificent spectacle.

Some years small parties of up to ten geese would stay on until April, odd ones even hanging on into May. I believe the highest recorded number for the Nene Washlands area is over seven thousand; that count was made in the nineteen-forties. Of course, when we were getting geese in their thousands the wintering population on the mudflats and sandbanks of the Wash coast was between fifteen and twenty thousand. The introduction of new farming methods in Scotland, with feed readily available, resulted in more and more geese staying in the North; the Wash coast

A thousand geese seen at Whittlesey Wash in 1960. Such scenes are no longer observed on the washes here.

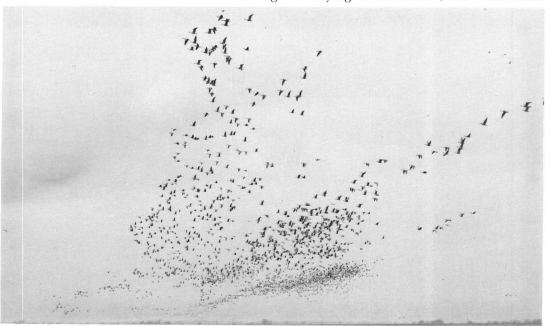

population dwindled to a mere three thousand, and ours dropped correspondingly. In fact, after the mid-sixties it was rare to see any, though small parties of whitefronts occasionally visit, for they love the grass.

March is the last month of the winter for much of the pigeon shooting at the roost, for the drilled crops need to be defended now. The strong March winds can sometimes help to fill the bag with woodies.

With the advent of April and May the grass really begins to grow. The waterside birds bring off their young, and broods of duckling, coot and moorhen can be seen up every dyke. Redshank and plover may be observed as they mince along, leading their chicks in and out of the tussocks, and snipe are there too, but shyer. Larks, pipits and the like are also to be seen, all feeding youngsters.

Spring floods wipe out virtually all ground nests, though coots and moorhens can sometimes beat the water by raising their nests. If that fails they'll just build on top of the old one. Years ago when (whisper it!) I was wading about in some floodwater collecting coot's eggs for a salad I came across a nest with no fewer than three layers of eggs. The bottom layers had been swamped as the water rose, and a new lining of grass had been woven in and the next clutch laid. There must have been a good three dozen eggs in that nest.

When nests are raised up like this they can be embarrassingly visible when the flood goes down. Standing by the field gate, I have counted eight coot's nests in one small field, little pillars of vegetation, perhaps two feet high, each with a very self-conscious parent on top of her penthouse.

Usually after a spring flood those birds that have suffered will quickly breed again. The resulting broods, hatching later, often grow up in better weather conditions and are fitter in consequence than survivors of earlier broods.

It was most likely a wet spring that brought back the ruffs and black-tailed godwits to us. The Hundred Foot Washes are quick to flood, so when Welney and Mepal are under three feet of water our wash at Whittlesey may be getting just a trickle on to the fields, and the waders washed off the Ouse will move across to us. I have seen a hundred godwits arrive within a day of the water showing itself; more than three hundred dropped in on Eldernell Wash in 1986.

RSPB wardens tell me that these large companies are most likely Icelandic birds making their way home. Since the mid-seventies, when we had a spell of regular spring floods, one or two pairs of black-tailed godwits have stayed to breed each year.

Though this species was "rediscovered" at Welney in the fifties, the old gunners will tell you that it was always there. Certainly, I think the odd pair may "always" have nested on the

Nene Washlands, at Guyhirn as a rule, though my cousin and I watched some at Whittlesey in May, 1956.

Ruff have always passed through our wash, but in the seventies ruff in breeding plumage began to show up, and eventually to breed.

Should the floods be deep enough in the spring some good sport can be had sailing a gunning punt across the wash. A boat which draws only an inch or two of water is the only practical craft

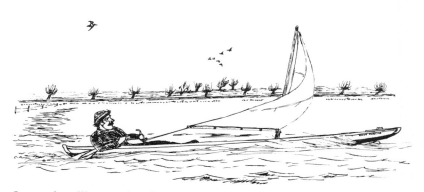

for such sailing, as in places the floodwater is very shallow indeed.

These spring floods caused the abandonment of some of the land that had been ploughed. It was either put back to grass or allowed to grow rough. It was in one of these tangled swamps that I found a pochard's nest; May, 1980, it was. I found a godwit's nest the same day. Both were found by accident, for I do not believe in disturbing nesting birds. I had taken my small son to see a secret pool in the middle of this high rough cover of reeds, rushes and sedges, and as we pushed our way through the tangled herbiage the pochard got off her nest right at our feet. We had a quick peep at her eggs, and did a prompt about turn.

One bird to have increased noticeably in numbers since the establishment of the Ouse Washes reserves is the Bewick's swan. In the nineteen-fifties we saw a few Bewick's and whoopers, rarely into double figures, but after some of our wash was ploughed the flooded arable land seemed to attract them. They have even flighted regularly out from Welney when we have too little water to hold them here. Nowadays we find several hundred wintering at Whittlesey most years. The first little party, perhaps only half a dozen, will arrive in October, and from then on the numbers build up. My personal record is of 880 Bewick's. I believe the total for the Nene Washlands that winter was two thousand or more.

I missed the geese when they left us, but the Bewick's are a fine

replacement. With their wild calls and their habit of flying in long lines and skeins they are very goose-like. When they first began to be seen in sizable parties one well-known local rogue pronounced them to be snow geese; he had seen plenty of them in Canada, he said. He almost convinced some people into organizing a snow goose shoot!

These swans love grazing on winter wheat; I reckon that the mute swans which now do this have copied their wild Siberian cousins. The Bewick's leave us in the spring, flying back behind the Iron Curtain to raise their families.

Speaking of families brings to mind a gipsy family who camped on the wash for a spell annually over a number of years. Fred Walker was the head. His vardo, the barrel-topped wagon in which the family lived, would appear overnight.

Back in my youth I was talking to Tom Hailstone on his celery land in East Delph when we heard a vague musical singing sound wafting up on the evening breeze. Looking along towards Little Bridge, where the camp was sited, we could see the fire blazing high. In the arc of light around it we could see a girl, Fred's daughter, dancing a flamenco-type step. I had thought that this sort of thing took place only in story books. We must have been privileged that night, for I have never seen any dancing girls since. Not down the wash anyway!

Fred Walker's vardo at Whittlesey High Wash in March, 1975.

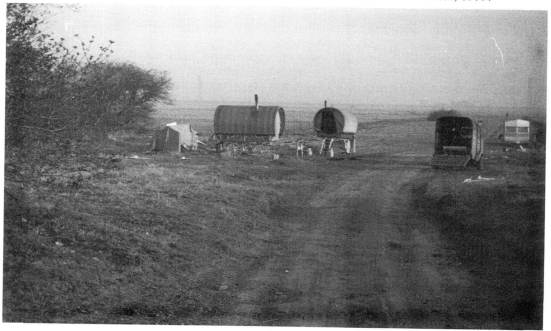

As the family increased, the vardo was too small for them all. The eldest children slept under the flat cart, with a canvas tilt for shelter. It was quite a sight at this time to see the family arrive in town. Fred, leading the vardo horse; Bella, his wife, and youngsters perhaps riding; the flat cart behind, driven by one of the sons, with a crate or two of bantams on the cart, a pair of lurchers and maybe a terrier running underneath; bringing up the rear a string of horses, the lead one ridden by another son.

Times have changed. Fred had about a dozen horses in those days; now he has perhaps fifty, and visits them in a pick-up truck.

A year or two ago their camp was on the Common Wash. I was half a mile away in Little Holt when I started a hare which ran, as hares will, in a wide circle. The route she chose brought her within sight of the gipsy camp. In a matter of seconds came a real hullaballoo; all the dogs were released and urged on by wild yells of encouragement. "Jill" went hell for leather across some high ground, followed closely by the lurchers, not so closely by the

Eel nets in the punt.

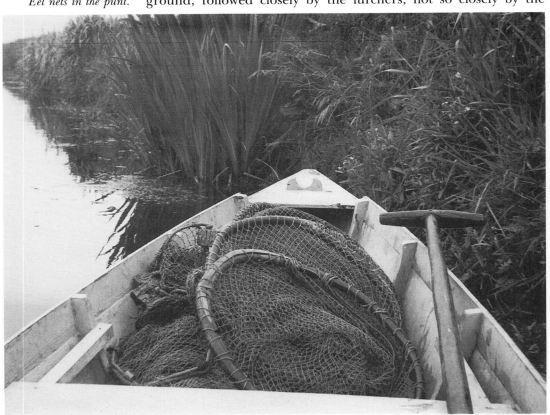

terrier and, well behind, by a collection of children. The hare was on home ground, and she used her knowledge well. Down she ran to the water at Delph Dyke. Springing halfway across, she swam the rest and was away. The "hunt" brought up short at the water's edge. That hare was in luck, for those lurchers are not taken along for show.

Spring and early summer is when the nets, eel hives and grigs come into service; some licensed, some not. I had a favourite spot in the tidal river once which was handy for a trap. On a bend of the river a section of the bank had been so undermined by the tides that eventually, under its own weight, it had crashed on to the mud below. The gap between the lump and the bank was just right for my wire hive, and I made some nice catches there. One day, on making my check of the hive, I came over the bank right on to a sheldrake standing on my mud lump, preening himself. I was within a few feet of him before he saw me and sprang up in alarm.

Those were the days before any attempts at ploughing had been made, days when the only other human to be seen would be Sam Hilliam, counting and watering his charges. I'd often be roped in to move some stock or to try to extricate a beast from a dyke.

The spring brings back some colour to the landscape. The yellow grass of winter greens up as the sap rises. Here and there the lilac of cuckoo flowers and the gold of marsh marigolds lights up the dykesides. These will soon be followed by purple loosestrife, meadowsweet, buttercups, lilies and yellow flags. And then comes watermint, which gives off that pleasant minty aroma as one walks through a wet meadow; I have been known, on coming to the end of a bed of watermint, to retrace my steps just for another smell!

All these plants, with bladderwort, willowherb, reedmace and great tall marsh sow thistle, add their contribution to the scene, each in its own season. Some of these are appearing now as we pass into summer.

In my early days on Whittlesey Wash the only other human being one might come across during the close season would be one of the shepherds. However, late June and July brought a week or two of hectic activity while the hay was cut, turned, baled and carted. Everyone hoped the sun would hold out for one more day; and that if the sun failed them, there would at least be a drying wind.

Some years the late harvesters would get caught out. A wet spell or a flash flood would make it uneconomical to cart the bales, which would rot in the field. Most years, however, everyone hit it right.

From the sixties at Eldernell and through to the early eighties on the Low Wash various owners experimented with arable farming on the rich peat of the washlands. The land was good

A pintail drake, photographed by Roy Bolton.

enough, but it was always a risky business. Some stuck at it; others, blighted by a cruel series of losses due to spring floods, gave it up as a bad job.

The fields that had been ploughed had had the dykes dammed off so that they had dried out. The natural consequence of this, as all who are familiar with the Fenland will know, was rapid land shrinkage. In five or six years much of the level had gone down by twelve inches, enough in fact for the normal summer level of Morton's Leam to put an inch or two of water on some fields.

Some of these fields became real swamps for a year or so, and were a haven for breeding fowl and waders. Among the duck which bred there were a family of pintail, seven in the brood, a nice record.

The warm summer days hatch out hordes of insects. If you sit in a punt up a dyke on a sunny day, the buzzing and humming you hear is remarkable. The sedge warbler reeling away in the willowherb stems does his best to outdo the flies, and he is hard put to it at times.

There was a female marsh harrier that turned up each June, always alone. She spent a lot of time in the swamp we called the "Ministry". For years she was the only harrier we saw, then some hen harriers began to winter here. Some would be seen as soon as the hay was cut, for then the beetles and rodents have lost a lot of cover for a week or two. Herons, incidentally, are not slow to take advantage of this opportunity; I have seen as many as twenty-one in one field.

As more land was left rough, so more harriers and other raptors began to show up. The occasional hobby or merlin joined the regulars like kestrels and short-eared owls. Before long the RSPB stepped in and bought a lot of the Low Wash, including the rough areas, and in the winter of 1983 a dozen hen harriers were using these marshes. A number of them established a harrier roost in a tangle of thistles and tall grasses. Several nights I watched with Malcolm Stott, the warden at that time, as the great birds swept in to their night-time quarters.

Regretfully the land could not be left rough, for thistle seeds blow on the wind, causing annoyance to neighbouring farmers. For a couple of years, though, we saw how much of the fen must have looked a century ago after Whittlesey Mere was drained. Tall grasses and rubbish grew over six feet high, and among the "rubbish" were some colourful flowers; I don't think I have ever seen so many butterflies.

I spent an afternoon with Malcolm Stott netting a certain species of butterfly; the Essex Skipper, I think it was. Malcolm was pleased to find several as he was able to confirm the report of the previous warden that he had seen one; it had been thought

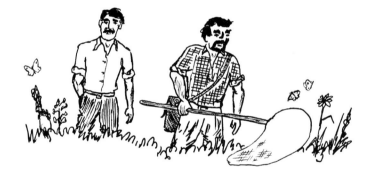

Whittlesey was north of the Essex Skipper's range. We let the butterflies go after confirming their identity.

In time the RSPB are hoping to establish a reed bed to provide the sort of cover in which marsh harriers would nest. Males of this species are now seen with the odd female who still visits.

Shelduck, renowned for nesting in rabbit burrows, once used those in the gravelly bank of the Counter Drain that runs by to the south of Lord's Holt. They still nest hereabouts, but nowadays usually in the grass like other duck.

One of our local GPs, Dr Dan Logan, was kind enough to allow the duck rearers of our wildfowlers' club to use his paddock for a rearing field. It was ideal for the job. The coops and runs lined up

between an avenue of elms. We always bought an old duck with a brood from a game farm. In larger runs adjacent to each small run we sank old tin baths to ground level, but we didn't risk the ducklings on the water straight away; day-olds might not have been able to get out of the baths. When the ducklings were three or four weeks old, though, they were allowed into the large runs with their own pond; they loved getting into the water for the first time.

When these duck were fully grown and some were able to fly we caught them up, a wild, muddy, smelly, noisy and hilarious affair—the latter if one was watching someone else diving across the mud after a duck!

Crated, or in sacks, our birds were usually taken over to Borough Fen Decoy, which belongs to the Wildfowl Trust. Tony Cook, the curator of Peakirk Waterfowl Gardens, was at the time the decoyman, and was very good to us. He usually gave a guided tour of his decoy, then helped us to ring and sex each mallard before it was released. We learned a lot from those sessions. For example, most species of wild duck have a coloured patch of feathers on the wing known as the speculum; on a mallard this is blue, edged with white. What we had not noticed, and what Tony Cook pointed out to us, was that on the female the white band extends on to the brown of the wing, whereas on the male it stops sharply with the blue feathers.

The immature drake has a bill of pale olive green, and his voice is hardly more than a squeak. The bill of the duck, however, is yellow, with dark spots; her voice is already a strong nasal quack. These points are good aids to sexing if the bird in your hand has not yet attained its winter plumage.

Tony Cook also pointed out that the tail-feathers of a bird of the year end in a wedge shape, while a mature bird's tail-feathers end in a fine point.

We must have reared six hundred mallard during the few years at the Paddock. If half of them reared families of their own we could claim to have put back into the air a few thousand duck.

One year I was hoeing sugar beet for my uncle at Feldale Farm. It was June and very, very hot. At the end of the beet was a neighbour's wheatfield. It had been sprayed that day and a shelduck had brought out her brood to the dykeside. They all lay nicely in a hollow.

As the afternoon drew on the old bird had not been near, though she might have been watching from a distance. The ducklings must have got overheated, for when I got down that end of the field again they were scattered up the rows, looking very distressed. Some, indeed, had already keeled over.

Usually it is wrong to pick up nestlings found on the ground, as the parent will come back to feed them. However, the old

shelduck had had time to come to her young. The field was long, and I was away from that end for most of the time. In a word, these youngsters were going to die pretty soon if nothing was done. It so happened that I'd got just the home for them, or so I thought!

Only a couple of days before I found the shelduck we had taken delivery of the year's batch of mallard ducklings at our rearing station. So, no more to do, I gathered up the tottering shelducklings into my pullover and drove quickly to the paddock.

At the first run I popped a couple of shellies under the boards. They ran to the other ducklings and were accepted by the old duck. Great! On to the next run. Two more introduced. It was a different story this time. This old bird drove the newcomers away from her brood; some of the old parent duck were very fierce and would even attack us when we went to feed them. I am pretty sure this one would have killed the shellies, or at least kept them from feeding. I had a devil of a job getting them out without releasing the rest.

After causing all that panic, I dared not try any of the other runs. There was only one thing for it; I took the remaining six home, and we reared them in the kitchen.

The theory was that the ducklings would stay in a run made of cardboard boxes, being let out for exercise for an hour or so a day. Practice and theory proved to be different things. My wife Pauline and I were both out at work all day at that time, and when we arrived home the first job was "hunt the duckling". They might be anywhere; under the washing machine was a favourite haunt. We

had a vinyl floor-covering in the kitchen, and when the ducklings ran over it their big feet made a slapping patter. They were amusing little creatures.

Towards the end of the three weeks that we had them in the kitchen they would come to you if you whistled that Cheep! Cheep! Cheep! call of theirs; a copy of the laughing quack of a shelduck would make their heads go up. At three weeks they were big enough to go into a spare run at the end of the paddock. Pauline was glad to see them go; a kitchen is not really the place for a duck pen!

We lost the two shellies I had left in the paddock, but my six grew to be lovely birds. In August we invited Tony Cook to select a pair for the Wildfowl Trust at Peakirk. Tony sexed them and found that all but one were drakes. He took the duck and one of the drakes back with him. Clem Smith, who with his wife Thelma ran our duck-rearing operations, and I ringed the other four and released them down on the tidal river; they would soon find some of their own kind along there.

Once or twice during the summer, for some fifteen years, we would make up a party for a day out on the vast expanse of the Wash proper with Tom Lineham of Sutton Bridge aboard his smack *Mermaid*. The day's schedule was to drop out with the ebb, then, once out in the estuary, to trawl for shrimps. Gradually we would work our way to Wisbech No 1 buoy, from where we would

Tom Lineham in the Mermaid *off Blueback Sand in the Wash.*

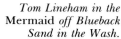

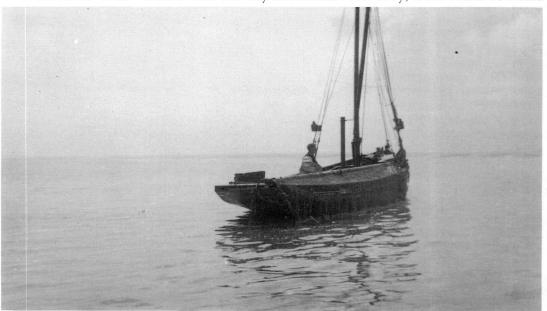

steer north-west towards Blueback Sand, which lies a few miles off Gedney Drove End.

Tom and his son Tom Jnr used the power capstan with practised efficiency to haul in the net. Old Tom had not always been as quick, though; once he caught a finger between the capstan and the rope. It threatened to twist his arm, but Tom chose to pull the other way and lose just a finger!

When the tide had dropped sufficiently, the *Mermaid* would lie at anchor while we were put ashore by means of the 18-foot boat they had taken with them. Armed with short-handled rakes and net bags with horseshoe-shaped wooden tops, we would set off over the sandbanks to the cockle beds. The sands, seemingly flat when seen from the shore, rise up surprisingly high from the water, ten feet or more in places, with hollows and creeks between them.

Some years, especially after a severe winter, the cockles would take some finding. In a good year one could rake up enough to fill the net in a quarter of an hour. Ideally, if the cockles were near a creek or pool, the net could be swilled up and down to wash off the sand after every few rakings. If your luck was out the water was a long haul away.

We would string out in a line, linked by the net bags, and begin the slow tramp back towards the dinghy. A net full of cockles weighs perhaps four stones, so after a while someone would want to stop for a breather. The offender always came in for some bullying from one of the fishermen, to the great amusement of the rest of the party.

While we had been ashore, old Tom would have got the copper going and begun to boil the shrimps. On our return we would unload the cockles, several hundredweight, and settle down to our sandwich lunch. This was the time when the crates of beer came under severe attack.

The idea was that the beer should be paid for at the end of the day, and bottle tops were kept by the drinker for totting up later. In practice many a top ended up in other people's pockets while they were looking the other way!

The cockles were boiled and riddled to separate them from the shells, and the bivalves would then lie cooling on the riddles. Handfuls of these and shrimps went down well with a beer.

Lunch over, we would lounge about listening to Tom's tales of local happenings since last year. If it was hot, some would strip off for a swim. After a couple of hours the tide would have flooded enough for us to make our way homewards.

While the *Mermaid* was surging up the main river Tom would measure out our share of the catch into plastic bags. We often had more than enough for our own use, and were able to give some to friends at home.

Cocklers all.

57

In the early days the Linehams were involved with an annual cull of seals in the Wash, joined by professional sealers from Scotland. In my more bloodthirsty teens I took along my rifle on our days out. One July day I went with young Tom and Bill, the crewman, to a wide creek between Gat Sand and Old South Middle. Tom was loading his .222 Hornet when Bill at the helm exclaimed: "Look, just around the bend!" There on the strand of a long curling bay lay a mass of seals, four hundred or more.

We made to within three hundred yards of them before they began to flip their way at surprising speed to the water; soon the surface of the sea was thrashed to a white foam. Bill steered into the strand. Tom and I jumped ashore, pushed off the boat, and ran along the sand. "Take only the young ones!" shouted Tom. After a hectic few minutes of firing, our skipper decided to pick up before the dead seals sank.

We turned to hail Bill. What a sight he presented! There he stood, his leg holding the tiller over so that the boat moved in slow circles, firing away like Annie Oakley. We collected eight seals, all of which were good skins. For me it was all an adventure, but I soon became disenchanted and decided I would rather watch the seals than shoot them. My rifle was left at home from then on.

For the fishermen it was a different matter. They were protecting their livelihood and no-one could blame them for that. No-one complains when a farmer shoots rooks and pigeons on his crops.

We had, as might be expected, a variety of days out there with the Linehams. Days of scorching sun, when we all returned looking like lobsters; days of fog and rain, and wild rough days when the boat really got a roll on; still others in late summer when we went home in darkness, with the winking channel lights marking the way. All magical days, sadly never to be repeated. Old Tom is dead, and the *Mermaid* was sold to a private owner down in Essex. I recently saw her on television, coming second in a smack race on the Blackwater. Good to know that she will continue to be loved and cared for.

Incidentally, in the *Victoria History of Cambridgeshire* one finds it recorded that in 1341 there was a lawsuit against the Abbot of Thorney and the men of Whittlesey, who had forcibly seized 3,800 acres of marsh from the Abbot of Ramsey. Later lessees of this marshland and fisheries were a Ralph Gray (for sixty years from 1527) and a Thomas Lyname (for eighty years from 1538). Whether either of us has an ancestor there I would not know, but it is a nice thought!

June is a good month for a run down the Leam before the cott weed makes passage impossible. By taking the punt right up to Lord's Holt one can hear the young herons clacking their strong

bills at their parents in a plea for the eel or fish Mum has just brought to the nest.

One day I took my young son Robert along the Leam to check a pair of fyke nets. There was a decent catch of eels, so I put Robert ashore while I emptied the nets. One eel slipped into the boat, but, it being safe enough, I left it there until I had dealt with the others. When I was ready I looked for the stray. There was some water sloshing about under the bottom boards, and the eel had taken refuge there.

I rocked the boat to swill him out into the open. Every time I made a dive at him, the eel managed to shoot back under the boards. At last he mistimed his move and I grabbed him and popped him into the eel bucket. I looked up to find Robert shaking with laughter on the bank!

Robert was six years old then. I had almost forgotten the incident when we went to a parents' evening at his school. We were inspecting his term's work when I saw it: there in his "news" book, where pupils record what has happened at home during the week, was a picture of a figure in a boat with something like a python writhing in its hands. A caption underneath read: "My Dad,

An eel net hung out to dry.

fighting the Eel." The Lord only knows what the teachers thought we got up to at weekends!

When the hay is carted the fields look like pale green carpets, edged and bordered with an emerald fringe of rushes. The year's young plovers gather here in their hundreds. After the grass has been allowed to grow for about three weeks cattle are often moved into these fields from the ones they have grazed off. Bands of starlings follow. They walk around the bullocks' feet, knowing that the horny hooves will churn up the soil and reveal the grubs and beetles therein.

Cowpats attract worms. The snipe knows all about that, as his boreholes in each pat testify. Do not be fooled into thinking that there are hundreds of snipe about, though; there may well be, but not all of those boreholes are made by snipe.

Butterflies, moths and dragonflies all go through their life cycles in the wilder corners of the wash and on the ungrazed dykesides. In the August evenings certain wildfowlers may be met as they wander down to favourite spots at dusk. Standing quietly by a gate, they will watch and listen for the whispering wings of this year's gathering of wild duck.

A cobweb lacework spun across the drove in autumn.

Some duck have only just grown new flight feathers after the summer moult, known as the eclipse period among the duck tribe;

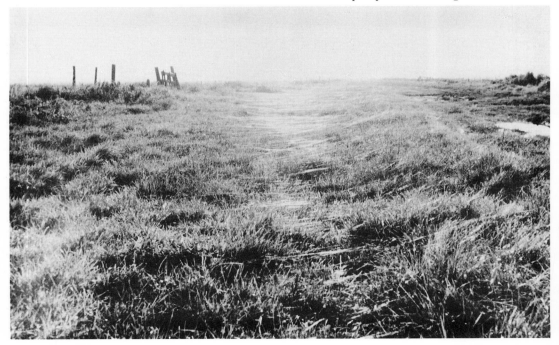

they are unsteady. Others are already strong in the wing. There is a lot of duck movement at dusk as some fly out to gorge themselves on spilled barley and as others, having already visited the stubbles, fly to the dykes for a wash or a drink after eating all that dry stuff.

When the old "Ministry" flight pond was THE haven for local-bred duck, I have sat hidden in the rushes, with gnats humming round my ears, and watched up to five hundred duck flight in at dusk. Large teams would swirl in, looking like so many gnats

themselves. With a baffling display of aerobatics they would suddenly be down. From all directions could be heard the splashing, dibbling, squeaks and quacks of the multitude going about their nightly business.

In the fowler's kitchen, the heavy duck guns are brought out, cleaned and oiled yet again in that glorious anticipation of the approach of a new season. The fowler's dog catches the mood, as dogs will, and his eye follows his master's every move.

After a wet July or August, some of those lovely sunny September days are welcomed as late summer rather than autumn. September is usually a settled month, one way or the other; more often than not it is fine.

Early mornings, or the evenings at this time of year, can at times be magical. The mist is drawn up in a fluffy blanket, three feet above the ground: the bullocks loom, legless and steaming, head and shoulders above it; isolated marsh gateways seem to float in mid-air and the fences are lost in the grey pall below. Not always, though, is the mist grey. At sunrise the sky may be of a glowing pink, and the mist takes on some of this colour. Standing on one bank and gazing across a sea of pink candyfloss to the far bank, a mile distant, the sight takes one's breath away.

It was on the salt marshes of the Ouse estuary that I had a similar experience once when I had gone to flight curlew on the

*Fence post "trees" on the
High Wash drove.*

flood tide. As the sun rose, the mist hovered in little puffs, wisps and balls over each salting pool; the sun turned all of these ghosts of vapour a vivid pink. The mud was brown and grey, the water silver with reflected light and the grasses of the marsh sage green; then this pink. It was a beautiful spectacle for just a moment, but in a few seconds the sun rose that fraction more and the colour was gone. The mist did not linger because the warming air drew it up.

September, and a new shooting season begins. On the first, many alarm clocks rattle their urgent summons at 3.30 am. The fowler quickly shuts off the noise and creeps downstairs before the rest of the household can complain at the disturbance. His clothes and gear will, as a rule, have been laid out the previous evening, with the various cartridges, large shot for high duck, with some No 8s in case the snipe tempt him.

A quick breakfast, with a mug of hot tea. More tea is brewed for the Thermos flask, and an eager companion who has been scratching at the door is allowed in. He cannot believe his luck, the old hound; his head moves back and forth, taking it all in, his tail thumping the floor and furniture. His eyes do not leave the boss for a moment; there is no way this dog is going to be left behind!

All checked and ready, and the back door locked, the pair crunch their way down the gravel drive to the car, or perhaps the old trade bike. The dog is prancing with unrestrained excitement.

A view of Blunt's Holt across Morton's Leam.

If the truth be told, it wouldn't take much for master to join in!

The air is cool and fresh, with a slight breeze flapping the lapels of the jacket as the man starts out. It is good to be abroad while others sleep. The stars twinkle as if in anticipation of the day to come.

Half a dozen cars are already parked at the top of the drove. "Hell's teeth!"—some of them must come down here at midnight! The doors of one of the cars are open, and the dim interior light glows wanly on half-hidden forms as they pull on long rubber boots or assemble guns.

As he pedals along the drove, the old dog pounding away at his heels, our fowler overtakes another trio of hopefuls on foot. Greetings and banter are exchanged, dogs disentangled, and on he goes, pushing for his chosen spot.

At long last the gateway of the favoured field appears in the darkness. The velocipede is left there to cool down and the fowler faces the walk down one of the dykesides of the half mile long field, all the time wondering if anyone has beaten him to the spot. Reaching the likely place, the fowler puts down his bag and walks on a further hundred yards, crosses to the far dyke and walks back two hundred yards. This done, he knows that there is no one within a hundred yards on either side or in front of him. When he is in position he will be able to hear others approaching in the

darkness and can warn them of his presence with a quick "wink" of a torch or a draw on a cigarette; some folk cough, others tell their dog to settle down. It is important to know where everyone is and to let others know where you are; everyone arrives in the dark, and lead pellets hissing through the rushes around your head do not lead to peace of mind!

Our man is at his chosen dykeside, getting down into the thick growth of rushes, making himself and the dog as invisible as possible in this natural cover, and the other gunners settle down in their hides all over the washlands and the river banks. There is always a long wait on the first day because, to make certain of one's place, a much earlier rise than normal is necessary.

During this time the hot tea from the flask is welcome. From various quarters the dull glow of a pipe or cigarette can be seen in the gloom. Eventually, after what seems like an age, the darkness in the east becomes a lighter darkness. Farm dogs bark as men arrive for work. The stars lose some of their sparkle. The gunner checks again that his gun barrels are clear of obstruction, and that his cartridges are of the right shot size.

Now it is definitely lighter. Fence posts show up that a moment ago could not be seen. A yellow or pink patch lights up the eastern horizon; if yellow, the day will be fine. A harsh cry, then a dark, heavy-winged shape flaps slowly across the light patch in the sky: the first of the Lord's Holt herons on his way to a breakfast of eels from the tidal river. Rooks are next to move out; chattering noisily among themselves, they move off in ragged formation.

Sss! SSS! Sss! Sss! Sss! Sss! Ssssss——. Didn't see them! The first duck of the morning go by on the dark side of the hide. It serves as a warning, and now every sense is alert. The next lot are seen: a tight bunch of black dots, flying swiftly across the front. Not near enough.

What is that line of birds approaching? A bubbling call soon provides the answer to the unspoken question. Thirty curlew, in line abreast, come on right overhead, a hundred yards up. The chorus of liquid voices comes clear and lovely to the ear.

Bang! . . . BaBaBang! . . . Bang! A spattering volley of shots from along the tidal river bank indicates that others have duck in range. From now on shots ring out from all quarters. Spasmodically, singles, doubles and occasionally a rattle of fire where two people are hiding close together. It is well light now; the sun is just at that height when to look to the east is to be dazzled.

Our fowler still hasn't fired a shot, and wonders if his turn will come at all. Has he chosen the wrong spot? He hasn't, for a lot of duck had been using the low places in the field, and some had headed for them this morning. They just weren't getting through the gauntlet of guns. Boom! That was right behind him. Thud! a

mallard hits the turf even as he turns. From a tangle of rushes and willow herb two hundred yards away a yellow labrador streaks out into the field, casting to and fro. It is not long before it finds the dead duck and returns to its master's hiding place, to be lost from view once more.

Ah! At last! Five mallard approaching, low, too. They are gradually slanting away to the left, but they'll pass in range. The first shot goes wide of the mark; still rusty after a season's "lay-off"! Our gunner swings on through as the team of duck climb madly above the dyke: the second barrel takes the leader fair and square. Wings shut, neck flung back, it drops like a stone; the thump of the heavy bird on the peat makes that early rise worth while. The faithful hound, tail wagging, brings in the prize.

Shortly afterwards another duck is added to the bag, then a brief period of quiet reigns. During this quiet spell another cup of tea and maybe a sandwich fill the gap that breakfast would normally satisfy. Taking advantage of the moment, our fowler breaks off a couple of stiff nettle stalks about a foot long, and inserting one end into the mouths of his birds and the other end into the ground he sets them up in a lifelike stance some forty yards out from his hide.

Parties of duck begin to appear again, but now very high in the air: they have quickly learned that it is safer to gain a bit of altitude. Soon, however, odd ones and twos will try to get into the dykes. Many do, in fact, manage to drop in unseen, especially in places where a gunner has had to leave early for work.

Our man kills two more duck over his natural decoys, and has missed another three. He has also added a woodpigeon, a snipe and a lone curlew to the bag, so it has been a good morning. Collecting his birds, he leaves to allow the duck a chance to come in to the fields and dykes to rest for the day.

Back on the drove he meets other fowlers, all homeward bound. Bags are compared, hard-luck stories exchanged, and a particularly early-plumaged bird commented on. The heads of

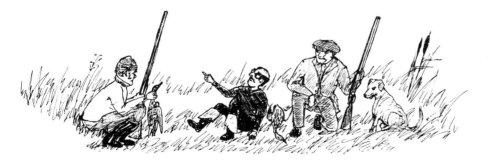

some of the drakes are already showing the first green feathers; another month and most of them will be dressed in their full winter splendour. Home for a late breakfast, very warm now after the early morning chill, content and happy to record another 1st September under his belt of memories.

The novelty of the "first day" past, the wash is not so crowded; perhaps a couple of gunners a night may turn out for the flight, maybe only one. These early weeks of the season are a fair menace at dusk: the abundant gnats and mosquitoes can make life difficult. After a frost or two they vanish, but until then the buzzing hordes must be endured as they dance in clouds above the rushes and all around the kneeling gunner.

It is a pleasant occupation of a September afternoon to walk the dykesides after snipe or the odd pair of duck. Shirtsleeve order is the dress of the day, and some old shoes are the only equipment needed besides the gun. Partridges, hares, or even a pound of mushrooms will add spice to these autumn tramps round the marshes.

The cattle are still on the washes, though they may have been moved to fresh fields where the grass has had time to grow again. Those people with some shooting on farms or smallholdings will be wandering around them now, picking up an occasional brace of partridge and assessing the pheasant prospects for next month.

When I first started shooting in the late fifties only a few local chaps shot our wash. On a September evening the place to be was

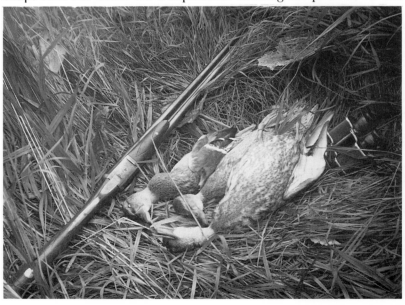

An autumn bag.

66

alongside of the New-Come-Over Drain. Everyone waited along there for the duck flighting into the "Ministry" marsh; after dark there would be perhaps half a dozen of us talking things over as we biked home along the drove.

The next stop was the Hare and Hounds (now renamed the Morton Fork), the first pub one comes to on the edge of town. This was a real pub, of the old sort. Wooden tables, high-backed settles and landlord Len Page bringing in the pints, straight out of the wood and carried in from the cellar. Ron Pacey, Clyde Anthony and Ted Parnell spent many an hour playing "Killer" on the dartboard there after an evening's shooting.

My very first "September 1st" was in 1958. I spent the whole day, with the exception of a couple of hours for lunch, at the New-Come-Over. Just after daylight Jack Gilbert, who was then fit and strong, had emerged from the "Ministry"; a tall, bearded figure, shirt open to the waist, he strode out with two guns in one hand and a bundle of duck in the other. He had a ten-bore and a twelve-bore. At daybreak he had (illegally) entered the swamp, fired four barrels in quick time into the rising mass of duck, and knocked down four. By dusk Jack had added another to his bag and I had even managed two myself.

We were joined by "Punch" Whitwell and a pair of other hopefuls. Tony P., a friend of mine, arrived in his ancient A40 van. As it turned out, nothing much happened at dusk. One lone duck was unwise enough to fly in over our line.

This unwary bird flew high over Gilbert and company, to be greeted by a rattle of fire from the twelve-bores, flashing in the half-light. There was a pause, then Booomff! **went** the heavy ten-bore; seconds later a hefty thwack was heard—**Jack** had scored again.

He rode home in the van with Tony and me. We dropped him off at the Ram in the Delph. As he entered the pub door, with his guns over one shoulder and half a dozen duck in his hand, he could have stepped out of one of those engraved prints one sees in Edwardian fowling books. Jack was a character, and a likable one.

As September passes into October the signs of the year's maturity begin to become apparent, like finding the first grey hairs in one's head. The sap falls back, leaving the vegetation with that yellow tinge, and after rain the gateways, soil churned up by a hundred beasts, remain muddy, to the delight of the snipe.

Families of short-eared owls turn up, to glide silently over the rough pastures in search of unwary mice or shrews. We have flushed as many as nine of these fen owls from one tussocky marsh. As youths we regarded these birds as the heralds of a flood, believing that the owls had some sort of prior knowledge; the truth was, of course, that the owls would come anyway, and when it did

flood, and it spilled over in most autumns in those days, the owls would naturally take advantage of the plight of small mammals. Sometimes scores of tiny creatures, marooned on islets of higher ground, would be at the mercy of predators.

The equinoctial tides occur at this time of year, hence the regular autumn flooding until the cradge bank was raised in 1970. On the coast the great influx of migrating waders is at its height: thousands upon thousands of birds on the move as the tide washes over the saltings. Curlews by the hundred flight on to the fields behind the sea wall to await the ebb. Before the curlew and other waders were protected we spent many a happy hour hidden in the creeks and gutters of Terrington Marsh, lying in wait for them.

They were exciting times, those tide flights. A mixed bag of curlew, 'shank, bar-tailed godwits, grey plover and whimbrel, maybe even a duck, could be the reward if things went right. There is a corner of Terrington Marsh where one could lie up on the saltings and get under curlew flighting to a piece of higher ground; then a hurried move back to the sea wall and a three-hundred-yard dash along behind it brought one, one hoped, under the very spot at which the same birds would cross the sea bank when the tide conquered their last refuge. Two flights in one, as it were.

Sounds simple, but it could only be worked on the very highest of tides. It turned out that, for me at least, only one or two of these special flights were practical. Five or six curlew was the most I ever took home; plenty for my needs. I don't think the curlew population was in any danger; not from wildfowlers, anyway.

My first dog, Rex, used to love these curlew flights. As soon as he heard one call his tail would begin to thump the mud; he knew what it was all about. Stan Moulding and I would have been stalking along the bottom of the empty creeks, suddenly to come across some curlew: as soon as a bird was shot, if it lay well out on the marsh, other curlew would see the dog going to it and all hell would be let loose. The dog was yellow and it may be that they thought he was a fox. They would appear from nowhere crying "foul play", to mob the dog.

We would remain hidden, for there would be a hectic few seconds of shoot, load, shoot, load, shoot! When the chaos had died down I would look around: there above me would sit old Rex, a pile of curlew at his feet and his tail flicking mud in our faces, his tongue hanging out a foot, and a big grin. He loved it!

Michaelmas. The cattle were taken off the washes to spend the winter in the crew yards. A walk round the wash then, even if you did not find a pheasant, might fill your bag with mushrooms.

With the pheasant season opening on 1st October the numbers of shooters swelled for a few weeks, until the birds got too crafty

for them. Sid Parnell was usually pretty successful in getting some of the washland longtails into his bag. He and others used to lie in wait for them at dusk, taking advantage of their habit of flying over from the barrier banks to spend the night in the tussocky fields. The observant gunner can see by the droppings if a field is regularly used.

The old cock bird is very crafty, however, and though he may be seen popping his head up over the bank, he is by no means "in the bag". The slightest hint of anything out of the ordinary is enough to make him choose another bed.

Part of Jacobs' "duck fields" had been too wet to cut for hay, so it had been left rough: some fifteen acres of shoulder-high sedges, with weather-flattened spaces here and there. Guessing that it would attract pheasants, I made my way in that direction at dusk one evening. Roy Whitwell and Clyde Gill were of the same mind, and it happened that we converged on the Nene bank. Joining forces, we waited a quarter of a mile back from the rough to allow the birds to go in. It was as well that we did, for bird after bird skimmed low over the river into the field. We waited as long as we dared, for the sun was down and the light would not last long. Going quickly but quietly under cover of the bank, we reached our target. I waited at the eastern end until Clyde and Roy got into their positions, then we all moved over the bank together.

A cock bird rose at my feet straight away. He fell into the adjacent field, so I walked round to fetch him. After I had picked the bird and walked back through the fence I could see the whole scene in silhouette. The others were shooting now; as they moved forward chaos reigned, pheasants going out to all points of the compass like rockets on 5th November. One hen gave me a fine

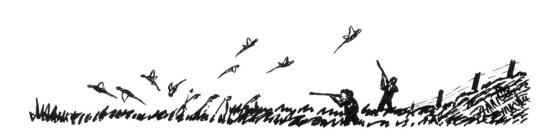

driven shot, right overhead, well up. She just shut her wings and dropped without a flutter. I moved to pick her, two birds burst up just in front—and so it went on. In that hectic ten minutes we put nine longtails into the bag.

The books tell us that the golden plover is one of the fastest birds in flight. Having been beaten by them in many a skirmish, I have found no reason to disagree. There were three thousand on our wash for a short spell one famous year; I have never seen so many since. A hundred or so usually show up in August and hang around for a month or two. They are a very sporting bird, and very nice to eat. The same fields seem to draw them year after year.

As the golden plover move on, so we will move on, for though some October days can attain 80°F, the nights are much cooler. The rough fields and the dyke sides now take on a sheen of beautiful mellow gold as the sun drops below the horizon. Soon the first frosts will remind us to check the car for anti-freeze. The glow of the fire, seen through the window, throws a cheery welcome as

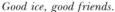

Good ice, good friends.

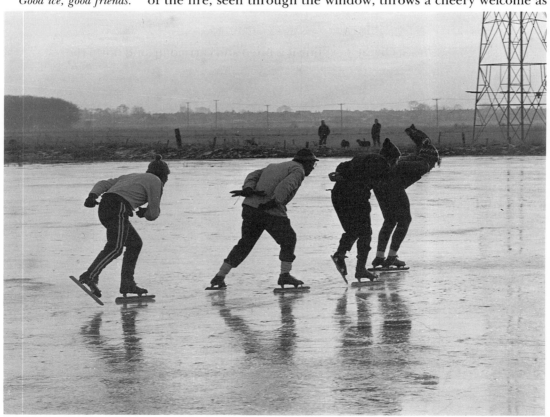

70

one arrives home. Yes, there is, after all, something to be said for the onset of winter.

For the fenland sportsman, winter is the best of the seasons. Winter is the only season when that most fenland of all sports, outdoor speed skating, is possible, and it is on bleak icy days that the very best of wildfowling, birdwatching and pike fishing can be enjoyed.

A favourite with me is the kind of day that often occurs in November, a day of white frost and sunshine. The sky is of the palest blue; the natural colours of the land, where the frost has melted, are browns, yellows and golds. A deep breath seems to take the pure, cool air right down to one's boots; never does the air taste cleaner than on such a day. I enjoy those days taking part in almost any outdoor activity; but best of all I like to be out with a gun, collecting perhaps a couple of brace of pheasants.

Only once can I remember enough frost for skatable ice in November. After that thawed we had no more skating that winter. It really bore out the old saying that "Ice before Christmas to bear a duck, nothing else after but slub and muck".

In winters past the great grey hordes of wild geese would arrive before Christmas and remain in the locality until the spring. Now, of course, they come no more, but I did see more than two hundred brent geese here in a very severe spell recently; I had only ever seen one of this species of black goose here before. The brent geese are increasing yearly on the Wash coast, though, so I suppose we may see more of them from now on when the snow drives them from the coast.

At any time during the winter, should wet or snow combine with high tides, a flood can be expected. Any water, be it a bank-to-bank inundation or merely a few minor pools and flashes, will bring in the duck. Our resident mallard are joined by hundreds, sometimes thousands, of teal, wigeon and pintail, intermixed with a considerable number of pochard, tufted duck and shoveller; even gadwall may make an appearance.

To be out under the moon in these conditions is fantastic. The place seems to be full of the sounds of wildfowl; it is like being in a vast high-roofed cathedral surrounded by wild music. A friend of mine once wrote of wigeon that in daylight, when the birds are visible, their calls are hardly noticed, whereas with a full moon and white clouds it is their exciting whistles and growls that take the biscuit every time.

Sometimes a full flood will freeze over. Later, when the ice breaks up and the water ripples with small waves, the pieces of ice clink against each other. The continuous bell-like tinkling can be heard from quite a distance. At other times when the wash is frozen the level of the water below the ice drops and the ice, not able to

Looking across the wash towards Whittlesey at the end of the nineteenth century.

support its own weight, cracks and drops with a loud bang. A crack will "Pinnnng!" across a quarter of a mile of ice in seconds.

In a sharp frost even the tidal river will partially freeze. During high tides the shallow water that covers the slamps is frozen; when the tide ebbs this ice breaks and lies down the sides of the mudbanks. On the next tide it is lifted and carried up and down the river until it melts.

On the last day of January, 1976, a hard spell of frost brought floes of ice six inches thick and fifteen feet square careering along the river, screeching and crashing as they rubbed along the banks. The tide flows at a good walking pace, so while no ice might be in sight at one moment, a mass of the stuff might be approaching a few moments later.

I would not send a young dog out among that, let alone the stiff old veteran of a Labrador who was my pal then; I did not attempt to shoot anything. Instead, after watching the spectacle for some time, I made my way back to the car. On the way along the bank I met three other gunners, one of whom had a mallard down beyond some ice. This to me was "proof of the pudden", so when he asked "Will your dog fetch that duck?" I replied "Would you?" and left it at that.

Reaching the Dog-in-a-Doublet bridge I found an amazing scene: the ice had crammed into the narrows and "packed", a quarter of a mile of ice, bank to bank, piled up in great jagged sheets, and more following!

The really notable winters of the last quarter of a century have been 1959, 1963 and 1981–82. In '63 the ships were frozen in in Wisbech harbour, but at our end of the river it was not completely frozen over. On Boxing Day, 1981, however, the Nene was frozen over all along its tidal stretch, from Whittlesey to Sutton Bridge. I have never seen it like that before or since, bitter, bare, bleak; not a

living thing in sight. The ice was thick enough to bear my uncle, his son and his grandson; they were all able to walk right across the tidal river.

I missed a lot of this particular frost as I work for the Post Office, and Christmas leaves very little free time for the postman. Graham Howson told me that when this ice had broken up the birds quickly returned. Among the wildfowlers who set off after them was a young chap named Stephen Bull. He was shooting near a horseshoe bend in the river, known as the Gull, when he killed a wigeon. His dog had no trouble getting out to the bird, but her retreat was cut off by one of the huge ice floes. The dog hung on to the foot-thick ice by her forepaws and drifted along helplessly on the tide. Young Stephen, almost in tears with concern for his dog, stripped off his clothes to swim to the rescue, but luckily for him some other fowlers came and stopped him. Suddenly the little bitch

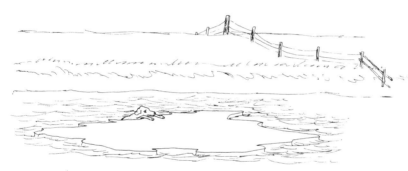

managed, with a final effort, to pull herself up on to the ice, where she collapsed exhausted. At a bend in the river fate was kind; the current brought the floe to the shore and the men were able to hold it there until the bitch had recovered enough to be coaxed to them—she was so frightened that she would not move for some time. Young Bull, now dressed and really in tears of unashamed relief—and who wouldn't be—was going to carry his dog home: irrational thinking, due to his anxiety. He saw the logic when one of the others suggested he let the animal run; she would soon warm up and get over her adventure.

Perhaps it was fortunate that it was a bitch. A dog, because of his sexual differences, often has difficulty in getting out of a hole in ice. In this case a dog could easily have drowned. I had experience of this hazard myself with old Rex. The wash was flooded and frozen, and I was walking along the Nene bank before daybreak to find a good place to hide. It was, by coincidence, at the Gull that a small bunch of pochard came whizzing out of the darkness; one

managed to run into my shot and crashed on to the ice behind me. I decided to wait there for the flight and to retrieve the bird later.

In due course we walked down the bank, and Rex made his way out over the ice towards the duck. All was well until he went over a hidden dyke; the ice was thinner there, and Rex went through. The old dog ended up swimming against the edge and getting nowhere. There was no danger, as I was able to walk out over the dykeside to smash a way out for him with a stout piece of driftwood.

Since I was there I carried on smashing a path out to my bird. When still a good ten yards from it I felt an icy trickle as the water found its way into my thighboots. Both boots filled, so to hell with it! I ploughed on out after the wretched bird.

Once back on the bank I took off my boots and poured out the water. It was still freezing, so my trousers froze "dry" in a very few moments. It is by no means unusual to have ice form on the base of decoy ducks, or after a dawn flight on the gun barrels as the sun rises. A wet dog often goes home with icicles in his fur. I have noticed that once a wet the line justeezes the animal will stop shivering; I think that the fur freezes away from the body and insulates it from cold winds.

In January, 1982, outdoor thermometers in Whittlesey recorded temperatures as low as minus 23°C, and that is getting pretty low. A skating match was held on the 16th. We know that the ice was at least eight inches thick because a tractor which had been scraping it clear went through! There was no risk of losing the tractor, I hasten to add, as the field is specially flooded for skating and the water is no more than thirty inches deep anywhere.

For years the Whittlesey Skating Association had to rely on natural flooding coinciding with a freeze, or a frost hard enough to make the rivers safe for a match, and as a result many years went by without a match being held. Then someone had the brilliant idea of buying a piece of wash especially for skating, a company was formed, the shareholders putting up the money for the land, and thanks to their foresight Whittlesey sees skating most winters.

The twenty-five acres has been banked round with a low bank. A slacker through the bank into the freshwater reach of the Nene allows water to flood the field in November, and it remains flooded until March. During the intervening months the water is there all ready for Jack Frost to do his stuff.

There were races at that January match for all age groups, including a half-mile for veterans, by which are meant those over fifty-five. Relay teams were organized, with names such as the Reservoir Runners, Wooden Spoon Fliers, Hunting Skaters, Wisbech Wasters, Red Lion Blades, Hotchpotch and the Fenland Flashers!

Three years earlier a match had been held over the other side of the main road, on the "Town Fifties". With almost half a mile of perfect ice the "Town Fifties" made a splendid arena. The last event of the day, the Whittlesey Dash, was run over a quarter-mile straight, with a back wind! In the serious races pairs of skaters are matched against each other and against the clock, but in this fun event everyone enters at once, in a long massed pack.

As we all waited for the starter's pistol to set us away, a young lad skated over to see what the crowd was all about. Unfortunately for him, he skated right across the front of the line just as the starter fired. The lad's face was a picture of open-mouthed horror as he disappeared under the hurtling mass of forty skaters surging forward. Several fell over the boy. Two or three more fallers in the first hundred yards, then it was all out for the line. We all went over in a bunch, Paul Whittome taking first place, with Richard Watson close on his heels.

The more romantic spectators likened our rush to a glorious cavalry charge. Old Fred Smith said with a twinkle that we looked more like a lot of old crows flapping out on to his wheat!

One always meets the regulars on the ice, some of whom won't be met again until the next spell of hard frost. Folk are attracted from all over the Fen, from miles around. It is most pleasant to be

A skating match on the Delph Dyke at Whittlesey in 1958. Such occasions result in meetings which will probably not be repeated until the next winter.

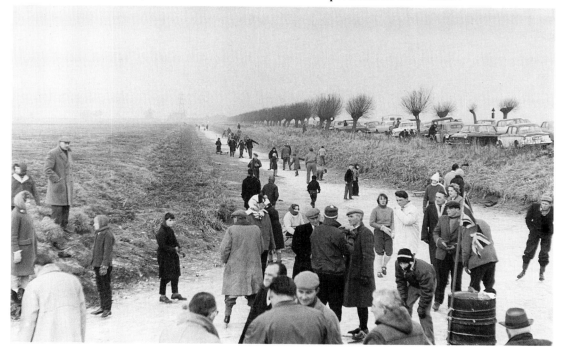

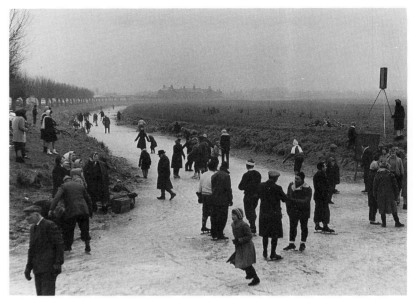

Old friends get together on the ice—another view of the Delph Dyke in the winter of 1958.

skating around and to be suddenly met with a handshake and a "Happy New Year" from one's old skating pals. Brian Fountain from Upton and the Smith family from Tydd can always be relied on.

The Lincolnshire champions Alan Fisher and Brian Naylor practise a lot on our ice during the week, when not so many folk are out. Paul French, one-time holder of the title "Champion of the Fens", and his brother John, who is perhaps the fastest skater the Fens have ever produced, also skate here. Paul lives at Coates, the next village to Whittlesey, so it is his home ground.

My father was a keen speed skater, and by all accounts no mean hand. I would very much have liked to be able to skate with him, but that was not to be. He told me of a chuckle he had when a crowd of skaters were all going round together and a complete circle of ice gave way; they all went through in a heap! There was only three feet of water, but the chaos, he said, was hilarious: girls screaming, men swearing, and all of them soaking!

This brings to mind another little incident, when there were several skaters out on the "Town Fifties". A swan took it upon itself to land on the ice, but once down it decided that after all the place was a little too crowded. It struck off on that flapping run that swans have to make to get airborne; as its feet could not grip the ice the run-up was much longer than usual.

Four chaps had been skating round an imagined half-mile track and happened to be increasing speed around the end of the

field as the swan made its last desperate effort to get up. Four skaters braking hard in a shower of ice particles! Two of them veered away, the other two bent double as the massive white bird lifted just enough to clear them—but only just! A near do, as the Fenman would say.

The great thing about skating outdoors is the feeling of freedom. Miles of ice lie ahead and the skater can go wherever he pleases. Anyone from toddlers to veterans can enjoy a day on the ice. Fred Smith gave up when he was eighty, and even then he could still show better style than folk many years his junior; it was a pleasure to watch him. Fred and his son Lawrence have between them held the local one-mile championship, undefeated, for sixty years. Nowadays, youngsters can train on indoor rinks, but until recently Fen skaters had to wait for the frost for a few short spells of favourable conditions.

Fred Smith used to train after work, and consequently after dark, on the town's Briggate River. "I used to take a clothes prop and a couple of storm lanthorns," said Fred. "I'd test the ice and then place a lanthorn in the middle of the frozen river. Then, holding the clothes prop horizontally in case I went through, I

The author skating on the Town Fifties in 1979.

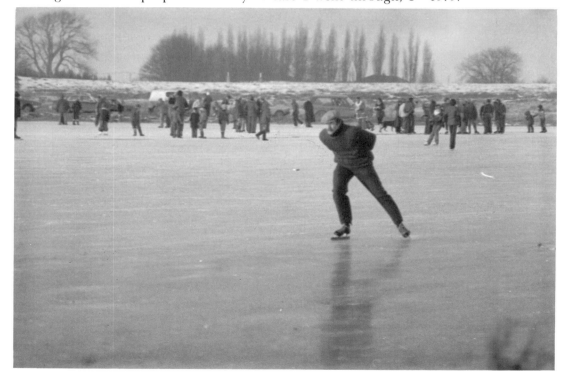

would carefully skate perhaps three or four hundred yards. If all went well I'd place my second lanthorn on the ice. I knew then that the course between the two lamps was safe and I could get on with my training."

A romantic vision can be conjured up of the young skater clipping along in the darkness between his two beacons. Such dedication is what champions are made of.

In years gone by when the wash was iced over the puntgunners would mount their long guns on to ice sledges and stalk out over the vast reaches of near-polar landscape in search of fowl. Charlie and George Hailstone remembered doing this, and were probably the last fowlers ever to use an ice sledge in the Fens.

Of course the winters are not all snow and ice. Some winters are very open and mild. Usually, towards the end of the duck shooting season, we get enough water and enough wildfowl to give good sport and to whet the appetite for seasons yet to come. At times a boat is necessary to reach a good spot, but at other times a wade through ankle-deep water will get the gunner there, with teal all the way, buzzing around his head like demented bees.

Sam Hilliam, Low Wash shepherd, arrives to top up the drinking troughs. He has brought his jet with him.

Now is the time the Fen fowler relishes. Out amid the wild scenery of open marsh and wide waters, with the whistle and growl of wigeon and the curious Prrrp, Prrrrp! call of pintail tickling his sense of anticipation. The lowering sun turns all the cover to a deep

78

gold, while a hint of frost creates a riot of colour in the western sky. The sun disappears at last, and then that delicious feeling takes over as he "knows" that the next line of pintail will come straight for him, and low, oh so low!

February gives another twenty days of possible sport on the coast, but here on the washlands the season is over at the end of January. The naturalist-wildfowler—and what true wildfowler can help being a naturalist too?—will go armed with field glasses in lieu of gun to see the masses of fowl on his marshes. Along with the usual duck and waders, hard weather birds may be spotted: goldeneye, mergansers, goosanders, smew and the big black old cormorants.

We may be lucky enough to get an extra day's skating, but now the sun is putting out a bit more warmth and as the month draws to a close the chances get slimmer. While skating in March is not unknown, it is rare.

The birds sense the slight increase in warmth and once again the snipe begins its drumming. The pairs of shelduck reappear, larks sing high in the sky and pairs of duck jump from every dyke. The year has come full circle, set steadily on its course once more.

As the warmth catches the face of the Washlander he oils his gun and puts it away. It's time to rummage for his eel nets. The spring run is not far off and the nets may be in need of repair!

Bert Weldon, Dr W. W. Watson and Patrick St Leger display their bag after a wildfowling outing.

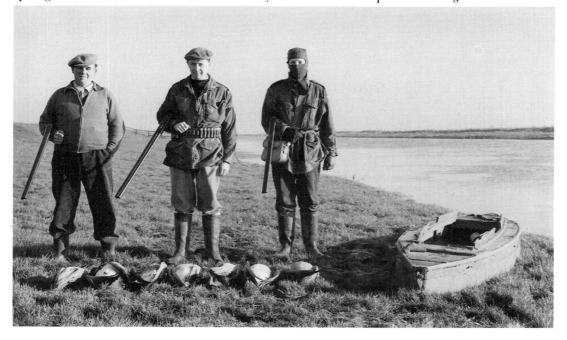

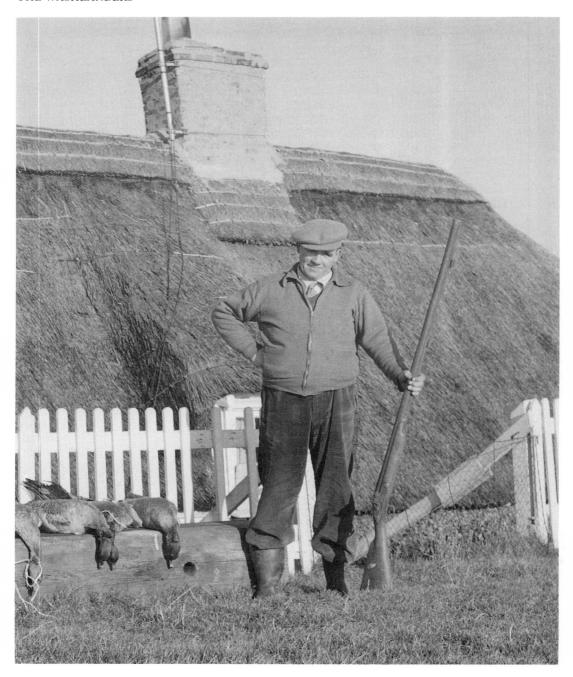

Nights at the Old Cross Guns 5

THE GLIMMER of light where the curtains did not quite meet beckoned welcomingly as we trudged along the riverside, the east wind tugging persistently at our heavy coats. The house, the home of Bert and Nell Weldon, was snug enough under the bank of the tidal Nene.

Before the Weldons' time three public houses had stood side by side below the bank here, the best-known of the three being the Cross Guns. It is a name which is attached to this part of the fen to this day; more usually it is known simply as The Guns.

The Weldons were expecting us, and as we angled down the bank the door opened, throwing a patch of yellow light across the threshold. "Come on in and set yourselves down. The kettle's on the hob."

Glad enough we were to get out of that biting wind. Soon, with steaming mugs cupped in our hands, we were seated by the fireside listening again to fascinating stories of the Weldons' lives as wash shepherds. As I have said elsewhere in this book, the name shepherd on the washes is usually a misnomer. They shepherded the traditional stock of the wash pastures, beef cattle, with perhaps a few horses. Though sheep are in evidence these days, they are really newcomers to the scene. The Weldons had at first lived with Bert's parents near the South Barrier Bank, at Eldernell. Later, in the fifties, they moved across to the north side of the wash.

But enough of this. Join us in the cosy kitchen and hear it for yourself. Pull up a chair; Bert is just telling us of how they used to take advantage of the flood waters.

"We used to set about the old hares when it was flooded. Me and old Bill Benstead got seventy one day. They would make for the nearest bit of high land, you see. One of us would get up one end of an 'island' and drive them down to the other one to shoot. That lot we took over to Peterborough market. They made four bob apiece.

"I've had the poor old things swim to me in the boat, thinking it was a bit of land. I'd pick 'em up by the ears and put 'em in the boat!"

This evening I had come with Stuart Rippon, a long-time friend of the Weldons'. He prompted Bert now. "You have had

Opposite page: *Bert Weldon at The Guns with his four-bore and some of the geese he had shot.*

81

otters in your boat, too, haven't you?" "Oh yes," replied Bert. "This particular morning I saw some duck go down to some water, over on the wash. I got the old boat out and went across after them. We had to go down a dyke that had just been slubbed out, muck on both sides, you see. I was going quietly along when I came across two otters curled up asleep. The next thing I knew they were in the boat with me! Of course, no sooner were they in than they were out, into the dyke. Just a trail of bubbles to tell the tale."

I asked if I could hear again about the swallows in the bedroom. "Ah, yes," recalled Bert. "That was when we were at Eldernell. We always kept the bedroom window open. This old thing made her nest up in a corner. We put a couple of sacks under it to catch the droppings."

Nell laughed and said, "Yes, and one Sunday morning we were in bed and he nudged me. He said, Don't move sharply, but just have a look on the bedrail. I thought, Good God, whatever have we got in here now? I hardly dared look. Then I peeped over the sheets and saw five baby swallows, all lined up on our bedrail. They stayed there until we got up, didn't they, Bert?"

"Yes," agreed her husband. "And for a long time afterwards they would fly in to perch on the bed."

Nell came in again: "We had a lot down here one year. So many that some people came to photograph them. They'd come along the Nene, the whole width of the river, for over an hour. I've never seen anything like it in my life. These people estimated ten million. There certainly were a lot."

The talk turned to the masses of pinkfooted geese that haunted the area in winter. "Me and old 'Kenzie [Mackenzie Thorpe, professional wildfowler] and two or three others killed eighty-eight on Berry's farm one day. They were on winter wheat," said Bert. "We had thirty-four one morning on the wash, seventeen up on 'Speedy Smith's'—in bad winters they got so if they saw a patch of green amongst the snow, they'd come in even if they could almost see you. But if you shot any they were as poor as rooks.

"My best shot at geese was eight. My best chance was when I was out late one night, waiting for the old wigeon to come in. Just yon side of Lord's Holt there was a field where the water had run off. Two thousand pinkfeet landed on there when it was almost dark. I went up the dyke to 'em, but when I got there the gun was set too low, a foot below the bank. I pushed back and pulled a lot of rodings and grass from off the drainside; I shoved these under the barrel to build her up.

"When I got back to the geese it was really still too low. I wasn't going through all that performance again, so I grabbed the trigger and let her go. She jumped straight off the punt into the dyke. I had to leave it there until the next day, until I could take a hoe and

drag for it. I got two geese, that's all. If I'd have been more patient and it had shot properly through them, God knows how many I should have got!

"I saw old Oliver Hailstone one day. He stood near the heading, agin Lord's Holt, when a big gang of geese came over from Thorney Fen. When he heard them he clawed his old punt gun off the boat and stuck her up on the fence. He was lucky, 'cos them old geese came right over him. He let drive and knocked five on 'em out!"

Before long the conversation got around to Bill Peaks, another of the punt gunners. Nell said, "Bill Peaks' sister married a Smart, Herbie's father. They was a big Welney family, the Smarts." "I've heard my father say how two of them Smarts had their heads blown off with punt guns," Bert broke in. "They always left the guns loaded and turned the boat over on top of them until they needed them. Someone must have drawn the wad halfway up the barrel and caused the gun to burst. His widow married another fowler; he had an accident with a gun, and if I remember right, he lost his life too.

"On the river here, one Sunday morning, I got twenty-two duck. Freezing like hell, that was. That little terrier bitch we had then, she weren't fully trained; if you dropped a bird nearer the far side of the river she'd carry on with them, then start to rip 'em apart. I got so as I'd send her out on a ferret line; when she reached the duck, I'd haul her in. That's how we got over that! Funny thing was, her daughter would retrieve as good as any shooting dog. I

had a golden retriever at that time as well, but that were a cranky thing; it would not go in the water.

"The terrier had one day to retrieve among floating ice. She got trapped by it and was going out with the tide. In the end I decided I would have to swim out to push the ice clear. Then suddenly that retriever swam out, snatched the duck from the terrier, and the little dog was able to swim out through the track through the ice made by the retriever. I could hardly believe it. Before that day you could not make that dog go in. I had threatened to polish him off, but after that he got a reprieve!"

"Was that the terrier that used to spar with the cockerel?" I queried. Bert grinned. "Oh yes, that was Topsy. It was a pity we never got a film of that. All I used to do was shout like a cockerel.

Out would strut the old cockerel to answer the challenge. Topsy would go up to him and strike at him, and he would stab at her, and that's how they'd be for long enough."

"They wouldn't hurt each other though," put in Nell. "When the cockerel dobbed his head down, Topsy would do the same. It was funny to watch. Bert's mother would say, 'There y'are, he's set them two off again!'"

"That was down at Eldernell," I said. "Was it there that you used the ponies for shepherding?"

"Yes, that's right," agreed Bert. "That old pony of mine got so used to me shooting—I'd have a .410 on the saddle—every time a pheasant got up she'd stop stunt so as I could shoot. It was all right if you were ready for it!"

Nell laughed and said, "If you were rounding bullocks up and you got 'em mixed up, or you just wanted a particular beast, you could put Kit, my pony, behind it, she wouldn't leave that beast. Mind you, if it went through the river, you went through the river an' all! You used to have to get up on the saddle, until she came out of the water. That, or get wet."

"We had 1,760 acres to look after," Bert went on to say. "A

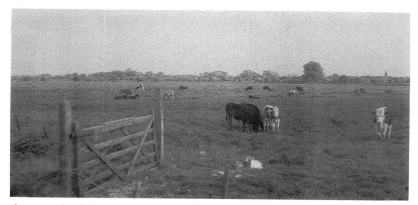

A summer scene on the High Wash, where shepherds sometimes had a thousand cattle to look after.

thousand of that was grazed, the rest was wild, derelict land. That came right down to the 'Guns' here. When there was a drought summer we used to rope all of the rough land in too.

"We had a pony each, looking after these bullocks all day long, and filling water tanks up. Ah! sometimes well into the night. I've known the time when we've had a thousand head of cattle, and five hundred horses. Of course, with that amount there'd always be some getting stuck in dykes. Then it was back to the farm to fetch a couple of horses, with a cart, to pull 'em out. Yes, it was a full-time job for the two of us to keep them right."

Nell commented that the biggest headache was when a farmer brought ninety-nine beasts into one field. "It was a damned job," she said. "We had to split them into smaller parties to go through and count them. I used to stand on Kit's backside, and she would walk on steadily. Sometimes you could get round them, but if they got into the wild part, with reeds over six feet high, you was never really sure if you'd counted the lot."

"Of course," added Bert, "the horses made us a lot of work if they got stuck in a dried-out dyke. They'd go straight down, you see. What we used to do was dig a hole the length of the horse, work down, well below his body, put a thick rope under his shoulders, and pull the front half round, so as we could free his front feet. Then, we'd cross his feet, snare them with the rope, and pull him out. You didn't hurt him that way.

"The worst was when we'd get a fresh bunch of cattle from off the highland. They had never seen a dyke before, and would wander straight into them."

"We'd be working so late then," laughed Nell, "that I would take the car down to work by its lights. You had to keep the engine running, though. It was an old Morris two-seater. The battery would soon go flat. We used to go rabbiting in that old car, too!"

"That's how I got my pocket money," added Bert. "My parents

didn't have a lot of money, you see. They didn't even pay me until I was eighteen. I kept anything up to twenty ferrets. We shot a lot of rabbits from the car in the autumn, sometimes thirty or forty a night, but of course, you'd your cartridges to buy out of that.

"We had a terrible plague of rabbits one year. The wash flooded so we couldn't do the hay work. Some people came to see Dad and asked if he would let me kill the rabbits until there was more work for me to do. I started in July and carried on until October. I killed over three thousand, getting up at daybreak, going round twice a day; I'd get about twenty a round."

"And most of them were shot with an old muzzle-loader!" interrupted Nell. "Yes, they were," agreed Bert, with a grin. "It was cheaper, you see. I used to pinch the old man's gunpowder!

"Every year, at harvest time, we'd have a real old bonanza at them, getting anything up to three hundred out of a field of wheat. We'd send for all the locals who had a gun—Dr Popplewell, Porter and Dunham the bank managers, and old Dickie Johnson—there'd be seven or eight guns.

"I remember once, young Sam Johnson, he got a bit excited and shot the tractor. That let all the paraffin out of the tank, so we had to finish with one tractor and binder. It took while dark to get done!"

"When we started," said Nell, "I was on one binder, and he was on the tractor. His father came to me and said, get orf there, and git out of the way, you'll git shot."

"Oh yes," enthused Bert, "'cos when we got to the last strips of corn there was more and more rabbits. The guns were getting

excited. They'd be firing into the standing corn and it were getting real dangerous. Dr Popplewell took a pellet out of one old bloke's ear as he sat on the binder.

"Nell shot a rabbit and the shot ricocheted up and hit me in the belly. There was red marks all over it. Just stung me, that's all! Poor old Dickie Johnson, he got frightened and cleared off home!

"One day they all ran out of cartridges, but still killed the last hundred with sticks. The safest way, too."

Nell, prompting her husband, said, "When Sam shot the tractor, you think of how many rabbits you pulled from underneath the binder."

"Oh ar", recalled Bert, "we had to stop, and I got down under the binder to clear it a bit, and pulled eighteen rabbits from under there!

"When we had a do like that we would send word up to the village. All the kids would come streaming down and take what they wanted. Of course that would spoil my trade for a week or so! I used to get eighteen pence a couple, and sixpence for a milky doe. Some families didn't care if they were milky does as long as they were big old rabbits."

Stuart brought us back to shooting again by asking if it was Mr Dunham who shot from a car on the wash. Warming to the tale, Bert replied "No, not old Dunham, that was them old Magistrates."

Turning to me, he explained, "in this rough derelict land down here, we had to cut tracks through all over it, like roads. These old chaps had an old open car. They used to put a plank

across it. They'd sit on the plank, high up, and let the dogs work on either side. The chauffeur drove them around. He'd stop when a bird got up so they could pot it.

"They was old men, sixty-odd, but booze? By God, they could shift some booze. They'd be too drunk to walk far. They got a hell of a lot o' birds, though. Course, the wash was full of them at that time a'day.

"They'd come home to dinner. Mother would lay a table. They brought hampers with them, and I've known the three of them to polish off the best part of a gallon of port after the meal!

"Pop used to have dinner with them, and of course, he'd have to keep up with them. They were good company. Nice old men, you know. Two of them owned Helpston Paper Mill, and I believe the other one was an army captain."

Bert paused to poke up the fire, sending orange sparks flying up the chimney, and the heat made us draw back a little. Nell in the meantime poured us all a glass of beer. When we were all settled again Bert began telling us of a big, long-barrelled muzzle-loading four-bore he once owned. I remembered the gun in question, for Bert had given it to Dr Watson, whose widow still has it. A four-bore is the largest shoulder gun used in Britain, and at one-inch calibre it is a hefty piece of armament.

"That were a most handy gun," recalled our host. "You could load her up with four ounces of shot, you know. When I loaded her in the dark, I used to have to guess how much powder I was putting in. Too much, and I'd have a black shoulder! I had seven wigeon to one shot with her once, and another time I picked up two geese at 82 yards."

I commented that I thought Albert Goodwin, one-time landlord of the Duke of Wellington, had a four-bore years ago. This old pub, now demolished, was on the bank on the south side of the wash, almost opposite the Guns but a mile away over the marshes; it was about midway between Whittlesey and Guyhirn and used to serve people walking along the banks in days when they were used as the main routes through the fens.

"Actually that was old A . . .'s gun. A . . . was the chap that lived there before Albert. The gun weighed a couple of stone, if I remember right.

"When Albert took over the pub he used to do a fair bit of flight shooting [duck-shooting at their flight times of dawn and dusk]. He got marooned out in the wash all one night. Did I tell you? Well, he was out after duck when a flood came down. You see, at that time of day they'd lift the sluices and let the water come, full width of the wash, all at once. Alby climbed on to a gate. He fired off a shot every so often to let his family know where he was, but nobody came to fetch him until daylight. They let him cool on the gate all night!

"That wouldn't worry Alby, though. He were a grut big strong bloke. He frit old Bert Snushall one day. Alby was shooting, out in that wild rough bit of the wash, when old Bert Snushall came across him. Now Bert used to think the whole wash belonged to him, you know. He said, 'What are you a-doing on, young Goodwin? You ain't no right to be on 'ere. If I see you on 'ere again I'll see that you

get put into the Army.' Albert didn't say anything, he just took out his shut-knife and began to sharpen it on a rub stone.

"'Now what are yow doing?' enquired Snushall. Albert looked up from his honing. 'I'm getting it sharp 'cos I'm going to cut your throat, you old bugger! Nobody will know who done it. There's not a soul for miles.'

"Poor old Snushall scuttled off, and he never did interfere with Albert again.

"I ended up at the Duke once, when I got lost in the fog," said Bert. A likely story! "I got over there and didn't know whether it was that bank or this one. It was a funny feeling."

"After that", put in Nell, "when it were foggy I used to keep watch. I'd go up on the bank and fire a gun to guide him home."

"What about when old Bill Benstead shot all them gulls?" prompted Stuart.

"That weren't Bill", corrected Bert, "that were his brother Tom. There was a lot of wigeon out here at the time. There was a similar-sized company of gulls, not so very far off them. It was moonlight. I saw Tom set off after these duck, with his punt and gun. Them old gulls must have gone quiet. In the dark Tom

Wild geese over the washlands.

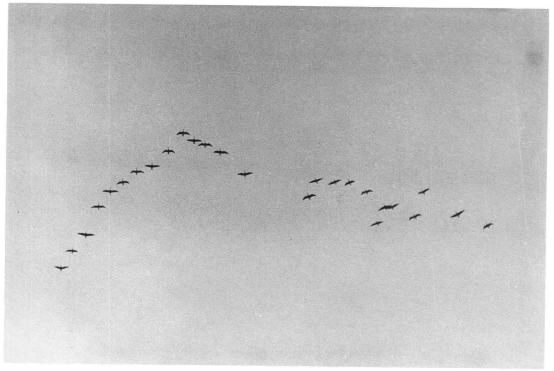

steered on to the wrong lot of birds. Thinking they were wigeon he shot straight through these old gulls.

"The next morning the bankside was covered with them, where they'd drifted ashore in the night. I reckon he got fifty or sixty of them. After he found out what he had shot, Lor', I could hear him swearing right across the water!

"In very hard weather we got some damned good sport along the tidal river, if the sun melted the snow a bit, so as the wigeon could feed on the slamp [slamp is a grass-covered flat bank below the main barrier bank, and above all but the highest tides.] The geese would come on there an' all.

"Old 'Kenzie was good at calling the geese, but then, he could call anything. He was a silly old davil though. He'd get permission to shoot the geese on all these farms, but if none flighted in he couldn't resist knocking an old pheasant off. Then, of course, the farmers would stop it all."

"Did you ever see any bitterns down this end?" I asked. "I shot one," and the old gunner smiled. "Took it to a bloke in Peterborough to stuff it for me, but they was banned. I didn't know, but he daren't do the job. I don't recall seeing any more, they were a rare bird even then.

"I did see a pair of stilted plover near Lord's Holt when I first started punt gunning. I weren't above sixteen. They were like a long-legged oyster catcher, but more white. They had legs that length." Bert stretched his hands to indicate about a foot. I asked what year that would be. Between them Bert and Nell worked out that it must have been 1932. I told Bert that almost certainly what he had seen was a pair of black-winged stilts, a very rare bird indeed.

"There's been quite a few old oyster catchers this last year or two," went on Bert. "When I first came down here with Dad it was teeming with frogs and snakes, and corncrakes as well. In 1942 I shot a couple of quail. I had that old golden retriever bitch at that time. When they got up I thought they were larks. She looked at me as much as to say, why didn't you shoot them? I walked them up again and killed a right and left out of them. There was twelve in the covey.

"When we used to come hay cutting here, when I was about seven, the cutter's wheel would be turning in water, it were so wet and soggy. Before they dredged the tidal river, about 1933, Dad and his mates could lay a sixteen-foot plank across the river at low tide and get across to the pub here, the old Cross Guns.

"There were three pubs here then. The one we came to live in, when it was no longer licensed, was the Bedford Arms. I forget what the third one was called. In our time the horse-drawn barges were still working." "Yes", chimed in Nell, "some bigger vessels too.

The barge Thyra *heading upriver towards Peterborough with a cargo of grain.*

When we were still at Eldernell there was a chap came shooting with Mr Dunham. Wilson his name was, Ginger Wilson. Well, there used to be a sailing barge come by here, the *Thyra*." "I remember her," said I. "Registered at Rochester. There was another one too, *Veravia* I think."

These sailing barges were seen on their regular grain runs from Hull to Cadge and Colman's wharf at Peterborough. Of course, from Sutton Bridge they came up river under motor power and not under sail. On occasion we would see one of them lying on the mud awaiting the next tide. *Thyra* hit the local headlines in 1964 when her young mate fell overboard and drowned while they were locking through Dog-in-a-Doublet sluice.

"There was a *Pudge*, also Rochester registered," came back Nell. "Anyway, *Thyra* got crossways in the river here and went aground. The skipper came ashore; could he use the phone? And who do you think it was? It was Ginger Wilson! We had a good old chin wag then, I can tell you.

"We got a big caterpillar tractor from off the farm there, but that wouldn't shift her. He had to wait for high tide to lift her off the mud. He was worried in case the tide went much lower; she could have broke her back under the weight of cargo. He'd a hundred ton of wheat aboard, running it from Hull to Peterborough. He was here nearly all day.

"The horse-drawn barges stopped at the Dog-in-a-Doublet. There was a stable on each side of the old wooden bridge, and plenty of hay. The crews stayed at the Dog, or the White Swan next door."

So the stories went on until we finished up talking about the floods of 1947. Again Nell begins the tale. "I went out late one night to the privy at the bottom of the garden. I heard a stone fall down into the counter drain. I stood still, and three or four more went. I went back into him [Bert] and said I thought the bank was leaking.

"Well, Mum and Pop had gone to bed. He said, Don't tell them till we're forced, but if that bank breaks, get up that tree. We'd got Aberdeen Angus pedigree cows and calves there, and I said, what about them? He said, you can't get them up the bloody tree!"

"And was it a leak?" I asked. "Yes," affirmed Bert. "By the time I'd got up—this was here eleven o'clock at night—it was gushing across the drain. I got on the phone to the Middle Level [the drainage authority]. They brought forty German prisoners out; they sandbagged the far side and saved the situation. The flood started to go down that night, as it happened. It was the same night as Crowland bank blew, and Postland was flooded. There's little

doubt that if Nell hadn't had to go outside there would have been some trouble at Eldernell that night!"

We would have loved to have carried on spinning our stories, but the night had to end some time. We thanked our friends for an entertaining evening and bid them goodnight. Out in the wind again, we could hear wigeon whistling out on the wash: they added to the magic of the night.

While dipping into volumes of the quarterly antiquarian journal *Fenland notes and queries* I came across an entry entitled "Old Scores" (FN&Q vol V, January 1901–October, 1903). It refers to the very inn which became home for the Weldons half a century later, the Bedford Arms. I quote the entry in full as it makes, I think, an interesting footnote to this chapter:

> Many years ago, long before the time of Board Schools, there was a public house on the north bank of Morton's Leam, near the Cross Guns, which was much frequented by men who earned a precarious living by fishing and fowling in the neighbouring washlands, and by the lightermen, or bargees, who did a flourishing business on the river, as they took loads of timber and other merchandise from the sea-board up towards Northampton, and carried back grain for shipment at Wisbech, then a much more important place than now. Even in those days "tick" was not unknown to inn-keepers: The landlord of the Bedford Arms, Will. Hercock, and his wife, though they were, as they told us, "no scholards, you know sir," yet kept their accounts in a way that proved their capability in business matters. They used neither book nor slate for their patrons, but the score of each customer was chalked up in a prominent place in the room. Each customer had his acknowledged position; the score of one would be on the stair-door, of another on the frame, of another on the mantel-piece over the wide hearth on which little but turf was burnt: and so on. Each man's score was thus well known to his neighbours and his pot-companions, and their remarks on what they saw often suggested liquidation. The old landlord would say with a smile, "Rub it all off sir? we don't have many long scores here."
>
> Perhaps the character of the marks will be understood from the following description. A quartern loaf was represented by a plain cross in a circle, like a hot cross bun. A semi-circle with a line from the centre to the middle of the circumference meant a half quartern. A horizontal line with a Q at the begining was used for beer, a short line drawn at right angles, part above and part below the horizontal line, standing for a quart, a short line above only, not crossing the long line, meaning a pint. Tobacco was scored up in the same way, a T standing at the begining, the lines and half lines indicating ounces and half ounces.
>
> From the memorandum book of an old banker, who had been ganger over a number of workmen, I find that in entering the work done in making fen drains, a simple square was used for a day's work; three sides, two sides or one side of a similar square, being put for three-quarters, half or a quarter of a day's work. These forms of accounts seem now to have vanished.

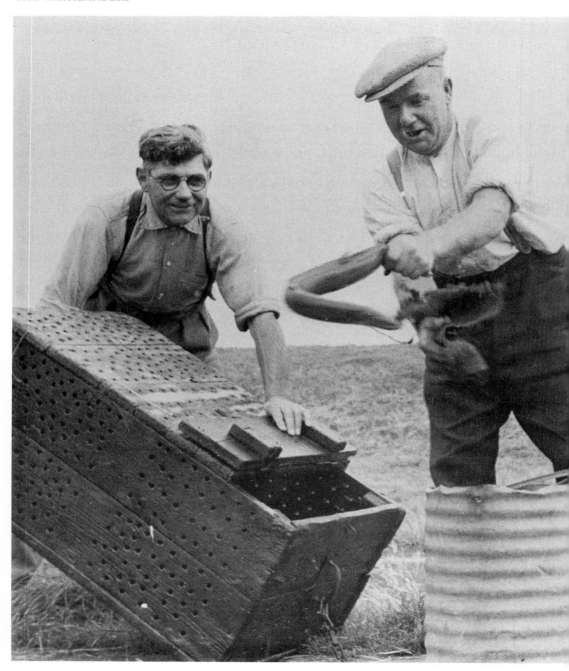

Plover Cottage 6

OF ALL the Washlanders, Ernie James of Welney is perhaps the most widely known. He has appeared on television and radio, and recently his biography, *Memoirs of a Fen Tiger*, was published by David & Charles.

Before this rise to fame Ernie was already visited by many people, some keen to hear about his way of life and others wanting to buy an eel hive or a gun from the old chap. I have had the pleasure of knowing Ernie and his wife Doris for several years now, and a more hospitable couple it would be hard to find. In 1971 I spent three days with Ernie learning how to make a willow eel hive or trap. My attempts are not a patch on the beautiful works of art Ernie creates, but they will catch eels, and at least the method will not be completely lost.

Ernie and Doris's home, Plover Cottage, nestles snug under the bank of the Old Bedford River. Many is the happy hour I have spent under their roof, enjoying their company. Often this has been shared with Stan Moulding, a good friend who first introduced me to the Jameses.

I recall a day when I had taken my young son Robert over there for a spot of fishing. It was a beautiful warm, calm July day.

After a cup of tea and a chat with Mrs James we went up over the bank to Ernie's fishing punt and he ferried us across to the far bank. Over that bank we walked, down to a plank over a dyke and into the willow plantation. Through these osier beds flows the River Delph. A couple of boats tugged at their moorings here. Ernie stepped into one of them, pushing out to check an eel net which had been set overnight; as the net broke the surface half a dozen eels could be seen wriggling and flashing silver in the cod-end.

Robert set up his tackle and began to fish, enjoying some good sport among the rudd. Ernie and I settled on an upturned boat, and to a background of singing finches were soon going over old ground, and also breaking new. We'll take it up as we were talking about Fred Smith, one-time champion skater of Whittlesey. Here's Ernie:

"I remember when we first come to Whittlesey to skate. The missus's uncle, they went to live your way. Well, they was all there and they shouted out 'Come on Welney, they reckon they're got a bloke here who can fly!'—that were Smithy. That were when he

Opposite page: Ernie James holds the eel trunk while Harry Wayman transfers a four-pounder.

95

Champion skater Fred Smith winning the mile race on Morton's Leam in 1958.

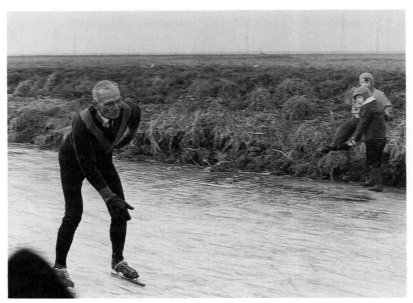

first come out. He beat us that day, but I think that were the only day he beat all on us."

"Was that on the Briggate River?" I asked. "No", replied Ernie, "it was on the wash. I reckon that day it was at Eldernell, but I have skated up towards the main road, and also at Guyhirn end.

"The last time me and Smithy came together in a race it was at Purls Bridge, Welches Dam here. I beat him that time. Then I had an accident that left me so as I couldn't skate no more, not in races anyway."

From skating we turned to boats, and in particular the ferry that Ernie's father ran when the wash was in flood. I heard several stories, some of which are in my friend's memoirs. But let Ernie continue:

"Well, I'll tell you another little tale. Josh's [Josh Scott, Welney shepherd] uncle Larry used to run a boat from yon side. He wouldn't come out, not if that were a bit rough, you know.

"The old toll keeper used to come across the wash to court the then landlady of the Lamb and Flag. Her old man was still alive, but he'd been in bed thirteen year. Anyway, the old toll keeper used to come every night to have his tea. Well, old Larry would bring him over, but if that cut up a bit rough, we'd have to take him back.

"One night old Larry came to fetch him. There weren't a great lot of water on the road. When they got going a little while the toll keeper says, 'You're getting a fair bit of water in the bottom here,

George.' Larry says, 'I'll run up on this bit of land and scup up.' He runned the boat onto the hard and got out and had a look. 'Huh', he said, 'them old boys up the village have pulled the plug out.' He only used to have a bit of rag stuck in to plug it, so it was easy and tempting enough for a boy to pull out.

"There were some rum old chaps about then, you know. Old Joey Butcher, he worked for my father for years, cutting rods [willow] and such. When I were a little old boy I used to like to be with him. When I was about like Robert, or a bit older, 'cos he used to tell such bloody tales, you know; the old man used to say 'Bugger your eyes, Joey.' He was telling us once how he was setting a net out here; he said 'I fell in in front of the net and the current took me right through and out the other side.' Well, you know'd he couldn't; if he hadn't had the cod-end on he might have done it.

"He was more comical than any of these comedians, you know, especially when he'd got a little drink in him. He could do all sorts of conjuring tricks, and I'll tell you what I'm seen him do in the pub. He could kick the ceiling backards, and frontards, and that was over six foot high, so you know he were a nimble old bloke, worn't he? The old woman [the landlady] used to say, 'That's

enough Joe, set down!' and if anybody was obstroclous, she would claw the poker up and sort 'em out.

"Old Will Kent went in there one day. He asked for his beer. She told him he'd had enough. There was a few words exchanged and then he said, 'You've got a fine snout missus!' and sat down. He couldn't get any beer so he kept putting his feet up on the table. Bugger! She jumped up and she took hold of his foot, giving him a shove. Down he went and hit his head on the floor.

"That was time I worked for him. His wife asked me about it in the morning, 'cos he'd only told her half a tale. She said 'He might

ha' been killed', so I said, 'Well, he shouldn't put his feet up to aggravate her.'

"The Kents used to come up to Welney every Saturday night for a 'gass'. They'd got a two-mile walk down that bank but they didn't think nothing on it. When the water flooded them out of their house they used to stop up at the pub at Suspension Bridge, either there or sometimes in this cottage. Old Jarmin lived here then, of course." (This was Jarmin Smart, one of the lesser known of the famous Smart family of skaters.)

I remembered the Kents' house; it was still standing when I first came shooting at Welney. I said to Ernie, "That was where he did all his plover catching, wasn't it?" Ernie affirmed. "Yes, and I did my apprenticeship down there with him. He used to make me laugh. We'd sometimes be both at one net, setting it on a raft, or hill, as we called it. Well, we was a-setting like that one morning and the birds kept going over us, you know. I said 'cawd, look at them.' Will was running up and down from one end of the net to the other, hurrying so we could get on. He ketched his foot in the line and the pole sprung up and hit him in the ear 'ole! All he said was, 'More haste, less bloody speed'!"

When Ernie had finished laughing over this recollection he carried on with his narrative. "When he was a-drinking, I'd be at one net, about half a mile yon side of the house, and he'd be at another one, half a mile this side. We'd allus come up and hev our dockey at the house, unless there was a lot of birds about; then the old lady would bring our dinners to us. She'd be watching to see if we was having a pull.

"Sometimes I used to go up for my dinner and she'd say, 'Ha' yer seen Will?' I'd say 'No, he een't in his hut.' She'd say, 'No—he's gone up the heap!' That's what she used to call the pub; there used to be an old woman keep the pub. Lots of days we'd be catching a hundred birds a day. They was worth a tanner apiece, and that was money at that time a'day. But that wouldn't make no difference to Will. He would set his net, then leave it and goo up there to the pub

till ten o'clock at night. I used to have to go and collect his birds and spring his net afore I went home. He would go for days on end.

"I did tell you that tale, didn't I? I don't know where Will was, but I think he was on the booze. Anyway, there was a lot of duck sat up near the Delph. I thought 'I'll have a shot with his gun'; he'd left his big gun in the punt. I thought, I'll draw the charge and load it to my own liking. Well, when I got unloading I spilt all the powder in the wet, then when I got the bag out there was nothing in it. It was getting dark then, so I decided to come down earlier in the morning and reload it so he didn't know I'd touched it.

"When I goes to the house the next morning I went in for a cup of tea before going off to set the net. She said 'Will's gone out today!' 'Oh', I said, 'where's he gone?' She said 'He's gone to see if he can get a shoot, down to Welches Dam.' I thought to myself, 'that's done it, I'm going to get wrong now!' He was a funny old man, you know. He'd as leave kill yer as not!

"Anyway, the next day when I went up I didn't say nothing; I

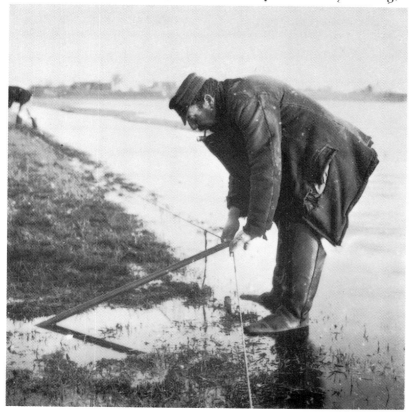

Plover catchers setting the net in the eighteen-nineties, from a photograph in the Parkinson Collection of Lincolnshire Museums.

99

just waited for him to blow up. I sat having some breakfast and she said to him, 'What was you doing yesterday? Didn't you get a shoot?' He said, 'No, I dropped my stick twice to shoot and the buggers jumped.' I thought 'No, and you wouldn't have jumped much if you had tried to fire.' He didn't never know; I went and charged it up again.

"But you know, when I was a-gunning, the first thing I done was to put my rod down the barrel. That would tell you straight away if the gun was loaded, or if anybody had shoved anything down the muzzle; you could be blown up if she was blocked.

"I used to shoot from batteries along the Delph bank here. If that were a-snowing I fixed an old tin can on a rod. That would be placed over the muzzle to keep it clear. When you wanted to shoot you could just push the can off with the rod."

"Did you get many at a shot from the batteries?" I asked. "Well, sometimes," said Ernie. "When that got froze up we'd take an axe and cut a bit out as wide as your shot would spread. We'd push the blocks of ice underneath so it were lovely and clear, then we'd feed the place with corn. After a day or two, just as soon as ever it got dark they'd [the duck] be there; they'd all be in this hole

washing up. Well, it was murder, 'cos you'd laid your gun. To clean that hole up I used to set a stick about as high as a duck's head at the far end of the hole, and lay the gun to that.

"All you'd got to do in the morning was creep down there in the punt, draw the sack off the lock, hit the trigger and you'd perhaps have twenty mallard. But don't forget, this wasn't done for sport; it was our living.

"By puntgunning properly my best shot was forty-eight ducks. Well, the biggest part of them were mallard, perhaps thirty; the others were wigeon and teal. I reckon if I could have got all I shot, I should have had sixty. The Delph was open water, and about thirty

yards out into the wash. All the other was froze up. They was skating yon side. I started at this end. After about half a mile I killed twelve mallard. I came to the shore, pulled my boat up. The sun was just peeping over the bank. Through the glasses I could

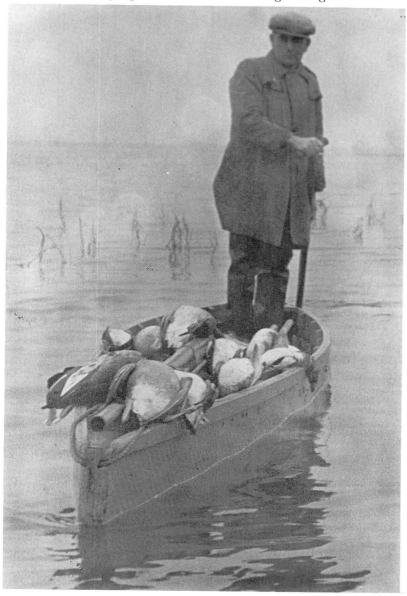

Ernie James homeward bound with a fine bag of wildfowl.

101

Ernie James with the author's son Robert in 1975.

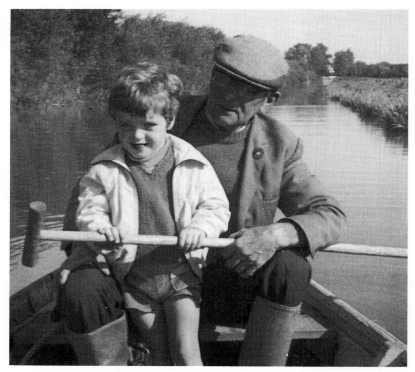

see something which looked dark on the ice, about another three-quarters of a mile down.

"I slipped along the river until I was level with the place. Then, seeing that they were ducks, I turned the boat straight for them. When I got to them the sun was just where I was going to shoot, right in my eyes, so I had to let myself drift out of the sun. When I did shoot, that cut a hole through them almost like somebody mowing a swathe of corn. Ah, and I tell you there was wounded ones diving under the ice and others flapping about on top. I got out of the boat, so you know'd it would bear, and knocked a lot over with my sprit. Anyway, I picked up forty-eight out of that lot, and I'd already killed twelve, so that made sixty.

"I came home, had my dinner and was back out there in the afternoon. I reckon I should have had another fifty but an aeroplane put them up just as I was going to shoot. I shot late and still killed eighteen. That day I had seventy-eight, and that was the best day I ever had.

"I killed several thirties of wigeon with that old gun. If you got anything over twenty you could say you'd had a good shot. When you get out there with all them eyes on you it takes a bit of skill, you

know. That gun I sold you was old Will Kent's before I had it. It was a flint gun, and he had it converted to percussion cap."

We broke off for a moment at this juncture to help Robert extract his hook; a rudd he had caught had gulped the whole lot down. A few moments with the disgorger released the fish and Robert was baiting up again.

Ernie and I returned to our perches. "Do you still get any coypu on this wash?" I asked, eager to hear more from Ernie now he was warmed up. "They breed in my willows here, you know," replied my friend. "There's a bloke that comes and traps them. He's had twenty this turn, I should think, here and in other parts of the wash. We've had a few mink here, too. I killed a white one last year, in them bushes over there, and two or three have been caught in my eel nets."

"What about otters?" I put in. "They're very scarce now, aren't they?"

"Well, yes," agreed the old Fen Tiger. "But I reckon there's still a few hereabouts. I don't get far afield now, but when I was always up and down with the dog and gun, I used to know where them old otters lay.

"There was a time when we shot them for their skins. I shot three one day, you know."

"This is the sort of bank otters would like, with all these trees along here," I commented.

"Yes", agreed Ernie, "they do. When we used to cut these willows there would be a lot of waste, brush stuff. We piled it up in heaps. When the floods came, the otters would get in that, you know. The three I shot came out of a heap like that. Two of them

Ernie James checking an eel net in the River Delph at Welney, 1984.

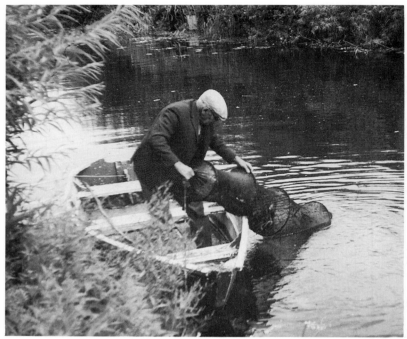

weren't much bigger than pups, but we got thirty bob to two pound for a good skin. That were a week's wages that time a'day, we couldn't afford to let that pass by.

"I killed four or five most winters because I just knowed where they was going to be. An otter, he'll allus lie just above the water, in a hollow stump. In that holt over there, every year I used to go around when the water got a certain height, and I'd allus find an otter there in the same stump. Every year. Year after year.

"I'll tell you what happened last time I ever shot at one. I'd only ever missed one afore, 'cos I used to hev 'em as they laid on the stumps. I went round there on this particular morning, and out goes the otter from this old stump. I knew it was no good waiting once he had made the water. Next day I stalked quietly round in the boat, with my hand gun on the beam, ready. I got in range of the stump an' stopped to watch. I saw something flickering in there, so I shot into the entrance hole. Nothing happened. I still kept my gun aiming at the hole for quite a time. As soon as I lowered it and broke it to reload, out came the otter!

"I went and looked into the stump and he'd got like another room in there! I reckon it was his tail I had seen flickering. He was that artful, waiting until I put the gun down like that. That was the last time I ever went after him.

"Well, when you're about here all your life you see all sorts of things. There were an old bloke come out here, reckoned he was the first one to see these here godwits."

"They'd been here all along, I should think," I interjected.

"We've seen them on and off on our wash for years," Ernie snorted. "'Course they've always been here! We'd caught them in our lapwing nets and sent 'em away, and one thing and another. When you sit out there plover-catching day after day, especially when the flood come down, you'd see all sorts of birds. You're sitting still, you see; they don't take any notice of you.

"Thinking of that reminds me of one night up the Flag," chuckled Ernie. "Two or three old gunners were swapping tales over their beer. The stories got taller as the level of the beer got lower. One old bloke said, 'I were stalking that steady to a bunch of fowl that a kingfisher come and settled on my head—that's stalking, that is, boy!'

"Joey Butcher were there and he said, 'That's nothing, I went to a gang of pockers [pochard] once, and I could only get to 'em back wind. I got pretty close when they started to get up. [Pochards run low along the surface of the water before lifting.] O' course, with that wind they flew straight at me. I fired as they lifted, and bugger me, all I got was a boatload of legs and feet!'"

And so we carried on talking. I've been in Ernie's company pretty often over the years, and hope for many more meetings yet. We were at Plover Cottage recently when Doris and Ernie celebrated sixty years of marriage. Ernie's mother lived to be 105, so at eighty we hope to see the old dog around for a few more years yet!

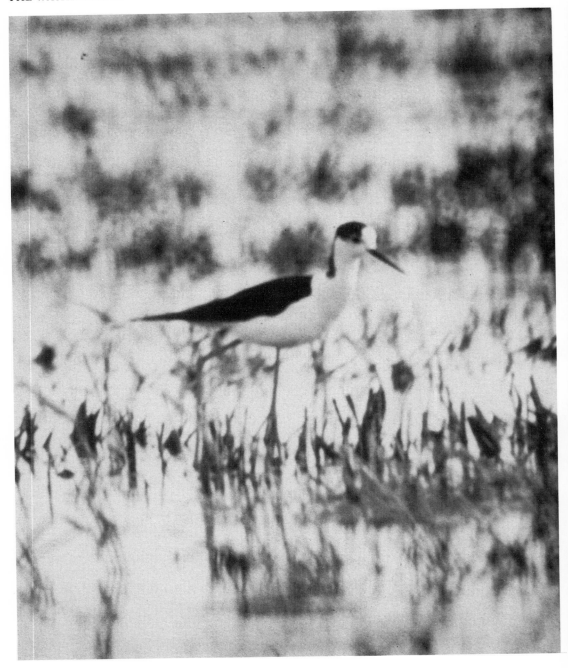

Of Birds, Beasts and Fishes 7

BY THEIR very nature the washlands and the arable fens around provide a rich variety of habitats for plants as well as for animals and birds. The flora of the area includes many species which have been lost almost everywhere else as a result of spraying.

It would require a far more knowledgeable botanist than I to list all the plants that can be found in this area: purple loosestrife, flowering rush, meadowsweet, comfrey, marsh marigold, clubrush, burweed and bladderwort are names that come readily to mind.

It is good to know that the future of these plants, and of the insects that depend on them, seems to be secure. The dykes must be cleaner than they once were, for frogs are making a comeback, and possibly as a direct result of the increase in the number of frogs so are the grass snakes.

The cleanliness or otherwise of the water did not affect a school of twelve dolphins which back in the mid-fifties forged up the river until the steel gates of the Dog-in-a-Doublet sluice brought them up sharp. For some reason one of them was shot and taken to Harry Guy's wet fish shop on the Market Place at Whittlesey. I can remember seeing this huge "fish" hanging by its tail from the beams of an outhouse; its nose touched the floor.

The sluice at Dog-in-a-Doublet has seen other marine visitors in its time. It is not that unusual to see seals in the river; I have seen as many as five together. I do not suppose we should be too surprised, bearing in mind that it is only about eighteen miles from the sea as the crow flies; it is a fair bit longer by river—the tide takes almost three hours to reach Whittlesey from the estuary near Sutton Bridge.

My cousin and I saw a porpoise making its way upstream in March, 1960. When we first heard it splash we turned quickly, expecting to see an otter. Every time the mammal arched out of the water it noisily exhaled a mix of spray and vapour from its blowhole. My cousin Martin had a newly acquired camera with him and managed to get a snap or two as it rose. Later we came across Ivan Hart with three of his pals ledgering for eels; they said that the porpoise had gone by them, then returned, and was heading back down river.

Sea trout used to make an appearance, but I have not heard of

Opposite page: *A black-winged stilt on Whittlesey Wash, 1983. A pair of these birds nested on the wash in that year but failed to hatch their four eggs.*

A porpoise in the tidal Nene in 1960. It apparently returned downriver after swimming up to Dog-in-a-Doublet Sluice.

any being caught in recent years. We might have boasted a whale in 1982, but it became stranded at Sutton Bridge; I think the harbourmaster at Wisbech was grateful that it came no further than it did!

Of course the rivers, dykes and drains of the locality all have their quota of coarse fish and eels. After a flood some find themselves stranded by the falling waters; then terns and herons have a field day. One year, a dyke with no outlet was boiling with a mass of bream; a couple of local wildfowlers netted them and transferred them into Morton's Leam—there were several stone of fish.

Ernie Taylor had a similar experience at Guyhirn Wash in 1980. Ernie shoots on the wash there and had gone to check the height of the floodwater; he was wading about in it when a mighty splash attracted his attention. Finding two large carp wallowing in the shallows, Ernie tried to capture them, but he found the task virtually impossible; in the end he drove for help, returning with a friend and a net. They managed to encircle one of the fish, which

108

was then transferred to a private pit; this carp weighed 23lb. The other fish made off during the netting operations.

Bream of 6lb have been taken by anglers in Morton's Leam; Lord's Holt used to be a good lie for them.

Of our feathered visitors, the geese were always the most spectacular. Their sheer numbers, their size and not least their wonderful music are all factors that impress where geese are concerned. On our Sunday-morning walks we would try to get very close to the mass of feeding pinkfeet, under cover of the bank; the nearest we ever got was within twenty-five yards of the outliers of a mixed party of pinks and whitefronts.

This was at Popleys Gull, a bend in the tidal Nene, where there was always a pool of water in a lower area, right under the river bank and at times two or three acres in extent. This we called the "Gull flash". Duck and geese could usually be found using this water, and more than once we saw lesser whitefront there. Our kindly mentor Mr Ellicott pointed out the smaller, clearly defined geese; on looking closer we found that there were several of these smaller birds with the pale ring around the eye.

In fact on 4th April, 1958, we saw at least fifteen lesser whitefronted geese. Although we did not know it at the time, had we sought verification of the sighting we ought to have been able to claim the record for this species; the UK record at the time was, I believe, eleven.

Our kindly mentor Mr Doug Ellicott, naturalist and archaeologist.

I have already told how the numbers of geese visiting us diminished, and how their place was taken up gradually by the wild Bewick's swan. Ninety visited the "Gull flash" in February, 1961; at the time that was a lot. The peaks in my own records have been: 185, February, 1971; 265, February, 1977; 602, March, 1979; and 880, January, 1986. I believe the total recorded for the whole of the Nene washlands in the 1985–86 winter was something in excess of two thousand wild swans. Obviously they find the Fens to their liking!

To really appreciate the wild voices of the Bewick's one must venture out to the flooded lands at the rising of the moon. In the darkness, with wavering lines half seen in the gloom, it is the wild music that dominates every time.

There is something about the very wildness of wildfowl that is in itself a definite attraction. It would be a sad day, I feel, if through total protection they became as tame and approachable as those seen in a city park. The mystery that surrounds them would be lost. They would lose that certain dignity, that independence that separates proud wild creatures from the pets of mankind.

From way back, man has always been stirred by a great skein of geese, or even a pair of wild duck jumping from a dyke at his approach. At Whittlesey we are lucky enough to be visited by most

species of British wild duck, including wigeon, pintail and teal in hundreds, sometimes in thousands. In frozen times perhaps three hundred pochard and tufted duck will turn up. Mallard, shoveller and shelduck stay on to breed in the washland dykes, and they are joined by one or two pair of the less common gadwall and garganey.

As youths we always used to go along the bank above the old Ministry flight pond and clap our hands. There would be a few seconds of dead silence, then a roar of a hundred pairs of wings. In the welter of whirling shapes that were mostly mallard a few representatives of the other species could be spotted. There were eight pairs of garganey in the mid-sixties; I don't remember seeing more than that since.

In summers of flood I have seen pintail broods in the swamps. Wigeon have also stayed on; I have never seen the nest or brood of this species, but a young wigeon was in the bag of a couple of poachers caught shooting down the wash in June, 1956.

The other "regulars" of the bird world are lark upon lark, reed buntings and sedge warblers, large congregations of lapwings, redwings and chacking fieldfare in the late autumn. Snipe and redshank are year-rounders of the wader tribe, joined by oyster

At the rising of the moon.

Brown's "swamp" at Whittlesey Wash in 1979. The swamp was perfect all the year.

catchers in the spring; the latter have now succeeded in bringing off their young three years in a row.

The rarer birds attracted by spring flooding are the black-tailed godwits, which have nested here on and off since the fifties and most probably long before that. The seventies and eighties stand out as vintage years of breeding success for this large, attractive wader.

Then there is the flamboyant ruff, with his individual neck and breast plumage. Twice in the last five years ruff have established a lek. When the floodwater was draining off, leaving little grassy mounds amid muddy pools, the ruff fluffed out their distinctive feathers and sparred around within a ring of admiring females. It was amusing to think of people driving miles specially to see this strange performance; here it was going on within two hundred yards of a public road, and very few people realized they were there.

Some spring floods will see up to three hundred godwit dropping in en route for Iceland. The dusky redshank also passes through; usually a lone individual. Curlew are seen in most months, but July to October is the best time to find them; they make their way to the coast for the winter. Bunches of thirty are seen at times, but half a dozen in a party is more usual. Whimbrel turn up occasionally, giving away their presence with their "seven-whistles" call.

111

Birds of prey have been more in evidence in recent years; kestrels, short-eared owls and the odd marsh harrier have always been with us. When the RSPB began to buy land at Whittlesey Wash hundreds of acres which had been under the plough were left fallow for a couple of years or so and the cover grew to a height of six feet in places, resulting in a dramatic influx of raptors. As many as twelve hen harriers were recorded in one day; they even established a roost in the thick tangle of thistles and willowherb. Merlins, peregrines, a hobby and a little owl all turned up. My brother and I were out pheasant shooting one October day when a young Montagu's harrier sailed by, the red of its undercarriage showing up vividly as it dipped over the reeds of the counter drain.

Severe gales blow in birds from the coast, miles from their home. "Wreck" birds, as they are known, have included razorbills, guillemots and gannet. Unfortunately a large number of these exhausted birds die. In November, 1961, Ron Pacey brought to me for identification a little auk which his dog had fetched out of the tidal river. Ron had attempted to feed the bird on sprats, but it would have none of that, yet it seemed spirited enough from the way it pecked my finger, so we released it hoping that it would find its way back to the sea.

I have had some interesting birds brought to me for identification, usually by fellow wildfowlers. One year, 1968 I think, was for some reason a year of hybrids. Puzzled gunners brought ducks that I could only guess at: mallard × shoveller, mallard × gadwall and so on; some were very beautiful. Roy Whitwell brought an eider, a female; I have never seen one here before or since. Ray Curtis came with an immature Greenland whitefront; that was unusual, for our whitefronts are normally of the Siberian race. An Egyptian goose was shown to me by John Lepla.

Black terns and common terns pass through during June, but quite by chance Ernie Taylor and I saw three white-winged black terns in May, 1965.

Bitterns are seen, but very rarely. I hadn't seen one at all until 1970, but I've seen and heard one or two since, the most recent

being in January, 1985, when one was flushed within ten feet of me from a reedy dyke on my uncle's farm, adjacent to the washland.

Of the very rare or accidental bird visitors, perhaps the funniest was a flamingo. This unlikely stranger was spotted by Jim Edey and Jim Carpenter as it ambled about on the low tide mud near Popleys Gull. We all swore that they'd spent too much time in the bar of the "Dog" and that their bird was in fact a pink heron!

The two Jims got their own back the following summer. We had all ventured out aboard Tom Lineham's shrimping smack, and there on the sandbanks and mudflats of the wash stood half a dozen flamingoes. Of course, we had to eat our words.

Malcolm Wear, a local birdwatcher, stopped me in the street one day in May, 1979, to tell me that he had just been down our wash and seen some godwits and a crane. I did not know Malcolm at the time, and to be frank I thought that another flamingo had turned up. The godwit part rang true, however, so I decided to cycle down just to satisfy myself.

Sure enough, stalking about in Jacobs' fields was a tall bird like a grey emu; it was a common crane all right, and stood somewhere about four feet tall. It let me approach one field nearer before making off. It flew only a couple of grounds, though, and pitched on the mud pans and remaining floodwater near the Gull, where it was immediately mobbed by plover fearing for their chicks—with

some justification. Trying to avoid the swooping lapwings, the crane jumped about, wings open wide and its long legs in all directions, looking for all the world like a demented ballerina!

I thought that this bird must be an escape from someone's collection, but it was very wild. Later I learned from a birdwatcher that several cranes had been recorded that year. In any event I mentally apologized to Malcolm Wear for doubting his identification; had I known him then as I do now, I would not have questioned it in the first place.

Over the years there have been some very welcome and

interesting birds on the washes, some staying a while, others merely passing through. Of all these, the star place must surely go to the pair of black-winged stilts that arrived in May, 1983. The Royal Society for the Protection of Birds had only just purchased part of our washland and Steve Rooke, the first warden, had left much of the Nene side land flooded. I was cycling down the drove one morning when I was stopped by Steve, who gave me a thoughtful look and said, "I've got something special to show you this morning. You're going to see it anyway, but I'd like you to keep it under your hat; follow me down."

I followed, and eventually we crept behind a low bank which overlooked part of the flooded area. The female stilt was busy feeding not above forty yards off, and she was soon joined by the cock bird, who had a black crown to his head.

We lay watching them for the best part of an hour, during which time they went through a strange ritual involving copulation. The ritual ended when the birds drew alongside each other, both lifted their heads and brought them down sharply to the ground. The long bills crossed, just like two hockey players about to "bully off".

"I don't know if you realize it", said Steve, "but you are now one of the very, very few people who have seen that taking place in this country. The last time stilts nested in the UK was 1945, and there is a good chance that they'll nest again now." I felt suitably honoured.

The black-winged stilt was a bird I had long wanted to see. That ambition had been realized two years previously when I had been the guest of friends on a hunting camp, on the banks of the great Zambezi. There had been so many new and exciting sights

Studies of the black-winged stilts which nested on Whittlesey Wash in 1983. At upper left the female is settling down on to the eggs, and at top right the female is sitting on the nest; her long legs, though bent at the knee, stick out quite a long way behind her. At bottom the male, having just got up from the eggs, looks on as the female takes over; she is tapping her foot on the nest to shake off the mud before entering the nest.

114

and sounds that the stilts I saw were just part of it all. To have them on my own doorstep, as it were, was rather special.

By June the stilts had nested and Steve, attempting a twenty-four-hour watch, was living in an old caravan overlooking the site. He invited me to come and have a better look through his telescope. On Steve's instructions I left my cycle half a mile back along the drove and waited for him to fetch me in his car, from which we were able to step straight into the rear of the caravan without upsetting the residents.

A contract warden, Rhys Green, was also in the small trailer. Steve brewed some tea while I sat glued to a large and powerful telescope which was focused permanently on the nest. The female was just visible; the vegetation had grown since the birds arrived. During the two hours I spent there the pair changed places four times. It was interesting to see how the bird taking over incubation shook the mud from its feet before entering the nest; the bird spent a considerable time carefully shuffling round before finally settling down on the eggs, its long legs sticking well out behind, even though bent at the knee.

The nest site was "protected" by all sorts of alarms. Only that morning Steve had been rudely awakened at two and had rushed to a window in time to see a vixen hurrying away with a plover in her mouth.

The stilt laid four eggs. I never did see them, for I didn't want to go out there against Steve's wishes or to be responsible for the disturbance of the birds; I had no idea how sensitive they might be. Steve had said that we might be able to take a peep when they were sitting tight, and I was content to leave it at that. Regretfully we never got the chance, for at almost the time hatching was due the eggs were stolen and the birds vanished. The RSPB investigations branch suspected egg collectors, but in view of the secrecy of the whole affair, I'd guess raiding foxes were responsible. Whichever it was, it was a tragic ending.

Steve Rooke gave me some photographs of the stilts, so I do have a souvenir of their stay. In my memory bank of special days is filed the thought that I was privileged to enjoy the visit of the black-winged stilts to Whittlesey Wash.

Foxes and other predators take a toll of nests and nestlings of most washland species. Weasels can be the very devil with the nests of waders, and there are a lot of weasels and stoats about. I had seen one or two stoats with half-white, half-brown fur during prolonged snowy conditions, but it was not until 1981 that I saw one in the pure white coat, with black-tipped tail, of the ermine. The January of that year was snow free and the grass as green as summer. When first I saw this piece of white jumping about I took it for a slip of paper blowing in the breeze. My Labrador ran to it

The white stoat from High Wash, 19th January, 1981, with a snipe for comparison.

115

and was nipped. The ermine paid the price; no one nipped that particular dog and got away with it! I skinned the animal and cured the fur as a curio.

I wrote to Mr Ted Ellis, the Norfolk naturalist, asking his opinion as to why, when it was unusual to see ermine here at all, this one chose to turn pure white when there was no snow? It must have made hunting very difficult, if not downright impossible. The previous winter here had been hard, and it was Ted Ellis's guess that a sharp frost earlier that winter had triggered off a reaction in this stoat's fur growth, turning it white at a most inconvenient time.

Although they are a menace, I cannot help liking the predators, perhaps because in a way I am one myself. As the snow lay on the ground last January a fox came over the bank of the tidal river at dusk as I was kneeling, with my bitch, in a rough hide of driftwood on the tideline of the opposite bank. Charlie ambled down, sniffing the slamp where the scent of moorhen, coot and duck still lingered, sweet to his senses. Shortly he came right to the river's edge, sat down and looked straight across at me; naturally I had "frozen" the instant he had appeared over the bank. He sat staring across the river for a full minute, then suddenly darted off over the bank, thick brush streaming out behind him; my scent must have blown across. His original curiosity puzzled me, until a few days later my bitch came into season; the old dog fox's keen nose gave him prior knowledge of coming events! I could easily have shot him, but preferred to watch his antics.

Deer are occasionally seen in the fen. Three red deer were put up east of Eldernell duck decoy not so very long ago; possibly they had strayed from Thetford Chase.

Deer are accidental visitors, though. Otters are the more natural mammal to our marshes, otters and hares. While hares continue to thrive, it is sadly some years since even the signs of an otter's presence have been noted. The spraint of mink has been found very recently, and we are all hoping that the animal was a lone beast passing through. Mink are bad news, destroyers of most other small species.

The weasel is the one mammal that seems to fear man not at all. More than once I have been sitting quietly waiting for a duck when out of the corner of my eye I have spotted a weasel, not four feet from me, standing up on its hind legs to get a better look and obviously trying to figure out what on earth this stranger is.

Once in the spring I had taken a walk before breakfast and lay on the side of a slough (a shallow, dry dyke), enjoying the warming of the morning sun, when I noticed a movement out in the field. Keeping totally still, I watched a weasel stalk me. From tussock to tussock he crept, peering round before moving on . Eventually he came down into the slough, where there were rushes and tussocks

a-plenty to cover his advance, and he thought he was doing really well. I happened to have a pocket camera with me, and managed to wind the film on without making any noticeable move. When the weasel was within a few feet it stood up on its hind legs to peep over a tussock; I was waiting and got my snap. Of course the little animal made a swift exit. I have often wondered since just how near he would have come had I played dead a little longer.

My uncle was walking from his crewyard to the farm house alongside a frozen dyke when a weasel appeared and began to play. It would scamper along the ice, slide, stop and stand up, looking at my uncle as much as to say, "Did you see that? I'm having a whale of a time, watch again!" Then the performance would be repeated. Obviously a little show-off.

Other creatures at times show remarkably little fear if one sits quietly. Bank voles will turn up looking like miniature beavers, to sit on their haunches eating a root of rush, holding it with forepaws as a child would hold a stick of seaside rock. In the quiet of dusk the

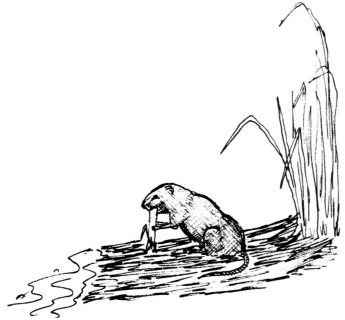

resulting crunching and gnawing sounds incredibly loud. Shrews, or rannies as they are sometimes known, are almost as much at home in water as on land; this is a factor which helps some of them to survive a bank-to-bank flood.

I am sometimes asked to give a talk at local schools, and one story which is always a favourite with the children is one I call

"Franny the Fenland Shrew". It is based on a true incident which happened one January day while I was punt-gunning on Whittlesey Wash.

I saw a dead heron floating on its back out in the middle of the wash, its wings acting like sails as the breeze caught them. I pushed over to the bird for a close look. As it bumped soddenly alongside a shrew popped out from under the breast feathers. It had obviously

been caught out by the floods, but had been lucky enough to spot the refuge offered by the corpse. Within the feathers it found not merely a refuge but a warm bed too!

For all the comforts the heron appeared to hold the shrew decided that my punt looked much larger and, in consequence, safer. Abandoning its feathered vessel, it hopped aboard and spent the rest of the day with me, running up and down the bottom boards or climbing up on to the gun beam, front paws up on the coaming, looking out across the water for all the world like a sailor watching out for land after a long voyage.

Not that there was anything anxious about my new-found friend. He was seemingly oblivious of my presence, calmly sitting down to wash within a couple of feet of my face. At the end of the day when I beached the punt at the main road, the shrew ran off to comparative safety. I wonder what story he told his grandchildren after that? It may be that he would have forgotten the incident within a few hours, but I know I won't; I shall remember the privilege of his company for many a long day. Such things make up the enjoyment of wildfowling.

Easter, 1983, fell in April. A late snow flurry had given the land a white blanket and it was a pleasant, crisp morning, the sun making the snow and ice dazzling to behold. I took my son Robert around the droves of the High Wash. We were on our way home when Robert spotted an injured snipe and he asked me to catch it. Against my better judgement, and after several unsuccessful manoeuvres, I caught the long-bill. The injured wing was almost severed near the shoulder as a result of the bird hitting a fence wire while in full flight; it looked a hopeless case. I said that it was best to

leave the bird, as life is like this all the time in the wild; if it was going to die it would prefer to die in its natural element, not cooped up and frightened in a strange place.

Robert insisted that we must at least try to help the bird, so we took it home, putting it for the time being into a grass-lined cardboard box. I dug some worms and was amazed when, after only half an hour in the house, the snipe scoffed the lot. I am sure this bird would have made an interesting pet, it was so ready to settle down, but the wound was beyond my limited first aid. I rang Tony Cook, who is now curator of the Wildfowl Trust at Peakirk; they had had similar cases in which the bird had survived after the wing had been amputated, so we drove over there and left the snipe with him.

Before I was married I found an injured kestrel which I kept four months; I thought the injuries had healed. She would sit on my gloved hand to pull and eat raw meat, but she died for all that.

My cousin Martin had kept, in turn, a jackdaw and a magpie. These were birds taken from the nest, and so healthy, fit birds.

The author's son Robert with an injured snipe found on Whittlesey High Wash.

Charlie the magpie was most amusing company. If a tray of shallow water was put down for him to bathe in, he would look at it in disgust and stalk off to the nearest muddy puddle. We couldn't understand this at the time, but of course he was only doing what came naturally. That bird was a born comic; I'll swear he knew when he caused a laugh, and he played to his audience. My cousins had at that time an ancient cat called Korky. Korky was tabby coloured, with a white tip to his tail. We all sat on the lawn laughing at Charlie's antics as the magpie hopped around between us. Korky, as cats will, decided to join the party. He came and sat with us, balefully eyeing up this black and white usurper of his domain. The cat's tail, flicking in irritation, caught the bright eye of Charlie, who began to tease Korky unmercifully. He would hop in with precise timing, take a peck at the white-tipped tail and skip back out of range. Luckily for him poor old Korky's aged reactions were slow.

While the collection of birds for mounting into glass cases is rightly frowned upon these days and no one wants to return to the times when birds were slaughtered indiscriminately by unscrupulous collectors, it is as well to remember that much of our knowledge of birds was obtained by early ornithologists studying dead specimens bought from wildfowlers or game dealers. Early artists were able to paint detail from subjects obtained from the same source.

In 1966 I happened to see a letter in *Shooting Times* from a Mr Peter Hanney, curator of the natural history department of Birmingham Museum. The letter was a request for any roadside casualties readers might come across, as the museum's exhibits were becoming rather the worse for wear and replacements could no longer be obtained in the old way. A few days later I chanced to find a yellowhammer hanging dead from a barbed wire fence with which it had collided. I sent the bird to Birmingham, saying that I would keep an eye open for further natural casualties. In the meantime was there anything that they were short of that was legal quarry?

Back came a letter saying that they hadn't thought of this, and would be pleased to receive almost anything which was surplus to requirements. Shortly afterwards a parcel arrived containing a hypodermic syringe, a jar of preservative solution and a quantity of assorted boxes for the dispatch of specimens.

Thereafter whenever we shot a particularly clean or well-marked example, off it went to the Midlands. After some time I received a letter from Peter Hanney saying that he had managed to get his employers' consent for a weekend collecting expedition to the Fens; would I arrange accommodation for him and his assistant, Peter Hillcox?

I booked them in at the White Swan on the bank of the tidal Nene, met them on 16th September at Whittlesey station, and drove them to their lodgings. After lunch we went along the South Barrier Bank at Bassenhally as an introduction to the washlands. Having shot a curlew and a bar-tailed godwit the previous day on the coast, I took these birds with me; we sat on the bankside and I watched while the birds were expertly skinned. Some minute intestinal worms were discovered in the curlew; these were placed into a small glass phial to be sent off to a friend of Hanney's at London Zoo—"he's an expert on this kind of parasite," it was explained.

Over the weekend we visited Terrington Marsh and Wingland Marsh as well as Whittlesey Wash. In the evenings, over a beer, I

learned a lot about Hanney's life and work; he told me that the largest specimen he had skinned, while working out in Africa, was a leopard.

When Hanney and Hillcox left for home on the Monday they had thirteen skins, one curlew, two bar-tailed godwits, four redshanks, a grey plover, three golden plover, a moorhen and a blackheaded gull they had found dead. Tom Thrower, the pump man, had caught two eels for them, and these they took home in a sock! It was also arranged that I should order and send on a wire eel hive from Tom Thrower and a willow one from Ernie James of Welney. These were duly sent to Birmingham, as was a fine list of wildfowl in all types of plumage. They even had casualty day-old ducklings from our rearing pens. We carried on for a year or two and another expedition was planned. Sadly, however, poor Peter Hanney was taken ill and died prematurely before we got around to it.

One or two members of our Wildfowlers' Club brought

specimens they had shot or found, and I like to think that we helped in a small way to replenish the exhibits in the Birmingham Museum's natural history department. Even now, twenty years on, people still bring me roadside casualties, which are often accepted by Peterborough Museum.

I mentioned earlier that we had often seen signs of the presence of otters. Well, one summer, 1959 I think, Martin and I were as usual exploring the dykes in our wooden canoe, *Windhover*, and had paddled down to the Ministry reedbed beyond the New-Come-Over Drain. The day had already been a good one, for we had been able to push quietly through the shallow water among the thick, tall rushes, peering through to the open stretches of water and mud. There, in these secret wild places, we had a high old time laughing at the antics of the ducklings as they dashed around their parents, playing and catching flies, quite unaware of how close we were.

A marsh harrier, a female with a buff patch on her forehead, swept over and caused not inconsiderable panic for a few moments. It was not long, however, before all the ducklings were out again as though nothing had happened.

At length we had to drag ourselves away and make for home. The sun was warm, though, and tempted us to allow the boat to drift along the clearer waters of the New-Come-Over. Suddenly an otter's head broke the surface not three feet from us. Like a seal, he

had popped up to see what new log had drifted into his territory. For long seconds we looked at each other; then, with a roll and a splash, he was gone. I can still picture that otter with the pearl drops of water hanging on his thick whiskers. Sights like that are treasured, and never forgotten.

Woodwalton Fen, a nature reserve not far from home, retains some of the old fen as it was in the days of Whittlesey Mere. I took a friend, Stuart Rippon, over there in June, 1981. As a matter of courtesy I always call at the warden's house. Ron Harold, the warden, said, "If you've got a moment, I've something you may like to cast your eyes over. I'll bet it's something you've never seen before."

Curiosity aroused, we followed him to a greenhouse in which stood several tubs of great water dock. On and around these plants flew some thirty Large Copper butterflies; Woodwalton Fen is the

only place in the country where this species still survives. Ron had reared these from eggs collected in the reserve, and very beautiful creatures they are.

A pleasant afternoon, marred on our return by the fact that poor Robert, then only eight, had fallen from his cycle and knocked out a front tooth. He was grazed, swollen and upset. Earlier that morning I had been involved in a motor accident which had rendered the vehicle I was driving unusable. So with one thing and another it was an eventful day!

Recently I was told an amusing story of an owl. Last year a young wildfowler, Vincent Hilliam, descended from a long line of fowlers and fenmen, came across a short-eared owl that had hit a wire fence. Its wing was hopelessly wound round and tangled. Vincent, getting help from another fowler who had just arrived, managed to free the bird, took it home and looked after it. Expert

advice was sought, and on being told the owl would never fly again Vincent decided to keep it. This lovely bird has settled quite happily, and sits at times on a wooden block in the family kitchen.

One day Vincent's father, Mr John Hilliam, was sitting in the kitchen when a man called to read the gas meter. The gas man gave the owl a glance as he went through to the meter, and on his return he stopped for a better look. Thinking the bird was stuffed, because it sat so still and unblinking, he thrust his face within a couple of feet of it, saying, "They've made a damned good job of that, haven't they?"

The owl opened its wings and hissed. The gasman leapt a yard into the air and spluttered "Good gawd, the bloody thing's alive!" John Hilliam was left speechless with laughter.

More Bankside Yarns 8

SINCE I was a youth of some fifteen summers I have met several interesting characters, shot with some of them, swapped yarns with them, and above all listened to them. Their tales, told to me on the river bank, by the cottage fire while the wind whistled through the osiers outside, or in a boat while setting trimmers for large eels of a warm May evening, bring alive scenes from a bygone way of life which proceeded at a tranquil pace.

When Fred "Tyko" Jackson was a youth and first tried his hand at duck shooting the fowl used to fly the length of the wash and back before coming in to land. The old gunners made part of their living from what they shot, so they would wait until the very last run in, when the duck had their paddles down, braking hard, before they would even consider shooting. They tolerated non-professionals so long as they adopted the same codes of practice; they could not stand the man who took an optimistic shot, especially if it was a miss. Fred told me that he once shot at a duck well in range, but not yet "coming in". Soon after he fired there was shot falling and hissing all around him: one of the old-timers had loosed off a barrel at him! The distance between them was too great for the shot to do any damage, but all the same Fred got the message, and remembered it.

I was on my way for evening flight on the High Wash when I met Joe Anthony making his way home. He had an old hare in his bag, so wasn't staying on. Joe confirmed what Fred had said, adding that he and Fred often used to station themselves along the cross drove of the High Wash. "You could usually take home half a dozen duck," he said.

"One night old Sam Youles was with us," Joe went on. "He had a big old muzzle-loader. We all spread out along the dykeside as usual. The first lot of duck come over Sam, and he let drive. Well, I don't know what he'd loaded her up with, but two bloody grut sheets o' newspaper come down all alight and set the dykeside afire! There was a good wind and it really got hold. We didn't get nowt that night, we all had to stamp out the fire."

Bob Sallabanks doesn't venture out with a gun now, but he still likes to yarn about the old days when he used to live near the "Duke", the remains of which can still be seen on the South Barrier

Bank. Bob told me that as a child he lived in a house on the bank a little to the west of the inn, in a row known as The Goose Houses. Why were they called that? Bob could not tell me.

"You'll remember Albert Goodwin, then?" I said. "He kept the Duke."

"Yes", affirmed Bob, "he wor the last tenant; I can remember the one afore him. It wor a bloke called A . . . He wor a funny sort of bloke, he wor. He had a wife a lot, lot younger than himself.

"Us boys used to go up to the pub and ask him how his missus was today. He'd say 'Hold on and I'll show yer!' Then he'd get a force line and drag out his wife in her nightdress with the line around her neck, saying 'Come on, yew old bugger, I'm a-goin' ter drown yer!' He'd drag her down the bank and put her into the Leam, pushing her in until she was over waist deep.

"Then he'd pull her out, saying 'I can't be bothered to drown yer today—git yew back ter bed!' "

Being boys, Bob said, they thought it was wildly funny at the time.

"He wor a rare cunning old shooter," said Bob. "He had plenty of fowl on his doorstep. The old pub was built right into the bank.

"One day he was showing us his gun; he had it across his lap and cocked it. His hand slipped, and both barrels tore holes in the door! Even when Albie Goodwin took it you could still see where the holes had been plugged and painted over.

"He used to shoot at us too! We'd bait him until his temper rose and he ran into the house, then we'd run like hell and throw

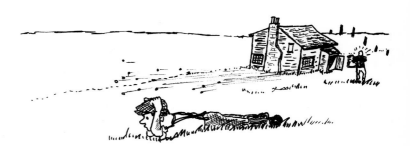

ourselves flat on the ground—you'd hear them shots goo a-whistling over you! Yis, he were a wild and excitable sort of man.

"His wife, though, she got back at him. They moved to somewhere away from here, I forget where. He came down the stairs one day and his wife stood at the bottom with the gun. She shot him, stone dead so they say. She told the police she'd been cleaning his gun and it went orf.

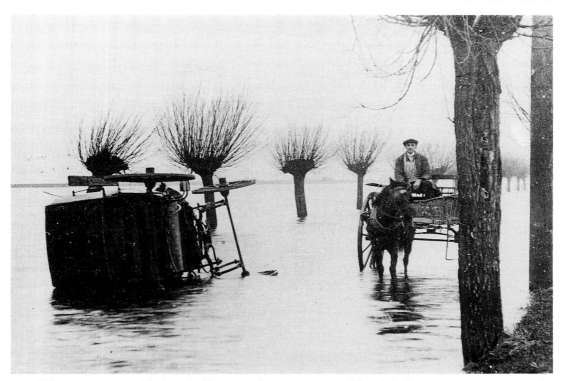

"She got away with it an' all. I say she got away with it! Ar! Them were some rare old days, they'll never come agin loike they were."

A Washland incident of long ago: a Mr Cranwell was killed when a wagon laden with potatoes he was driving overturned on Dog-in-a-Doublet bridge; the hearse was on its way to collect Cranwell's coffin on the day of the funeral when it overturned on the same stretch of road.

Just after the Second World War Neville Giddens was a regular guest of Tom Canham, who rented the sporting rights on Eldernell Wash. Neville saw an otter often enough in one particular place to note its habit of escaping via a culvert, and decided to play a game with the animal. As it vanished into the culvert Neville would nip round to meet it coming out the far end. Mr Otter soon cottoned on to that ploy, however, and changed his tactics.

There was a spell after the war, from 1946 into the early fifties, when some small syndicates of men rented some of the shooting on the Low Wash; Len Hart, Charlie Patman and Neville Giddens hired a fair acreage from Archie Jacobs. There were naturally several poachers; one of them was "Mad Jack" Gilbert. They could not keep him off. In the end they allowed him to shoot provided he kept other poachers away. Whether he did or not is debatable.

127

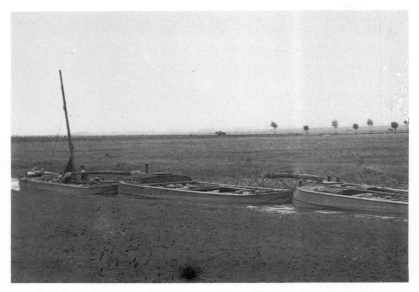

Jack's father was just as rough a diamond as Jack himself. Long ago Gordon Garner, then a young butcher boy, was delivering meat to the Gilbert household. Jack senior was out on his nursery land when Gordon arrived. "Put the meat on the plate in the pantry, bor," came the instruction. "Don't forget to shut the door or the cat will hev it." Gordon made his delivery and departed.

The following week the elder Gilbert met him with "You young hound! you left the pantry door open last week an' the bloody old cat got the joint."

"Cor, I'm sorry, Mr Gilbert, I thought I'd shut it."

"Never mind, Boy", came the response, "We et the cat!"

"Do you know", said Gordon as he told me, "I never did see that cat again."

Another funny happening, due to an excess of alcohol, concerns a certain Wash coast fisherman who shall remain nameless, but whom we will call "Shrimp" for the purposes of this story. "Shrimp" had been out for his evening pint and was returning home along the river bank when the skipper of a moored boat hailed him and invited him aboard for a nightcap. The "nightcap" turned into a long session at the whisky.

Eventually Shrimp decided that he really must go home. The tide had been ebbing and he was now faced with a climb of twenty feet or so up a vertical steel ladder. When almost at the top our hero slipped backwards into the soft mud. Gallantly he tried again.

Right: *Harvesters going to work by boat at Whittlesey Wash in August, 1912, when torrential rainfall caused heavy flooding in parts of East Anglia.*

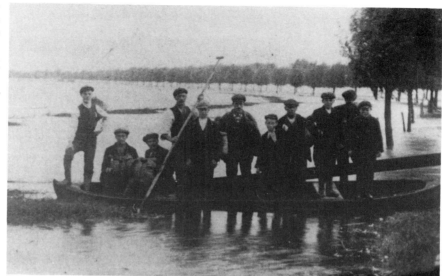

Below: *Waiting for the ferry at Whittlesey Wash in the nineteen-thirties.*

129

Tired now, he fell from halfway **up**, cutting his face and ear on the way down. At length he **prevailed** and arrived home covered in mud and blood.

His wife took one look at him, muttered something uncomplimentary, threw him a clean set of underclothes and left him to it. Shrimp somehow managed to scramble into the vest and pants and fell into bed, out like a light.

By the time one eye cracked open in the morning Mrs S. had gone off to work. Shrimp's head, still caked with dried blood, was throbbing. That he was used to; it was the terrific pain in his chest that was new to him. In the end he could stand it no longer; crawling to a window, he called a neighbour, asking them to fetch the doctor.

Back in bed, he waited another hour. No one came. By now he was sober, if still feeling in a sorry state. The pain however, was just as bad. "I must have broken at least three ribs," Shrimp estimated to himself.

Deciding that he now dare have a peep at the damage, our friend gingerly turned back the sheets, to find that he had got his head and one arm through the same hole in his vest!

Driving along the bank of the Twenty-foot River one fine May morning I spotted Ted Easton in his boat near the far bank. I drew up and asked how the eels were running. The not unexpected reply came back that there had been a run in the first two weeks of

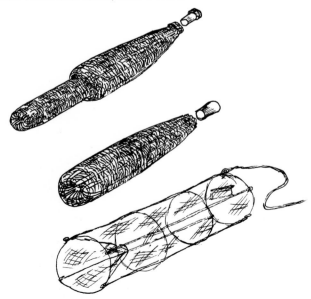

Three different varieties of eel hive.

April, but now only the odd one or two were being caught. No eel catcher will say he is doing well!

We chatted for a quarter-hour or so, during which time Ted told me of the days when he netted the tidal Nene regularly. He caught fourteen stone of eels on one tide, so took a lot round the pubs in Whittlesey. At the Angel, Ted recalled, several men bought eels and tried to take them home in paper bags; it wasn't many minutes before the taproom floor was alive with squirming eels and men trying to recapture their purchases.

I once asked Sam Hilliam where I might obtain an eel gleave, once used by many a Fenman to catch eels. Going into his shed, my old friend produced a beautiful example from under the bench. Three tines it has, made by a blacksmith in Crowland, Sam advised

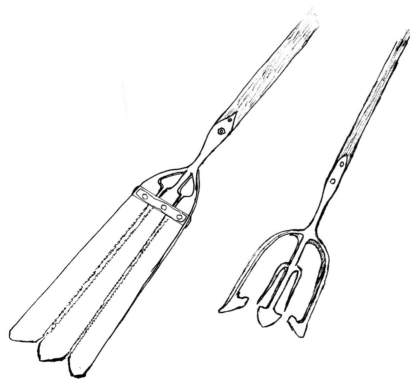

An eel gleave and pike dart.

me. I still treasure that spear; it is a work of art. Sam also gave me some plover net poles. He did more plover catching than any other fowling, and expressed his love of the game thus:

"It were a lovely bit a' sport. We used to set the 'coy birds out

131

*Plover catching on
Cowbit Wash in the
eighteen-nineties, another
photograph from the
Parkinson Collection of
Lincolnshire Museums.*

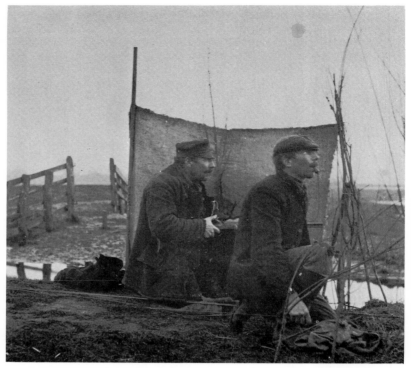

on the battery [an artificial island or hill, fifty feet by twelve] and watch for the old plover to come over. You wouldn't think they'd see the 'coy birds from the height they flew sometimes, but we'd give the old 'coy bird a pull up, so that he'd flap down, and the wild 'uns would tipple out of the sky, and tumble down, going 'chi, chi, chi!' It was lovely to see 'em come in like that. We'd let 'em get right down and then pull the line.

"If you'd got sprung poles the net would come over real sharp, but father used the old sort of poles. You just had to pull harder, that were the only difference. Sometimes you'd get about four dozen at a pull."

Stan Moulding is a carpenter and in his spare time has built some fine wildfowling punts. He and I have been friends for years and we have had some good days on the marshes; we must have been among the last to venture out on Welney Wash and Welches Dam with a punt and big gun.

I gave Stan the first punt gun I owned in exchange for some work done on a big old Norfolk punt I possessed at the time. The gun needed a new lock, so we went to see Sam Hilliam and asked

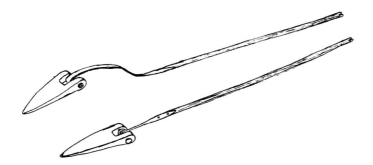

Plover net poles.

him if he knew anyone likely to be still able to lay their hands on a punt gun lock. We were amazed when Sam said "I might have just what you want!"

He rummaged through a jumble of objects on a high shelf and came down with a large flintlock, complete with flint. "Is that any good?" asked Sam. "You can have it for five bob."

Stan made a new stock for the gun, converted the lock to percussion, and it worked well. We never did great execution with that gun, but couldn't we tell you some hard-luck stories!

When Herbert Smart still lived at Coates village I called on him one day to find him in the garden digging a few roots of horseradish. As usual our conversation wasn't long in getting round to wildfowling. His uncle, Bill Peaks, was a gunner and plover catcher owning at least two grounds on Whittlesey Wash, one of which could be flooded for plover catching by means of a slacker or small sluice through the river bank. Live decoy plover were kept in an aviary at the Smarts' house and young Herbert and his sister were paid a shilling a week to dig worms to feed these birds; if it rained at night the children would run out on to the cobbles and lawns picking up a week's supply of worms in a very short time.

Herbert was allowed to earn more pocket money by trapping snipe, which he did with little round traps like miniature gin traps. At the edge of the flooded grass he would scrape out an arc with his heel, setting the traps under water in the trodden-down grass. He said it was surprising how many walked along those scrapes to be trapped. Snipe made him one shilling and sixpence (7½p) each, which would be a fair sum in those days.

In March, 1983, the Smarts retired and moved to Whittlesey, and before they moved Herbert sent word for me to drop by. Several years earlier I had bought one of his uncle's punt guns; now Herbert asked if I would like any of his old tackle while they

133

were clearing out the outbuildings. I came away with two plover nets, plus pulley and rope for same, stalking sticks, four bags of shot and a rusty cocoa tin containing several old lead bullets and musket or pistol balls of almost .5 inch calibre!

While all this clearing out was going on I heard some stories I hadn't heard before. Herbert's father grazed horses on some land he had along the South Barrier Bank near Eldernell, and Herbert began work with him when he was but seven years old. He and his father were working down there one summer evening when three thunderstorms met overhead. They took refuge in a thatched hovel on the bank; let Herbert take up the tale:

"The thatch were almost three foot thick on there, but the rain started to drip through even that. So when it 'bated a bit father says 'Come on, let's make for the old iron shed.' This were an old corrugated iron shed about two hundred yards away. We scuttled as fast as we could to it. It were drier in there all right, but we hadn't been in there long, it were gettin dark, when there come an almighty bang, and a ball of fire came through that there shed between me and father! 'Booger me!' says father, and we were soon scuttling back to our thatched hovel, dripping or not. There we stayed until the storm finished.

"I was working down that same bit of bank, forking straw up in the stubble and burning it. 'Pont' comes along the bank with his

Opposite page: Alf Bedford, dyke roder, about to begin work with his scythe.

Below: Clearing the growth of weeds and rushes from the dykes was essential if good drainage was to be maintained. The man in the right foreground is Bill Peaks, wildfowler, of Coates.

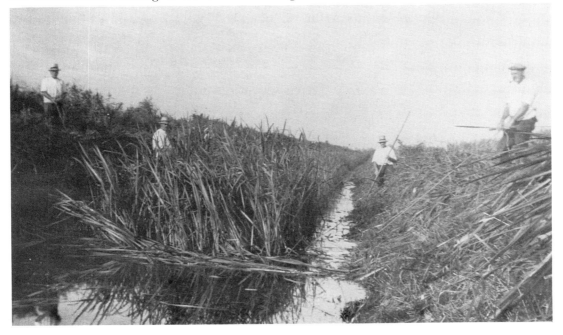

gun. He'd got a couple of old hares and a pheasant or two. He bid me good day as he passed by.

"A short time afterwards I heared him fire his gun orf. Then he called me, 'Come over Herbie, come and have a look at this!' I went over and he'd killed a big otter. He held it up and its tail touched the ground.

"'Dew yew want it?' he asked.

"'Ar, I'll hev it if you don't want it,' I says.

"So he throws it over the drain. 'What are yew gonna do with it?' he asked.

"'I'm a-goin' to eat her,' I says.

"Pont laughed and held up a pheasant. 'I'd sooner hev one of these!' he says.

"'So would I', I says, 'if I could get one.'

"Anyway, as soon as he'd gone I wrapped the otter up in a sack, got it on my little old bike and biked home as fast as ever I could. You see, Father, Uncle and Ducky Benstead had shot some otters the week before, and I knew that they'd sold the skins for a lot of money. Over £3 a skin, more than two weeks' money for a man.

"When I got it home my mother said 'Oh, that's a lovely skin, I'll buy it off you and have it made into a fur.' She gave me £3 for it and father skinned it; he made a lovely job of it, skinned out the feet and everything, then it went away to be cured and dressed. It were a beautiful fur when it came back. The furrier said that up London that would have made £25."

Herbert's family are part of the Smart clan of Welney, famous speed skaters in the nineteenth century. James Smart became world champion, and when a firm invented road skates, an early roller skate, James demonstrated them for the company; Herbert still has a pair of these unique wheeled skates. Herbert is a man of happy personality, and is always interesting to listen to. We had a mutual friend in old George Hailstone.

On a certain foggy day I was talking to George and the murky weather prompted him to reminisce about foggy spells when punt gunning. A lot depended on having a good ear and using your judgement; waiting for duck to call, moving towards the sound, listening again, and so on. One instance George recalled was when he was east of the decoy, where the ground was higher and there were more shallow places for the fowl to feed. The fog was thick, but presently he heard a mallard and worked towards the sound. After a while the punt was so close to the birds that George could hear them dibbling. As he watched a green head popped up from the flooded grass. Ten minutes later four heads appeared. The gunner peered along the seven-foot barrel, beaded with dampness, and saw that the gun lay just right for those duck. Right, he

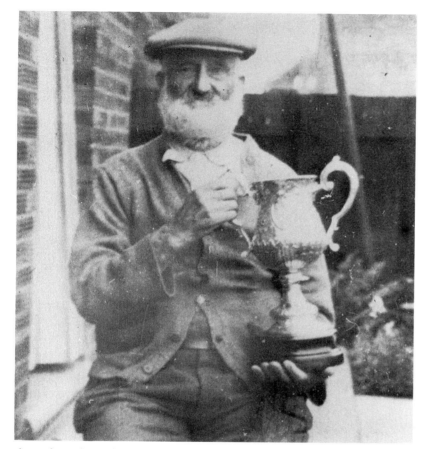

Oliver Hailstone, wildfowler and eel catcher, with the Whittlesey Skating Association cup won by him in 1897.

thought, when they show again I'll give 'em one. At last the heads came up again and the loud Booom! of the gun rolled across the water, echoing off the banks. When he paddled through the smoke, which lingered in the thick air, he found not four birds but twenty, eighteen mallard and two wigeon. George said it quite often happened that you shot more than you could see because of the cover.

I would have loved to have had the opportunity to speak of gunning with old Oliver Hailstone, as I have with his sons, but by the time I was becoming interested the old fellow had died. From his family, and others, one gains the impression that Oliver was a strong, independent character. He was a part-time professional eel catcher and wildfowler, with more than one punt and big gun to his name, and no mean skater either, by all accounts. He won the first cup ever put up by the Whittlesey Skating Association when it was

137

formed in 1897; his daughter still has the cup, engraved with his name and the date. She told me that she used to tease her father when he was an old man. Knowing his answer in advance, she would ask "What was the happiest time of your life, Dad? Was it the day you got married?" The response never varied.

"Good God no gal! The happiest times of all my life was the times I was coming home off the wash with a boatload of duck or eels, with a back wind to push me and a red sunset in the west to draw me home. Them were the happiest days."

Tom Thrower, the pump man, said that when Oliver was well into his eighties he would go out on the ebb tide with a boatload of willow eel hives of his own manufacture. Tom would keep a discreet eye open for the old man's safe return.

When the Hailstone family lived in Claygate, Whittlesey, my uncle Ellis Anderson lived with his parents next door. Ellis can remember seeing Oliver return home with duck all tucked into his leather belt. At other times the neighbours would be shaken by a mighty roar as Oliver fired his punt gun in the yard "to give her a clear out". This grand old father of a family of gunners was into his nineties when he died.

The third Hailstone brother, with whom I have often passed the time of day, is Charlie, who is in his eighty-eighth year and still riding his cycle. We had a long session at his house one afternoon discussing washland matters, beginning by talking about eels and methods of taking them. Charlie explained how a "lamb net" (for fish, not lambs!) had purses sewn in. These are one-way traps of netting, like valves, so that once in the net the quarry could not escape. All eel nets and traps have this sort of component. The lamb net was eight feet across its mouth, tapering down to nothing.

Lamb netting in a fenland river.

138

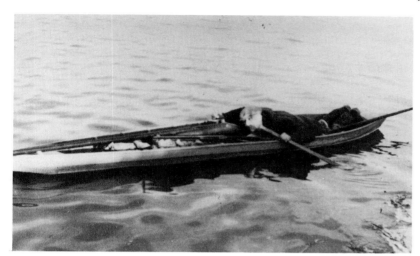

William "Ducky"
Benstead setting to fowl.

The whole was fixed to a sixteen-foot pole and held in the river or
dyke. Another man would "dump" or beat a hundred-yard stretch
of the water at a time, driving the fish into the net.

Most of the time dyke nets were set. These were wing-type nets
set in dyke ends, especially when floodwater was running off. Let
Charlie tell the story of one incident:

"Me and the old chap went down when it were coming on
water, down at headland ten, by the long drove. We'd put a net in
the droveside dyke, the smallest net we had. When we went to it
father said, 'This has got some in it.' We had a bin, three foot high
or more. He shot the eels into the bin, and he said, 'Look at that
one! Lor, that's the biggest eel I'm seen in my life.' We kept looking
at it; our boats were abreast, you see. He said, 'Do you know, I
reckon that could get out of that there tin.' He hadn't said the
words many seconds when it come up, tail first, and flipped out into
my boat in a flash. It jumped over into his boat, then back into
mine, and it weren't half making a noise. Father were trying to
reach for the eel scissors, to hold it. It jumped backwards and
forwards a time or two, but we were staked in blea* water, and one
jump he did, he was gone for good! We ought to have put a sack
over that bin."

From the size Charlie indicated, length and girth, I'd guess at a
ten-pound eel.

I asked Charlie if he did much punt gunning in his younger
days. "Oh yis", he ventured, "I started before George. I had twenty
year on there [the wash]. I had that gun afore George. We had to

*When flooding rises to link all splashes in a field into one sheet of water, the field is
said to be blea.

139

go over on a ferry to West Lynn to fetch it. The best shot I had with her was eighteen ducks and wigeon. I were gunning on the wash there before that 'coy [Eldernell duck decoy] were built; when it were just little trees. They never used it, only to shoot out of the windows of a hut in the middle of the pond. The trees were planted over seventy year agoo, but I don't know who by.

"Plover catching were the best job. That were a clever bit of work, that were. The battery was made like a paling fence; four of them, twelve feet long, were joined together to make artificial land forty-eight feet long. The 'coy bird sat on a stool to keep him dry. Old Ducky had a lot of the right sort of tools; he had a land trap, which was a big help."

What the Hailstone brothers called a battery Bill Peaks more correctly called a "hill"; it was a floating frame covered with cut grass or turf to look like an island in the shallow flood. A "land trap" was a spike of steel about a quarter-inch in diameter which stuck in the ground; another rod of the same material was hinged across the top like a see-saw. One end of the see-saw was formed into a horizontal ring which was covered in canvas; the decoy bird sat on this. Two buttonholes were made in the canvas to allow the legs of the bird to go through. The other end of the see-saw had a smaller vertical ring, through which was passed a long line. In practice, when a party of plover flew over, the catcher would pull the line, gently raising the 'coy bird off the ground. On releasing the line, the decoy dropped. Feeling itself falling, the plover did the natural thing and opened its wings, flapping in to land gently. The wild birds would see this as a signal that all was well, and here was a safe place to feed. In they would come to join their fellow. As soon as they were on the catching area over would come the net in response to the catcher's pull on the rope. Perhaps several dozen would be trapped under the four-inch meshes. However, let Charlie proceed:

"We used to catch linnets like that; we made small land traps out of the hinged stays from an old umbrella. The linnets were sent to London as cage birds.

"Me and brother Jack went to Crease Bank to try for some one day. We had three decoys out, and took the watch line back to a dry dyke, where we were hiding.

"Some linnets came round so I pulled up a 'coy bird, but it was hanging down, limp. When I went to the nets all three birds were dead; a weasel had killed them in that space of five minutes or so. That was the end of that. We had to pack up and go home!

"When I went to school, I used to go to school in Low Church Street. An old chap named Negus would be coming home, about a quarter to two time. He had a three-wheeled bike, and his pack were tied on the back; a pack of cages in a sack. I used to wonder

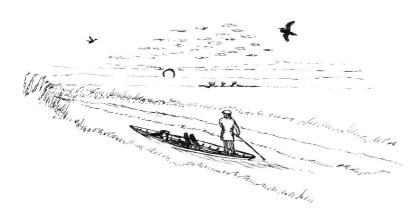

what he'd got in there because you could hear this twittering noise, you see.

"Later on old Negus told me, if you go linnet catching see as you come home by two o'clock, so as your birds can be fed and watered before dark, or else you will lose some birds. That's what he was doing when we saw him as schoolboys. He were a better man at it than we were."

We talked on, and eventually came back to the topic on which we had started, the old cash crop of the Fenman, the eel.

"Morton's Leam was a good little river at that time a' day, because they kept it running. Tons of eels must have come down there. We've had plenty by totting, and with nets, and we'd put a gleave in the boat at the back end of the year.

"We caught more on the haling bank* stretch than anywhere. We'd been along there early one morning getting our nets up. Father took up the gleave and began having a stab or two. We were that busy getting these eels, we didn't notice old Tant [Hilliam] come along.

"It were about four o'clock in the morning; just broke daylight. He came up behind some rushes and catched us. He wanted to know what we were doing in there. The old man said we were only getting a few for breakfast. Tant didn't reckon a lot to it, though. They thought that river were their'n, you see. Old Joney [Charlie Jones] was another. He hired a long stretch of that river. Little old

*Haling bank—the bank on which horses walked when haling, or hauling, fenland lighters years ago.

141

Jack Oliver used to go totting every night. He'd go in the tide river until it were dark. Then he'd creep back and have a hour or two with his bunch of worms and lead weight in the Leam. He always made sure he was seen coming from the tidal river at the end to keep old Joney from being suspicious!

"Our eels we sold at fourpence a pound, skinned. A pound of beef steak was sixpence then. We used to hire a pony and cart from Fred Henson for half a crown a day. He had six or seven carts and plenty of ponies. Some gangs hired them to go to work in. Ours we used to take eels to Peterborough. We sold them from the cart in the streets in the New England area of Peterborough. A lot of the people there worked for the railways, and they had regular wages. We did a good trade there. It were a good life we had. I'd do it all over again if I had the chance."

"He came up behind some rushes and catched us. He wanted to know what we were doing in there."

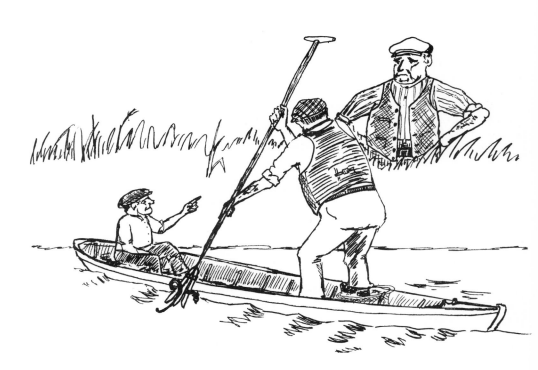

A Washlander's Diary 9

THE ENTRIES in a diary can be sparse, brief and to the point, or they can be elaborate, descriptive and full of information. Much depends on the writer and the purpose of the diary.

For example, my diary for a certain January day could have stated: "Evening flight, Whittlesey Wash, shot x wigeon and mallard." That entry would have been true, but there was much more to the day than that. It was a squally afternoon, with a gale of wind from the south-west and sudden showers of heavy rain. Crouching with my back to the elements, I began to wonder what on earth I was doing here.

That particular train of thought was interrupted by the far-off cry of wild swans, heard faintly over the buffeting wind. Before long the calling became clearer, and then I saw them. They came high on the wind, from the west. The sun, also in the west, lit on the dark clouds of the east, making them look almost black.

The swans, Bewick's they were, broke from their massed companies to spill out of the sky like white leaves in autumn and dropped to the flooded fields all around me. About a hundred passed by, to turn back into the wind. As they turned, the sun lit them to a dazzling white against the black sky beyond.

What a spectacle! What a picture Peter Scott could have produced from such a scene! No need to wonder why I was there; I knew all along really. This just endorsed the point.

To round things off, a very heavy squall followed the swans in, and then the wigeon began to flight in earnest. Another fowler had arrived and settled three hundred yards away. We splashed our way home together in the dark along the flooded drove, each with a pleasing bag of wigeon, with an odd mallard by way of variation.

Either the swans or the wigeon flight would have made for a good afternoon's enjoyment. Together, they made it a memorable day. We were more than lucky with the wild weather, of course; that was the root factor that led to all the other events.

All this was recorded in my sporting diary; not that I shall ever need the diary to remind me of that particular day. A diary is nice to keep, though; it is a pleasure to look back sometimes. The records can be useful; for example, from the twenty-two exercise books that record my experiences on the washlands I have at various times been able to provide information such as old bird

records, location of gravel seams, heights of floods, dates when river banks were raised and so on.

When our small local museum put on an exhibition of fen skating the diaries provided a list of dates when ice had been skatable during the past thirty years. Incidentally, it was noticeable how often 11th January figured on that list.

Freak weather conditions, the excavation of a war-time bomber, counts of wildfowl, the passing on of a shepherd or

wildfowler, they're all there among the everyday adventures through each season. I have selected some entries for this chapter that reflect the essence of the diaries without, I hope, becoming monotonous. So, let's start with one of the earlier ones and browse our way through the years.

7th April, 1957. Martin [my cousin] and I found a dead teal drake on the Nene bank. I kept the wings.

5th May, 1957. Found a kestrel's nest with five eggs, and a reed bunting's nest, five eggs. May get a young kestrel when hatched.

7th August, 1957. Martin and I camped on the "Island". We had a fire and cooked beans on it. It was moonlight so we went down the river in the boat until 9.30 pm. Seven herons roosted in the trees. They woke us in the morning. It was fun and I had a good night's sleep. There are two lots of swans with cygnets.

14th December, 1957. Great news! The geese are in! Patrick St Leger and I went duck shooting near the New-Come-Over. We waited from daybreak until 8.30 am but saw no duck. Then a thin black line showed on the horizon. When they got nearer we could see that they were wild geese. We saw two skeins of 150 each and two smaller skeins of seventy-five and ten. They were flying high and out of range, but they were calling all the time. It was thrilling to see them.

Boxing Day, 1958. This afternoon Bob Payne and I went along the Nene bank to the New-Come-Over Drain. We waited there a good while, and never had a shot. Later, as it grew dusk, we went back to the "Gull", where there was a bit of floodwater. We waited there until it got dark, and the full moon cast our shadows on to the grass. A pack of wigeon came over, then another; whistling shrilly, but unseen by us. I did see a third lot tearing up the river. My gun flashed and roared. We heard the bird fluttering about but, in the dark, with no dog, did not find it. Two geese passed by, out of sight but so near we could hear the creak of their wings. The calls they made seemed almost liquid. After a quiet spell, I put my hand into my pocket to find my watch. While my hand was "stuck" there a mallard whizzed over my head low as you please!

Later we went out to the water. A team of teal tore over us, silhouetted sharply against the moon. I still missed them. Three more vast companies of wigeon flew in, the cock birds whistling away madly. Bob knocked one down but we lost that as well.

Fog shut down as we left for home, but it was still very light. We walked to the milking sheds, where we had left our bikes, amid the wild calls of duck and geese. To me, even though the bag was empty, it was I think the best night I have been out so far.

8th August, 1959. This morning I went down the low wash drove, heading for the flight pond. I got as far as the small willow half way down when Sam Hilliam called out "Can you spare a minute? I've got a cow in the dyke."

I went over. The cow was up to its neck in water. We tried to drive her out, but the banks were too sheer. Sam said he would have to go home to phone the owner of the beast. I said that I could bike up there quicker than he could. I did just that and Sam's wife phoned Charlie Green of Beggars Bridge, who is the owner. Then I biked back.

Sam had dug the side of the dyke away like a ramp. By the time we had driven the cow back up to the ramp Green's Landrover drew up. We got a cartrope around the cow's horns and the six of us, like a tug-o-war team, hauled her out. She lay panting for a minute or two, then got up and ambled off into the field. When Green had left, Sam gave me two shillings for my help.

15th December, 1959. Before daybreak I was down the wash with both my eight-bore and my twelve-bore. I reached the flash opposite the "Gull", and put up some duck and geese. It was getting lighter now, so I squatted at the water's edge. Several wigeon passed just out of range. I also missed one or two of the nearer ones. Then two swung in low across my front. I dropped the drake. A big one this. I waited but missed the only other chance I had.

I walked down to the New-Come-Over Drain. It was still drizzling; it had been all morning. I waited there for a while but nothing came. Not a goose had I seen.

A bunch of wigeon went ripping along the river, so I moved along the bank. Then at last a skein of geese came over. I called, without effect. They went on, over the flash where I began the morning. I thought the flash

would be a good stand if the geese were going to come in. I hurried across to the drove gate.

This was where I broke all the safety rules. I didn't unload. I just made sure the hammers of the eight-bore were uncocked, and put that over the gate. Then I climbed over myself with the twelve-bore in my arms.

The gate rocked and the eight-bore started to slip. Put my hand out to stop it and jumped down. BOOOOM! I felt a rush of air and my hand flew up. I looked at it. The index finger was hanging on by only two small pieces of skin.

I put my hat on the wound and started for my bike. My bike was a mile away, and it seemed a very long mile. Two guns, weighing over twenty pounds, heavy clothes and waders made it a hard walk. I managed to ride my bike a little way when I met Sam Hilliam. I left my guns with Sam and biked to the Doctor's.

[I remember that I was in hospital for four days but was out shooting again on 28th December, less than two weeks after losing the finger. Such is youth! Sam Hilliam, bless him, had cleaned my guns and taken them home for me. I went to thank him. He was out. His wife said, "I've never known anyone to put Sam off his breakfast, but you did that morning. He came home and said 'Young Gray's blowed his hand orf!'" Poor old Sam. The lack of appetite was only temporary, however. I am pleased to report that he was soon back to normal.]

The Delph Dyke, Whittlesey, in summer; a contrasting picture to those of the same area on pages 75 and 76.

20th August, 1960. This morning, on the High Wash, I met Len Hilliam [Sam's brother]. He told me how his father had bought the droves on the

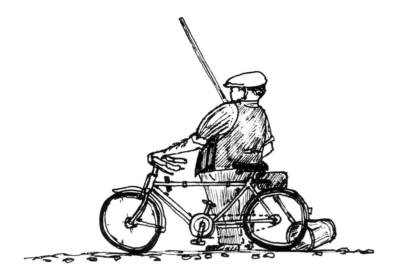

High Wash from the Duke of Bedford when the Thorney Estate was broken up.

Len asked how my hand was. I showed him and said it was doing fine. He said, "I'm glad you're gitting on all right, me ole bewty." Then he went about his work of shepherding.

This evening I went down to the Ministry swamp, to see the flight. I wanted to find out how many young duck were on the wing. I sat on the bank for a while, then went into the rushes on the east side of the ponds.

There I sat, watching small parties come in. The biggest lot I saw was of twenty. This was followed by smaller teams. At 8.45 pm I was getting up, wondering where all the duck had got to. I had started to walk back when I saw a black mass swirl by in the half-light.

Through my glasses the shapeless mass was transformed into a company of a hundred duck. They all set their wings simultaneously, and how that roared as they settled. That's that! I thought. But no, another lot of twenty came. Then, four lots of forty, one bunch after another, 160 duck, all settling together. From where I stood, I could hear them splashing and talking among themselves. Some 420 duck had pitched in tonight, mallard in the main of course, but I did see eight teal and one garganey. Things look good for the start of the season.

7th December, 1960. The floodwater had risen a little overnight, so Clem [Smith] and I left Ralph [Plumb], with his shorter boots, near the Milking Sheds. We went on to our spot of yesterday. As we went into the field we heard geese. It was still dark, but moonlight, so I called. They came over us, five silhouettes, a long shot even for the eight-bore. I tried a single shot, without success.

At daybreak the duck began to move. On Monday they came over so fast that by the time the sound of one lot had gone, so the whistling pinions

of the next lot could be heard. Today they were not so thick, but at least they were lower. Some wigeon went over Clem. Bang! One bird spun down to smack into the water. Two mallard, swerving away from that shot, climbed past me. The eight-bore cut down the drake. They were the only shots we had today.

28th December, 1960. At 6.15 am Martin and I set out from Feldale in the *Windhover* out over the floods. We had cameras this morning instead of guns.

It was a very cold morning. At the start we had to smash through some thin ice. The sturdy timbers and steel-beaded keel of *Windhover* made short work of this, however.

Taking the deeper reaches of water, we made for the decoy. As we approached, dawn was breaking and everything was lit with a pinkish light, warning of a rough day. We went round to the north-east corner of the wood, entered into the trees and spied out with the glasses.

As it was cold we paddled to the Nene bank, a quarter-mile away, to have a walk to warm up. After beaching the boat in a handy gateway we walked along the waterline. We found the bodies of a mallard and a goose. Neither had rings.

All this time the wind was getting stronger. The waves were breaking with a continuous roar. White foam, broken reeds, boxes, bottles and other nameless jetsam lay littered all along our path.

Looking out over the water with the naked eye not much could be seen. But with the glasses duck could be seen dotted everywhere. We must have seen at least five thousand. Further along our bank, near "Abel's Gull", we could see a raft of duck just off the shore. Stalking down behind the bank, we came up opposite them. Fifty of them, which we found were scaup, a sea duck not usually seen here.

Several duck were in the air as we walked back to the boat. We set our nose for the decoy, but this time we had a head wind. The waves were very high, smashing on the bows, sending spray flying back all over us. Once, we

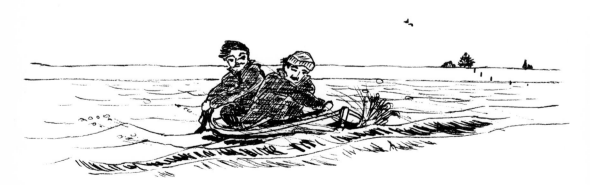

Pinkfooted geese over the washes.

failed to keep the bows head into the waves and water swept along the gunwale and over Martin's seat in the stern. In less than ten minutes his trousers had frozen to the boards!

Glad we were to reach the sheltered water of the decoy. In the middle of the wood, the island was still above the flood, so we paddled across. After a walk round, we took photos of each other on the island.

Leaving by the south-west corner of the 'coy, we were well on our way back. Paddling through some tall reeds, we came across five hundred wigeon. Another five hundred flew in to join them as we sat there. We got some photos of these. There were a lot of shoveller this morning, over a hundred; about sixty in one bunch.

It wasn't long before we reached the smaller Heronry Wood, of Lord's Holt. It was rather like paddling through a mangrove swamp, but with a much lower temperature. Then it was only a matter of crossing over the bank into Rolands Drain at Feldale. Apart from all the duck, we also saw 250 geese, all pinkfeet as usual.

28th January, 1961. 6.15 am. Slight fog. Light breeze. Ice still on the water. Hid in the same place as last Saturday, two fields back from the "Gull".

Only ten minutes after I had settled, I heard a goose calling. I called back. The calling came nearer, then I saw a silhouette. It passed by, very low, on my left. Was it in range? I hesitated and the chance had gone. Damn! I called again. In the end it turned back. As I was now turned round, the bird came, once again, by my left hand side. As the goose passed, at a range of fifty yards, I swung on to it and fired. Boom! Down he came. The eight-bore had done its stuff again. I retrieved the bird, a whitefront, my first of this species.

I met Brian Whitwell on the way home. He laughingly swore at me; apparently the whitefront had been heading straight for him when I called it back.

It was a well-marked goose, and weighed 5lb.

27th January, 1962. While it was still dark I walked across to the "duck fields" in the hopes of surprising a mallard. There was a thick ground mist, which gave good cover. I walked right through the water but only snipe were flushed.

From here, along the bank to the "Gull". All I could see between my bank and the south bank, a mile distant, was a fluffy white sea of mist. As the sun was just rising the clouds were pink against a background of apple green. The mist, too, took on the pinkness, like candyfloss. Beautiful.

Walking down into the mist, I crossed to the drove again and walked to the New-Come-Over Drain. As I passed the small flash opposite the

"Gull" I saw a skein of fifteen geese gliding down, black against a rose-coloured sky. Someone shot at them but did not connect.

Frank Dexter was the only other gunner along the New-Come-Over. I briefly acknowledged him, then settled down among the rushes to enjoy the beauty of the beginning of a new day. Several duck were flying around a flash of water near Eldernell.

Later, hearing someone approaching, I turned to find that it was Brian Young. He sat down near me and began to talk. I was at first a bit annoyed at this as I prefer plenty of room when duck shooting.

Brian showed me his latest gun, a Greener eight-bore. Hammerless, it looked lighter than it was. It was a lovely gun. Four pintail whipped overhead. We both missed.

We set off along the drove together, making for home and breakfast. We had gone by five field gates when a skein of twenty geese glided by. We dived into the thick cover of the droveside and called. The geese turned at once, coming back straight at us, wings set.

Brian said "Wait until they're right over us." I was still waiting when he fired his first shot. I'd been stung! However, the geese were right in front and flaring; I swung the eight-bore on to one and fired. The great bird crashed straight down. I missed with the second barrel.

Brian had had two shots and his bird flew over a hundred yards before dropping, stone dead. Both were fair-sized birds for pinkfeet, about 7lb.

21st May, 1964. Took Rex for a run this afternoon. Went to check the ducks at the "Gull". As we crossed to the bank Rex put up a hen pheasant so close that it flew over my shoulder, its wings beating my arm! At the "Gull" I tied the pup to the fence and crawled through the long grass to the top of the bank. Parting the grass, I could see a nice few duck in front of me: 105 mallard, all drakes, twenty shelduck, eight pairs shoveller, some teal, two pairs wigeon, some mallard ducklings with three ducks. When I had seen enough I left them undisturbed.

11th June, 1964. Again out with Rex for a training run; again it was a beautiful day. I biked down past the "Gull" to Butcher Brown's fields, noting that he had left a pile of fence posts for us to erect later. Then I biked back a couple of fields to one of the rough tussocky fields. Rex and I walked the half-mile length of the field to Morton's Leam. All the way we put up snipe and redshank. The 'shank kept gliding around my head crying a monotonous Teu! teu! teu! teu! teu! There must have been several nests in those rushes.

At the Leam a drake shoveller jumped, a splendid fellow. I looked along the river. Sure enough, there was his mate with five or six young "broadbills".

I threw the dummy right over the Leam into the cover on the far side. Rex swam over and found it very quickly; good for him! I can't wait to try him on duck.

During the afternoon I saw at least ten broods of mallards, all with eight or more ducklings. One duck had a dozen half grown! She must have been an exceptional mother.

I almost trod on a grass snake which basked, motionless except for its tongue, in the sun. With this burning sun and the tall grass waving and whispering, and with fat bullocks grazing shoulder deep through it, it was easy to imagine oneself in a vast prairie. The wide flat horizon added to the illusion. I felt happy with my lot, and so did Rex. I'd swear he was grinning from ear to ear!

26th September, 1964. Five of our small syndicate went this afternoon to our piece of shooting at Welches Dam [on the Ouse Washes]. The five were Jack Carswell, Ted Parnell, Chris Goodson, Charlie Hillier and myself. These fields are far easier to get at, but they don't go right across the wash, as does our Welney shooting. The whole twenty-two acres here is of rushes, thistles and nettles, the latter, incidentally, over six feet tall.

On seeing the field, Ted and Jack immediately went back to the car for their thighboots. The rest of us walked through the rough cover.

Charlie's black dog and my Rex had been growling at each other for some time. Suddenly we had a fight on our hands. We let them sort themselves out, and they worked together like old pals after that.

We had skirmishes with a pair of snipe and a lone duck as we reached the boundary dyke. After we had been settled for some time eight mallard appeared and circled around. They eventually went over Chris, who managed to get off four shots from his automatic [it is now illegal to have more than three rounds in an automatic shotgun]. One duck fell dead in front of Charlie, another fell in the next field, and a third glided down in the same field, but right away on the far side.

I stayed put, thinking that Charlie's dog would have the situation under control. After five minutes they seemed to be still searching, so I joined them. Before we got to the scene Charlie shot a mallard that rose from the dyke. His dog had retrieved that one, but had found none of Chris's birds.

When we reached the dyke a strange spectacle greeted us: there was Chris, trouserless, trotting about in the next field. The two dogs found a duck apiece, while Chris picked the third. Charlie and I were making rude comments to Chris as he splashed back with his shirt tails flapping in the breeze.

Rex shot past me into the nettles with something white in his mouth. It was Chris's underpants! I couldn't stop him, as Charlie and I were falling about with laughter. Rex arrived back at the far side of the dyke. We asked how he had got across without getting wet. "It's easy", said Chris, "there's a shallow bit here to walk on." The words had only just been uttered when Chris slipped from his "shallow bit" to flounder neck-deep in the water. This naturally caused more laughter, and when Rex ran down to lick the face of the helpless Chris I don't think I could have taken much more; my sides really hurt.

I took Rex away to give Chris some peace. The dog hunted around in the cover, there was a sudden scurry of movement, and Rex brought me a winged mallard.

As the sun lowered to the horizon we were joined by Jack and Ted. There was not a lot of duck movement, as it turned out. In fact the only duck we got I killed in the very last light; it fell out among the nettles. Chris was out there like a hare, beating the dog; when he handed me the bird it was still fluttering. He said he kept his eyes on the fall. I thanked him for his quick thinking. He had obviously forgiven me for my earlier ribald comments!

25th March, 1965. Rex hasn't been out for a couple of days. He looked miserable, so I took him for a run. As I cycled towards the Dog-in-a-Doublet, I stopped to glass over the water remaining on the Skating Association's field. "Maybe some waders here" was my first thought. There were waders, but something else caught my eye, a pair of pintail. Panning a bit brought into view a drake shoveller, then a drake garganey. That was early for the latter species, it's usually April before we see them. I settled down to some close scrutiny. The result was: ten shoveller, six teal, four pintail, two mallard, six garganey and three shelduck, all paired except the one odd shelduck—thirty-one duck of six different species, all within a hundred yards of a main road. The sun shone right on them, illuminating every beautiful feather.

Rex was becoming impatient, so I moved on. Along the tidal river bank I stalked another flash of water. On that one sat thirty teal, a pair of mallard and six wigeon. I was glad to see the wigeon. Haven't seen many here all winter.

1st May, 1965. Ernie Taylor and I went to look at our bank at Bassenhally. Among other things we saw a drake garganey, two shoveller drakes and a brood of six mallard.

While we were there we walked across to look at the pits near Decoy

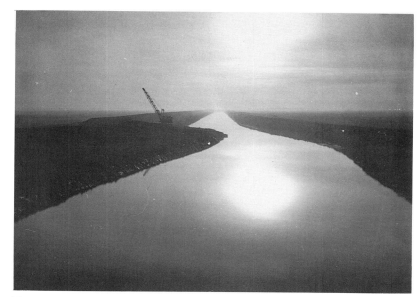

Moonlight on the tidal Nene.

Farm. We were watching a single drake shoveller which was swimming on the pits when three birds arrived. These three circled and dived for some time: they were white winged black terns, a rare passage migrant. We see common tern and black tern coming through regularly at this time of year, but I've never seen this species before.

10th March, 1966. This afternoon I decided to drive over to Cowbit to try to find some of the old puntgunners of Cowbit Wash [near Spalding]. I stopped at the very first house along the bank, made enquiries of the lady of the house, and was told that only a hundred yards up the road lived an old man who used to go punting.

I found the house in question. A man in his forties led me down to some sheds and a greenhouse, where he introduced me to his father. Mr Scholes, for that was his name, informed me that he had sold his punt gun quite recently. The Cowbit Wash no longer floods, and his son was not interested. He still had his old boat; it lay near the greenhouse, but was just rotting away. It was the same shape as Tom Hailstone's, a true Fen punt.

We went into the shed, where Mr Scholes showed me a photograph of his grandfather. I recognised it straight away: it appears as a frontispiece in the books *History of the Fens* and *The Modern Fowler*. I said I'd seen it there. "That's right", said Mr Scholes, "and if you look a bit further in the *History of the Fens* you'll find a picture of a gunner on the ice, holding two dead swans."

I said I remembered the picture. "Well, that's my father," he went on. This Mr Scholes looked more like his grandfather than like his father. His son looks more like the man holding the swans, his grandfather.

Mr Scholes said his best shot was at wigeon sitting on ice. He was able to stalk up on open water. Firing the moment their heads went up, he

picked up thirty-two. Many of the Cowbit gunners apparently had what they called grey plover guns, four-bore bank or gate guns, with a barrel over six feet long, used for shooting into flocks of fowl. Mr Scholes said that as a boy he would have to walk in front of his father with the long barrel resting upon his shoulder; his father managed the butt end. This

way they would stalk up to bunches of grey, or more likely golden, plover as they fed on the wash pastures.

They had some good bags when their luck was in. "No other sport in the world like fowling," said the old gunner. "I have been out on the floods at night when the last light in the village has been turned out, and still afloat when the first light came on next morning."

Thanking Mr Scholes for his hospitality, I asked if he knew anyone who might be able to show me one of these "grey plover guns". He suggested a Mr Walter Tyrrell, who lived a little further along the bank.

Walter Tyrrell's house was not far away at all. Unfortunately I found him not in the best of health, still recovering from a bout of 'flu. Two punts lay in his yard, both rotting. He had no grey plover gun now, but knew someone in the village who had. We went into his shed, where he showed me no fewer than three punt guns, all of slightly different bore and all in fair condition, as Fenland punt guns go. They were fitted with bootjack or slipper boards on the stocks for taking the recoil.

Mr Tyrrell also showed me a measured-up load of shot in a tube made of newspaper and cotton, just the right shape and size to slide into the barrel. The idea was that the shot stayed together longer and so threw a better pattern at longer range; it was also convenient when loading not to have to measure out the charge.

This evening Duncan [my brother] and I drove over to Welney to see Ernie James. Duncan wanted a fresh pair of skates and Ernie usually has some for sale. First we sat in the cottage chatting, mainly about Mrs James's relations, the Smarts of Coates. Ernie also brought out his photo album, full of pictures of fowling, eeling, etc.

Later we went out to the shed. These old fowlers and their sheds! Duncan tried on several pairs of skates until he found a pair to suit him. They soon completed a deal which suited them both.

I bought a willow eel hive. Ernie's a real artist with willow. Mrs James called us in for some tea and cheese.

While we had been outside another friend of theirs had turned up. He told us that his house in Manea had been burgled the previous night. This made way for a lot of talk of robberies of one kind or another, and Ernie came out with a good story. "You ought to have done like old Ike See!" he said. "He heard a burglar one night and went down to see what was going on. Ike says, 'What are you a-doing here?' Burglar says, 'I'm looking for some money!' So Ike says 'Wait till I get me trousers on, I've bin here fifty year and I een't found none yit. I'll come down and help yer boy!'"

All too soon it was time to make for home, but what a day!

4th October, 1967. Terrington Marsh. Duncan and I went for the tide flight. NW wind, very strong. Went up to Northern Corner and followed out a convenient creek.

Duncan got a curlew just before we reached the edge of the saltings, but on the whole things were quiet for the moment. I was showing my brother some pits which I had dug out last season. After all those tides they were still usable. The tide must have begun its flood, for suddenly the curlew started to flight off the muds; by far the majority of the birds passed just too far out for us. Duncan was farther out along the creek than I, so eventually some birds began to give him chances. He shot two before one came over me and I was able to open my account.

Duncan shot another. Rex was as usual very happy to bring all the fallen to make a heap of dead curlew near me! He loves a curlew flight, does Rex; he only has to hear one whistle to start his tail wagging.

During a brief lull we moved to try to get under the main flight line. Of course, the bulk of the birds had gone in, but there were still some on

the move. Two mallard were missed by Duncan. Then a curlew foxed me by coming very low over the mud. Another followed shortly after it. This blew a hundred yards on the wind after I'd shot it.

The tide washed us back off the marsh. While we were wading ashore, a curlew 'coyed in to the dog, near enough for me to add it to the bag. We hid under the sea wall until dusk. Some duck did flight in, but too far off. A curlew flew parallel with the bank, as they often will, low and just over the water. I fired, somehow pulling both triggers at once. The double discharge almost knocked me over! The curlew flew on, calling blue murder.

Quite soon afterwards another followed its exact path. This one I killed. It was a big bird, carrying the longest bill I have seen on a curlew; it measured six and three-quarter inches. The usual size is between four and

a half and six inches. We went home with eight curlew, well pleased with the flight.

[I have since shot a curlew with a bill measuring more than seven inches. I have read that the curlew with the longer bills are usually females.]

16th November, 1968. Clem, Stan and I arranged to have an evening flight on the Fenland Wildfowlers' Association fields on Welney Wash. As the water had deepened since last time we decided to take my punt.

Clem and I took the punt on my van and Stan joined us at Welney Bridge. There was a lot of water, but it seemed not to come anywhere near the road; I took the punt along the river while the others walked over the plank as usual. Rex was with me, and didn't look too happy.

When I found a gap in the willows I left the river and poled across to Clem and Stan, who had reached a dyke. We ferried ourselves across, and again into the third field. The water was about two feet deep all over here.

Clem stayed about halfway down the third field while Stan and I punted on into the fourth and last. There was a lot of cover from rushes and nettles in these last two washes.

Thousands of wigeon flew up and down the wash, miles high, however, in typical Welney fashion. At first the only fowl that came anywhere near us were teal. I missed the first half-dozen shots before I killed the drake from a pair I'd whistled in.

Soon I called in another lot and brought down a hen bird. The spring

of teal swung round over Stan; he also knocked down a hen. It was dusk now and things really began to move. Duck were coming in lower, wigeon in gangs, whistling and growling all around. Bang! . . . Smack! Stan had something down over the dyke.

I moved up there to send Rex over. In the short time the dog was retrieving, I shot two more single cock teal. Rex came back with Stan's bird. I called him a "Jammy So and So" when I saw that it was a drake gadwall. In the exciting minutes that followed I added a lone shoveller and a wigeon, from a pack, to my bulging poacher's pocket.

More wigeon swung round over Stan. Bang! . . . Bang! . . .Splash! . . . Splash! Good old Stan! It was nearly dark now, so I went to help Stan to look for his birds; he had found one, but though we searched and searched, we couldn't find the other. We had given it up and were walking to higher ground when I caught a glimpse of white. What luck, it was the lost bird; I was so glad we found it. They were a lovely pair of wigeon drakes, in full plumage, unmarked.

We decided then to pack up so that we could help Clem, should he have any birds down not yet picked. When we reached him it was dark. The duck were still piling in. Clem said he had a mallard down over the dyke. After a search I came across his bird. "This is not a mallard," said I. "Ooh", exclaimed Clem, "it's not a ruddy coot, is it?" "No", I replied, "it's a drake gadwall, and a beauty." That pleased Clem.

So we poled back. We found a dyke that went right to the road, so all we had to do was bring the van down and load up, a nice easy end to an exciting flight, with a bag of good variety: five teal, three wigeon, two gadwall, one mallard and one shoveller.

On the High Wash, 1968. Shooting Times.

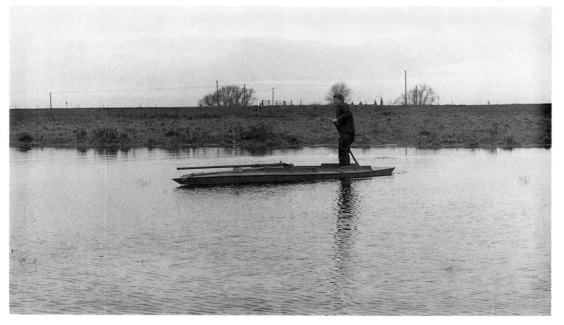

22nd January, 1969. Dawn. After reversing the van to the water's edge on the Low Wash drove, I unloaded the punt and slid her straight into the water. With the punt gun loaded and dropped on to its rest, I only had to lock the van to be on my way.

Today on the Low Wash I was pushing east. I poled off into the darkness. Away across the Common Wash, on to the Leam. There the current of the river was enough to carry me along nicely, without use of paddle or spread; just sat in the stern, steering and enjoying the first light. It was, for a change, a fine morning.

Several wigeon and teal rose from the Common Wash near Bassenhally, but it was too dark to see how many. I was soon passing through the cut between Bassenhally headland and the "Hills"; the latter was now, of course, an island in the floods. A hundred wigeon sat out in the open, four hundred yards ahead. I tried a stalk. Something went wrong, or they just decided to flight, for they got up well out of range.

It was lighter now. As I neared the pumping station there was a very rough field. The cover showed well above the water, and mallard and teal could be heard calling within its shade. Pushing past, I found that the next

field was the same. The wheel tracks of last summer's hay wagons had left a flooded droveway the length of the field, alongside the dyke. I laid down and stalked along this, well concealed by rushes on either side.

Two-thirds of the way down, my plan was to cross over the dyke into the rough cover. Before I made my move, however, fifty mallard and pintail rose, to glide over the dyke to my side, only a hundred and fifty yards ahead!

Keeping well down, I pushed on and on. Thinking I must be getting close I peeped over the gun. Yes, damn me, yes! The nearest, a mallard drake, was no more than twenty-five yards away! There were duck swimming back and forth among the rushes beyond, but out to the right. I pushed with the left-hand setting stick, again and again! she wouldn't go round to the right. In agonies of frustration I shoved and shoved, but the tussocks preventing my passage were too high for the boat to be pushed over from the prone position.

All this time several duck were craning their necks to see what was going on. At last they decided all was not what it should be and away they went. Another chance dashed at the last moment! What a chance too, if only I could have got the gun to bear.

I stood up now for a glass around. Seeing nothing, I poled down to Lord's Holt and through the trees, returning to the rough field to eat my lunch.

The way home was across the fields, away from the pull of the Leam. Most of the fences were slack enough to pass over; one or two, however, were the source of cuts to both me and the punt!

I was passing through Blunt's Holt when I noticed at least six hundred woodpigeons settling on a flooded barley stubble on the headlands; here was a chance of a novelty shot. Lying down, I stalked the woodies. I made it to the water's edge, but even at its highest elevation the gun would not bear. Backing off, I went back in from another angle. Even then my bad luck wasn't over. I lined up on the thickest part of the birds at a hundred yards' distance and pulled. Nothing! The lanyard had fouled somewhere. Blast! They were up, but not all that fast. I recocked and pulled again. The shot arrived just in time to catch the stragglers. I saw them fall back through the smoke. Beaching the punt, I walked over to find six birds lying there. Not bad for such a late shot. I had made the novelty shot, but have often wondered since how many would have fallen had the gun fired first time!

6th April, 1969. Walked along the Nene Bank to the New-Come-Over Drain, and back along the drove. During the walk I saw the following: one pair shelduck, forty pairs mallard, twenty to thirty wigeon, five pairs pintail, fifteen pairs shoveller, two or three hundred teal, two goldeneye, both drakes, five Bewick's swans, fifty golden plover, twenty-two mute swans, a hundred coot, a cormorant, a mallard's nest with two eggs, and seventeen ruff.

The ruff were on the "Town Fifties", right near the main road. I had just glassed over the mud, looking for dunlin, or I wouldn't have spotted them. Only one was in his breeding plumage: he was beautiful, chestnut ruff, white flanks, with large black spots.

30th January, 1970. Dawn, at the "Gull" flash. Nev Garton of Farcet was in the next field. I had only just settled after putting out the 'coys when a pair of wigeon gave me a chance; the first shot of the day killed the cock bird. Seconds later four more wigeon appeared overhead. Bang! . . . Bang! . . . Splash! . . . Thud! Right and left, cock and hen. Next, two misses, at pintail. Then seven more wigeon, high overhead. Two crossed as I fired. Down they came to the one shot, cock and hen again. This was fast and furious.

It slackened off as it got light, of course, but I had added a pintail, a mallard and a teal, all drakes, to my five wigeon before I left for home, well pleased with the morning.

21st, 22nd, 23rd February, 1971. Spent three days over at Welney learning to make willow eel hives, with Ernie James as my instructor. If I can get hold of some osiers next back end, I am confident that I shall be able to make a usable hive after a bit of practice.

It was quite sunny and warm during these afternoons when we went over the river to Ernie's osier beds. On Monday we turned over his punt. Tuesday, to top an old willow tree and trim it up. We took some good wood out of this for making the "chairs" in the hives. The chairs are the internal trap, and the only separate component that is not osier rod.

Ernie was telling me of the old days when his father employed several women at rod-cutting time. It was a good job, as it paid 1s 6d (7½p) a bundle. A bundle measured twenty-seven inches around the butts. You could, with practice, said Ernie, cut sixty bundles a day. That would be £4.50 a day; very, very good money in those days.

Getting the idea.

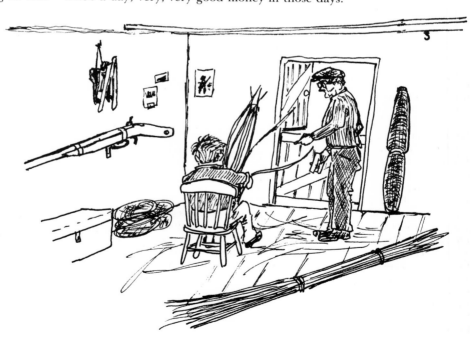

14th May, 1971. This evening Stan and I had a ride over to Welney to see Ernie James. After we had had a cup of tea at Plover Cottage, Ernie said, "I was just going to set a few hooks, ha' yer got time for a run up the Delph?"

As we were going out of the gate, we passed my two first attempts at eel hive making which had been brought along for Ernie's comments and guidance. Ernie turned to his wife with a grin, saying, "If anybody comes time we're gone, mother, them's fifty bob apiece!" We all laughed; they weren't worth fifty farthings.

We crossed over the Bedford River, in which bobbed Ernie's eel trunks, and over to the other moorings on the River Delph. The duck punt and a larger rowing boat tugged at their painters near the osier bed.

We shoved off in the rowing boat. Ernie passed me his sprit, saying, "Yew keep us gooing, I'll just get a few lines baited up." It was a lovely calm evening, and as we poled along quite a few redshank, snipe and duck got up from the wash. There had been some godwits, but none showed up tonight. Ernie told us that the men from Anglia Television had been filming him putting on a mock plover-catching operation. During their stay they had got some film of a godwit on her nest.

We threw out half a dozen trimmers, baited with pieces of small eel, before turning back. We were shown a large hive that Ernie had started on my last visit; here it was in action. A few small sprats were in it; our old friend hoped that by morning some eels would have decided to keep them company! He also hoped for some big 'uns on his trimmers.

During a spell two weeks ago when some floodwater was running off, Ernie says, he was catching a couple of stone of eels a day.

Back at the moorings we made all secure before returning to Plover Cottage. Once there, we settled down for a couple of hours yarning and mardling, with plenty of Mrs James's tea to keep our throats oiled.

[A trimmer is a short length of round wood, with a length of fishing line attached, weighted and hooked with a large hook. The line is wrapped round the stick, leaving perhaps three feet loose. This is baited and put into the river. If an eel or pike takes the bait, the line runs off the stick. In the morning, the fisherman searches for his trimmers and sees what he has taken. Instead of a stick I have known a bottle to be used, the stretch of loose line being lodged in a nick in the bottle's cork.]

161

9th December, 1974. Was walking back along the Nene bank after morning flight. At Saunders' stubble I found it well flooded. A dozen pintail were feeding there, well out of range. I watched from the cover of the bank, hoping they would feed nearer. They moved but kept at a safe distance. Then I had a idea: Why not use the decoy dog theory? Rex was fox-like in his colouring. I threw a stick over for Rex to retrieve. Plover and redshank scattered, screaming blue murder, but the duck stayed, heads up, alert. Another retrieve, and the pintail swam towards me. It was working! Over again went the dog, but the duck would come only so far. I decided to have a go. It took both barrels but I killed a duck, so the little experiment was a success. I strung the pintail with a wigeon I had shot earlier, and walked home.

3rd August, 1975. 6 am on the Leam. Last night I had put out the eel sett again, just off Blunt's Holt. This morning I pushed on by it to land at the "Hills". Found a pigeon's nest in the hedge there, with an ugly looking squab in occupation. It was a grand morning; the sun, already hot, was drawing mist up from the river in white puffs which hung around the rushes. There was an incessant curring of woodpigeons from nearby Bassenhally Pits, backed up by a family of sedge warblers reeling to each other as they swayed about on the wheat straw on the headlands. Coots clanked, moorhens clucked, golden plover came piping overhead, a pheasant crowed and the bees buzzed, each enjoying the morning in their own way.

From my vantage point on the "Hills", a mere six feet higher than the surrounding fen, I seemed to be on top of the world. Surprising the difference the small elevation made to the view.

At 7 am back along the river to Blunt's Holt. The sun was now high enough to shine through the surface, to light up even the mud on the bottom. There were shoals upon shoals of roach, some a pound in weight. Haven't seen so many fish in the Leam for years, not since we used to come down in the old *Windhover*.

At the sett, no eels today but three small roach and a very nice bream of around 4 lb.

24th May, 1975. 4.30 am: took the light fibreglass sneakboat down the Leam to the godwit nest field (since 6th May we have known that a very rare nester, the black-tailed godwit, is nesting down the wash again this year).

Placing a green tarpaulin over me I stalked up the dyke. My plan went a little wrong, for while the godwit field had highish grass, the adjacent field was being grazed by a herd of Lincoln Reds. Consequently, if I raised myself to view the godwit field, I was in full view of anything on my right. I therefore stayed where I was for half an hour, taking in the goings-on in the grazed field. There was a flash of water in the middle of the field and another at the end. In general it was pretty swampy.

Half a dozen redshank came yelping around me when I was spotted by one of their number. I kept dead still and they soon calmed down. My outline, in a boat and broken even more by the sheet, couldn't have looked like a human form.

A godwit flew over, and, though he saw me, he didn't panic as would

have been the case had I walked into the field. He landed near the flash, where I watched him stalking about on his long legs among the tussocks. A plover stood nearby.

One or two shoveller drakes pitched in. Three garganey, two drakes vying for the favours of the duck, were continually darting about, courting, then dropping down to mate. A pair of tufted duck sat further along on the dyke. Thus the little world around the boat came back to life.

I got within seven yards of a snipe who sat on a fence post. Later, I did the same with a redshank. Before I left I raised myself up to see if I could spot the sitting godwit. Naturally, the cock bird I had been watching saw

me at once and flew over, hysterically crying, Wicca! Wicca! Wicca! So I beat a hasty retreat, not wishing to disturb the nesting bird.

Later in the day I took Robert to the skating field; there are coot's nests all over it—at least eight can be counted from the road.

[The nest sites of some birds, including black-tailed godwits, are strictly protected by law. I was licensed by the Nature Conservancy Council to visit this nest, but I used my licence merely to keep an eye on the nest site from a distance. The only godwit's nest and eggs I have ever seen were found by accident; as with most waders, the eggs are surprisingly big for the size of the bird.]

One of my favourite books is *Fowlers' Moon*, by Nigel Thornycroft. The author describes some experiences of pre-war wildfowling. He disguises the location, but I was pretty sure it was some marshes that I shoot on myself. Since the book was published in 1955 the author had gone off to farm in Rhodesia, but in 1973 I wrote out of interest to see if I had guessed correctly. Since then we have kept up to date with a letter or two annually and have visited each other's homes. My visit to Africa was a fantastic new experience for me. I was able to accompany Nigel and his family on

a hunting and fishing safari into the wilderness of the Zambezi Valley, but that's another story! The first time Nigel visited us was in 1975; here is the diary entry that records the event:

21st November, 1975. Nigel Thornycroft duly arrived last night, and spent this morning at the Wildfowl Trust Reserve at Welney. This afternoon we went to Admiralty Point (Terrington Marsh). Except for the new enclosure, he said, it hadn't changed a great deal.

We headed for Northern Corner and the wigeon grounds. The flashes were full after the high tides, and signs of wigeon were evident. Geese could be seen farther on, between three hundred and five hundred brent geese. What a sight, and what a glorious sound as they jumped. Nigel said that they were a rare bird on this stretch of coast before the war.

The evening flight was rather a non-event, only to be expected as the moon is full. I did see three teal, then I heard a shot from Nigel's direction, followed shortly by a hefty thump. I heard it clearly although he was all of three hundred yards away. It turned out to be a young cock wigeon, an outrider to a team of seven. As Nigel said, "With all that marsh to fly over, it was a damned unlucky bird!"

After the flight we sat on the sea wall to eat the sandwiches Pauline had packed for us. Talked for an hour, then, as the sky was clear and bright, with no sign of any cloud on the way, we decided to leave. Had cloud blown up for us to see, we would have stayed on.

27th November, 1975. 4.30 am: picked up young Edward Sargent, who was coming along to watch. We went to the Bombing Range Marsh at Fleet Haven Outfall. We followed the creek that I found on 10th November. We

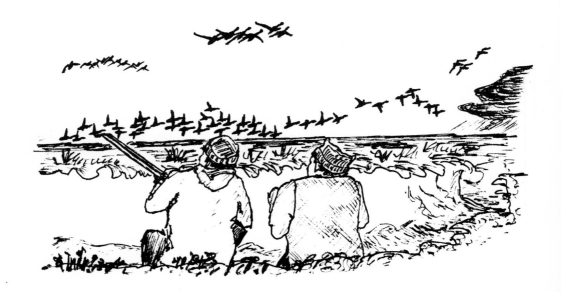

got down into a small gutter just as the sky was lightening; it was a lovely pink, which was bad news for later. It was a frosty morning, and the wind, though off the land, was hellish cold.

Geese could be heard from time to time, and as it got lighter the first lot jumped. They were only six hundred yards away, but flew straight in. This first skein, of about thirty, was followed almost at once by a mass of four hundred. Their calling was blown to us on the wind. It rang in our ears.

A lull, then another hundred and fifty came in, a little nearer this lot. Eight stragglers, in fact, came right overhead, but far too high. There followed a long spell of quiet, so that I was beginning to think that all the geese had flighted. Then the wild chorus broke out again. Two hundred pinkfeet had just jumped. These were nearer. More than that, they turned to come straight for us. We pushed our faces into the grass as the music drew closer.

On either side and right overhead came the whole two hundred. Skeins, vees and lines. Huge grey geese. High; how high? Loaded with three-inch No 1s and SSG, I had two shots. The SSG seemed to shake the goose a lot, and for a moment I thought it was coming down, but on they went. Two other gunners also had a chance, but with no more success than I.

We saw fifty brent fly along the shore. We had to leave at 8 am, by which time, as forecast by the pink sky, the rain and hail was pelting down. As we moved off forty wigeon dropped in to the muds.

A real fowler's morning: frost, wind, rain and a magnificent show of geese. A thousand all told, I'd say, coming in like a Peter Scott painting brought to life. And that wild music! It really was worth coming just to see and hear them.

16th June, 1976. 5 am: at the Low Wash and out in the duck punt. I went right down to Lord's Holt today. Near Bassenhally I found a moorhen's nest with one chick already hatched out, and a beak was chipping its way through one of the remaining five eggs.

Saw a pair of tufted duck near the pumping station; they seem to be increasing as a breeding species here. As I neared the Holt I could hear the young herons making a terrific din as their parents brought them food, squawking and clacking their bills together in anticipation of a tasty eel or roach.

Turning into the New-Come-Over Drain, I moored the boat and walked through the trees towards the noise. As I got close the young herons shut up, and the old birds flew off. I could see at least two of the youngsters perched near their nests. There are at least eight nests.

Back to the punt. Took a short run up the New-Come-Over. This drain was like a duck nursery. At a rough head count there looked to be some fifty ducklings swarming about, hither and thither across the surface.

Made my way back along the river beyond the boat dyke to check my nets. The first fyke held one eel, and was re-set. The middle net had nothing, so was lifted. Finally, I checked the big wing net. Four eels wriggled and flashed in the cod-end. I bagged them and re-set. Not a mighty catch, but enough to keep the frying pan sizzling.

29th September, 1976. Went to the High Wash for another crack at those snipe. I went at 3.30 pm, but it wasn't the same as Monday afternoon. In fact, at first there were no snipe at all. I lay in the corner of the field for two hours before any showed up. During this time an old heron glided leisurely across the wash to land on the drove. Shook himself, then stepped sedately down into the dyke. He didn't see me though he was less than a hundred yards away.

The first snipe came in, circled, saw me and went off in a hurry. I moved out to the edge of the water, but with no cover the same thing happened several times. Snipe normally take little notice provided one keeps still, but these had been shot at here only a couple of days ago.

The bullocks in the field came plodding up. They were soon all around me. It wasn't long then before I got my first snipe. They really

started to flight as the sun sank down. Ones and twos. Wisps of a dozen and more, dropping in like stones. I missed three in quick time. So as to keep the western sky in front, I moved round a bit. As it got darker, however, the snipe dropped straight in without circling. By the time I saw them it was too late.

Most of them came from Thorney Fen; high over the power cables they came. I moved again, this time to the outside of the field, near the cables. I found that I could stand upright in the marsh, catching them as they were still quite high in the copper-coloured sky.

I missed one or two at first but then killed three in succession. They didn't seem able to see me at all, for in the end they were landing all around me, one within a few feet, until I moved. I finished with four. A very exciting and enjoyable flight.

11th–21st February, 1978. With the exception of Tuesday 14th I have been skating every day. This must be the longest spell of skatable ice we've had for a number of years. It wasn't really good until we found some on the 19th. In all I had sixteen hours of skating, so I had my share.

All of our family seemed to enjoy some time on the ice. Pauline got her hand in again, and young Robert, at five years, his first attempts. A pleasing end to the winter.

On 15th I met Brian Naylor and Alan Fisher, rivals in the Lincolnshire Speed Championships. They usually come here to practise when their ice is closed ready for the match. On 20th Fisher took the championship from Naylor at Baston Fen.

18th February, 1979. Snow still with us. The snow pushed off the road in West Delph forms a bank higher than a man. The road at Horsey Toll is clear; a single track between huge banks of snow. [This may seem old hat to folk living in most parts of Britain, but it is most unusual for roads in the Fens to be blocked in this way; water, yes; snow, no.]

This morning I took Robert with Ben the pup for a run along the Nene bank. It was a polar landscape that greeted us. All the water, still bank to bank, has frozen. Unfortunately, as it froze while it was snowing it is in ripples and therefore useless for skating.

The tidal river was, as expected, full of duck. Right near the bridge sat four cormorants fishing. Quite near to them, also fishing, seven goosanders. With a dog and a small boy it wasn't ideal for getting close to fowl, and the birds on the river were flushed.

The goosanders joined more of their kind, a total of thirteen; a record number for me. Five goldeneye swam near them, so all the hard weather fowl were arriving.

Over on the ice was a sight to remember. Hundreds and hundreds of duck, packed in lines and masses. I checked and rechecked. My estimate was three thousand between the milking sheds and the New-Come-Over. It was not a good light and the mass was far away on the Leam side, making identification difficult. By far the majority were wigeon. The numbers I judged to be as follows: two thousand wigeon, six hundred pintail, three hundred teal, a hundred mallard, six shelduck, five goldeneye, thirty snipe, thirteen goosanders, four cormorants and a short-eared owl.

11th April, 1979. Water seemed a little higher today. Later I was told that the Black Dyke slacker boards had been left on and the water had found a way round them. In other words the bank had burst.

Took the mast today and sailed the punt. It handled very well until the mast came out of the step and broke the restraining ring at the top! That happened after two hours of sailing, though, so I had had my fun.

I sailed from the town at East Delph to halfway along Peter Brown's land—the first fence to obstruct me! This I did about four times, and once

The author's punt fitted out for sailing.

right to the skating field. Straight runs of between three-quarters and a mile. The sun was out and there was a good wind. A fine bit of sport.

After the mast ring broke, I poled the punt through the length of the trees of Little Holt back to the moorings. The swans nesting on my "island" now have three eggs. Heard some oystercatchers nearby.

8th January, 1980. Again at the Low Wash for dusk. Cycled as far as the milking sheds. The drove was too muddy then, so from there on it was shanks's pony. Sid Parnell caught up with me; then he, too, left his bike in a gateway. As we walked the drove, a bunch of forty teal was buzzing around like a swarm of bees. Line after line of wigeon and pintail flew high overhead.

I headed for Brown's "swamp"; these low fields are full of water again. Sid went on a couple of grounds. Plenty of cover in my chosen fields, so I unslung the gun, while transferring the bag of 'coys to my left shoulder; this would leave the gun free should anything spring from the rushes or flooded grass. A pair of duck was flushed from the adjacent field, but too far out.

The teal came into view, so I crouched down and whistled. After circling several times the whole forty swept low over the water to my left. Just time for one shot, which brought one down over the dyke. Ben soon had it to hand, a nice little cock bird to start the day.

At the far end of the field was short green grass at the water's edge, with long yellow grass and rushes all round the perimeter; with clumps in the water it presented a lovely idyllic scene. I set out the nine decoys and made a hideyhole for the dog and me.

There was quite a long wait for dusk, but it was far from uneventful. To a chorus of wild whooping, a great skein of a hundred and fifty Bewick's swans thrashed across the sky to join some others at the "Gull".

168

At dusk pintail and wigeon were once more on the move. The sky was a bit better than last night, but still not good. Most of the time fowl were too high to see; the sound of wings was constant.

A pair of duck came round over the decoys, swinging over me when I called. Missed, both barrels! Seconds later fifteen duck followed their lead. This time I didn't make a mistake, I picked an outrider. It crashed as I fired at another. Thought I connected, but couldn't see if it dropped. Ben was back with the first bird, a mallard duck.

After hearing a lot, at last I saw a bird drop in, twisting and swooping like a rocket; it folded and crashed to the shot—a female shoveller this time. It was almost dark when about a score of wigeon swung over the water. I could just make out a moving mass. This shot was a miss. Time to pack up when shooting at shadows. The ice was already forming on the bases of the 'coy birds.

21st March, 1980. Spent the afternoon with George Hailstone. He taught me the basic steps of braiding a net. I was pleased with the results at the end of the day. George, incidentally, at almost eighty still rides his bike, and a motor-bike!

As usual George was talking of the old days, when plover nets and eel nets would be left hanging up to dry near Little Bridge. In George's younger days punts would be left upside down, with the big gun and perhaps a shoulder gun left underneath. In slack times they might lay there for three weeks, and nothing would be touched.

George's father, Oliver Hailstone, chewed tobacco. They knew an old man who was hard up and asked Oliver to save all his chewed-out "plugs"; the old man dried these in a tin, then bought a half-ounce of new tobacco to mix with it!

Wing net and fyke net. The fyke net is set across the river or dyke, not in line with it.

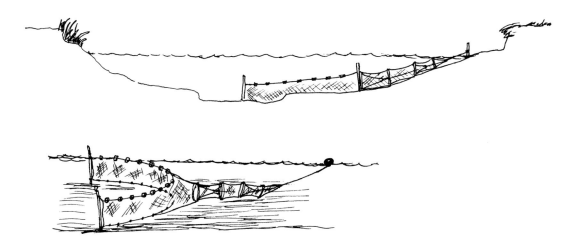

23rd–24th August, 1980. Bank Holiday weekend. Robert had been asking me to take him camping in his new tent. Thursday evening I had bought a light fen gun punt from Stan Moulding, so we decided to try out both our new toys together.

We loaded up the faithful old Maxi and drove to our ponds on the Common Wash. While Robert went off for some dead wood I pitched the tent near the trees. This done, I set the large wing net out in the Leam.

At dusk we waited with my single-barrel twelve-bore for pigeons. A few did flight in, but none offered us a chance. In the last light I dug the fire hole. Heard several curlew fly by, but did not see them. We soon had a good blaze going, sparks flying well up.

Herons and moorhens were on the move, and once some duck. The moon, almost full, shone down on us as we ate our sandwiches and drank our tea. I smoked a cigar to finish it off properly.

At 10.30 pm Robert, just eight years old, was ready for bed. I got him settled in his sleeping bag and sat by the fire for a while longer. Then,

locking the loose items in the car, had a last check round, scratched out the fire and retired myself.

In the morning, after a 6 am rise, we went along the Leam in the punt as far as the "Point" at Bassenhally. Returning to camp, we saw a team of waders, golden plover or ruff, some twenty birds. They dived down to the splashy fields near the skating field.

We lit the fire to heat up some beans and tea for breakfast. This over, we cleaned and cleared everything up before checking the eel net. I knew we had something out of the ordinary as soon as I tried to lift the cod-end. We hauled in the best catch I have ever made, about three stone of eels ranging from two ounces to three pound.

A splendid catch, all due to the floodwater running off; this was the time the old eel catchers used to love. We struck camp soon after and spent the rest of the morning vending the catch! Robert enjoyed his mini-adventure weekend very much. No less, I may add, did his father.

22nd April, 1982. Down on the High Wash. Walked the Roundabout Drove to the skating field. Dykes full of "cuckoo" flowers. Frogs croaking, snipe drumming, redshank belling. A pair of shoveller out near Delph Dyke.

The skating field water almost gone now, but a nice marsh left behind for a while. Making use of the swampy facilities were five shelduck, a dozen 'shank and seventeen ruff. Well, at least four ruff, most of the others, if not all, being reeves. The four obvious ruff were beautiful birds: three had "ruffs" of black and chestnut, the fourth had one of pure white with black spots.

The "ruffs" were shown off to advantage, for the birds had chosen some drier patches in the marsh to perform their lek. They circle each other like sparring bantams, "ruffs" fully bushed out, trying to impress the females! Eventually, they all flew across to a tussocky field near Delph Dyke. A real picture.

15th January, 1984. We wildfowlers, and other bodies from the town, are re-pollarding the willows along the wash road. They haven't been done since the Oldfield brothers (thatchers) retired. If they are not topped regularly these ancient trees would soon become top-heavy and liable to blow down in a severe gale. Grazier and butcher Peter Brown brought his tractor and trailer along for carting away the cuttings. A cold windy morning; snow in the air.

9th July, 1984. Hoping to try out the punt gun on the new punt tomorrow, so had a dummy run in the garden. Loaded the gun with half a charge of powder, no shot, and fired. The paper wadding broke a hole through the trellis fence, leaving it smouldering. The garden was filled with smoke. Our neighbour's twenty-two-year-old daughter looked over the wall to ask if I was all right. "Just giving the old gun a clear-out, my dear," I explained. Then we both had a laugh at the funny side of the situation.

16th February, 1985. Skating match. Hurried home from work this morning, had time for a quick lunch, then off to the skating field. Many cars already there when I arrived, but although entries had been taken no races had yet been run.

I went over to the start and was immediately roped in as a timekeeper. The first event on the card was the mile race for the Fred Smith Cup. We

had a short (220-yard) course, so that would be four times up and down for a mile. Unfortunately there were only two entrants, Laurence Smith, the holder, and Bev Hurn. It was a good close race, with Laurie taking the title once again.

Next came the men's half-mile. A much larger entry for this. When I got a chance to hand over the stop-watch for a spell I went over and added my name to the list. Some of the heats were one-sided, but others were very close, making exciting races. One or two fell as the skater panicked and lost his style.

I was pleased, with my forty-four-year-old legs, to clock something like 2.20, while the winner, Johnny Clark of Throckenholt, won in 2.02. It did my ego good to find several slower times than my own!

There followed races for under-eighteens, under-fifteens, boys and girls. Then under-eleven mixed, pairs races and relays.

The final event was, of course, the Whittlesey Mad Dash. There must have been well over a hundred skaters in this mad charge over 220 yards of ice.

It was a really capital day. The ice was perfect, the sun shone, and with hardly any wind these must have been the best conditions for a match that most of us had ever seen. Robert Markillie, the man who beat me in the heats for the mile at the last match, came second in the half-mile today.

Fred Smith, eighty years of age, was on his skates. I took his photo to record the occasion. He said, "When this ice has gone, I doubt if I shall ever put them on again." Even with his years, he still skates in fine style.

Keith Timms, the official starter, was resplendent in scarlet blazer and cap, with two enormous .38 pistols and a big cigar to match. Hubert

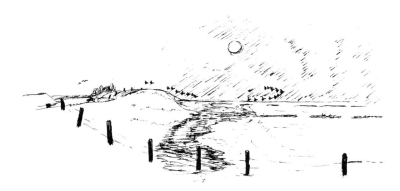

Oldfield and Jack Smith, veterans who skated years ago, were on the sidelines today, but enjoying the sport nonetheless. I don't know how many folk turned up, but Mick Speechley said a hundred and fifty cars had gone through the gate. A day to remember.

22nd May, 1986. Two inches of rain fell in a very short space of time on Tuesday. Today, two days later, I cycled to see if any water has arrived from the high lands. The land along Delph Dyke on the High Wash was blea, but elsewhere didn't look too bad. It would be a disaster to many ground nesting species if we got a full flood, even if only a few inches. At Guyhirn, where it is lower, the wash is flooded bank to bank.

While standing on Little Bridge looking at the height against the level board, a pair of crows attracted my attention. A heron was ensconced in the rushes of Delph Dyke, no doubt for a bit of quiet fishing; the crows had spotted him and were mobbing the lanky grey bird.

One by one the crows dive-bombed the heron, passing and repassing, just missing his head. Poor old heron didn't know which way to look. He kept ducking his head down into his shrugged shoulders. Then, all of a sudden, patience ran out. One of the crows whizzed in full of confidence. The heron's long neck darted out viciously, with all the pent-up anger behind it; the dagger of a bill could not have been far off the crow's chest. How the black bird avoided the stabbing bill I do not know; it shot straight up in the air in a state of panic. That finished that game; the two mischief-makers made themselves scarce, leaving old Frank in peace.

5th October, 1986. Stan and I drove over to Welney this morning to visit Mr and Mrs Ernie James. At Plover Cottage we had the usual session, during which Ernie showed us his "new" fiddle, 150 years old. "It's full o' music," grinned the old chap, striking up with "Smoke Gets in your Eyes" to prove his point.

After signing our copies of his book *Memoirs of a Fen Tiger* Ernie led the way to the shed, to show us his latest batch of eel hives. He says that he can't make so many these days; his hands are not as strong as they were.

Next, this marvellous eighty-one-year-old pushed us across the river to his osier bed and the rod cutting place. Here, on the River Delph, we

went out in one of the other boats to check three fyke nets. Just a few eels in two of the nets.

Back up the river, we crossed to some more osiers to check a mink trap. It was unsprung. It was a glorious warm still morning as we stood there on the wash listening to the old fowler.

All too soon it was time to leave for home. A morning with the Jameses is just not long enough; you need at least a day! On 23rd of this month the Jameses celebrate sixty years of marriage.

And so we could go on. Lack of space prevents me telling of Missen the molecatcher and of how Powley's dog was bitten by a coypu, of catching teal at Borough Fen Decoy or of the geologist finding a weather balloon down the wash. Maybe one day I'll put down some more tales of the Washlanders for you.

Meanwhile I'll wander down to the Dog-in-a-Doublet to watch the old herons drop in for a night's eeling. I shall imagine that I can hear Tom Thrower's pumps fighting against the rising waters. "Thump! Thump! Thmpa! Thud! Thud! Thud!" Yes, and maybe see again, as I saw once, 500 pochard and tufted duck rushing overhead, black as coal in an orange and copper sunset, or the ghost of old Oliver Hailstone in his punt, drifting out on the ebb as he baits his eel hives. "Good luck, old fellow, may they run well for you tonight."

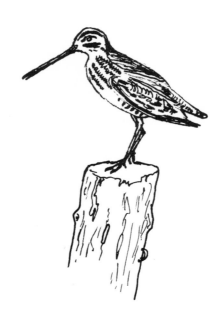

Appendix one

Extracts from *Wisbech Standard* referring to fen skating at Whittlesey, 1881–1908.

2 January, 1891
SKATING MATCHES—A few days ago several visitors attended on Briggate river, Whittlesey, to witness the racing of the labouring men. The first race which took place was the Champion race for the Whittlesey district, when S. Hilliam was the winner, receiving a leg of mutton. B. Reid, of Coates, being second and winner of a shoulder of mutton. Whilst J. Bullamore and W. Catling, of Eastrea, the two other competitors, each received 4lbs of beef. The distance being 1¼ miles. The next race which took place was also for 1¼ miles. There were 32 competitors, with the following result. The winners in the final heat were: 1st H. Cole, about 14lbs of beef, 2nd W. Brown, about 10lbs of beef. The winners of three heats, Messrs W. Billings and J. Marshall, obtained 7lbs of beef, while the winners of two heats, Messrs H. Parrish, D. Catling (Eastrea), W. Stallebrass, and G. Easom received 4lbs. Messrs H. Lovell, J. Scotney, T. Taylor, W. Dawson, S. Easom, J. Oldfield, Isaac Lard, and E. Mason, being the winners of one heat, about 3½lbs of beef fell to their share. The remaining 16 losers received one quarten loaf each. The recipients expressed many thanks to the organisers for arranging these races, and to the many kind friends who had so liberally responded to the call made on their behalf.

18 January, 1895
SKATING MATCH—The second skating match this season for labouring men was held on the wash on Thursday, January 10th when the balance of the money collected by Messrs Cox and Binder was competed for. As on the previous occasion the prizes consisted of groceries, bread, meat and coals. A large number of people assembled, and some good racing was witnessed.

1 February, 1895
SKATING—During the week an association has been formed with a view of encouraging speed skating in the district. A strong committee has been appointed, and has met with good support from townspeople. The first match will take place on the Wash today (Friday), weather permitting, when a challenge cup valued 10 guineas, and 10 guineas in money prizes will be competed for. The races are open to all comers. With a fine stretch of ice in close proximity to the town, and of easy access, there is no reason why this should not become one of the great skating centres of England.

5 February, 1897
SKATING—The Whittlesey Challenge Cup was won by Oliver Hailstone at the Skating Match held on Thursday in last week.

30 December, 1904
SKATING—was indulged in by a goodly number on Monday, on what ice was available on some reaches of the Wash.

17 January, 1908
RETURN OF THE FROST—The frost having returned again with some severity at the end of last week, the Wash was once again soon covered with a good stretch of ice. On Saturday a few skaters were to be seen enjoying themselves on their

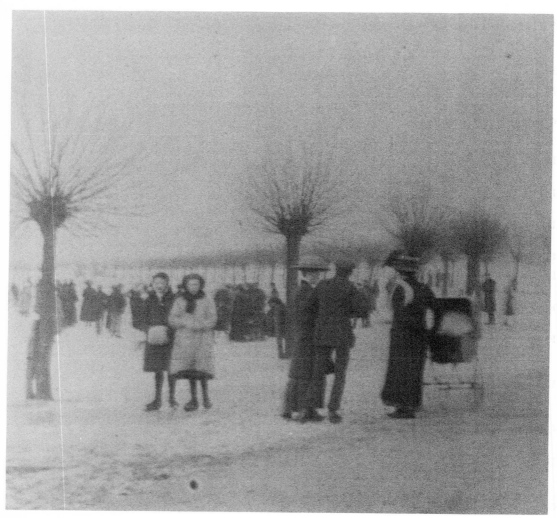

Skaters and spectators on Whittlesey Wash about 1917.

"patterns". The frost continued on Saturday night, and Sunday being particularly fine, with a nice gleam of sunshine, hundreds of people turned out both in the morning and afternoon, and were disporting themselves on the long stretches of ice for which the Wash is so famous. The skating was continued on Monday, and some races for boys were inaugurated. Miss Annie Slater, who was enjoying the sport on her "patterns", had the misfortune to go under the ice, and become immersed up to her neck. She pluckily struggled out of the water and walked home, and we are pleased to hear that she is none the worse for her ducking. Mrs Sismey, of the Old Crown Inn, who was also on the ice, had rather a nasty fall, receiving injuries to her head. On Tuesday a partial thaw set in, which rendered the ice on the Wash unfit for skating, but some races for meat etc, were run on the Briggate River in the afternoon, giving amusement to hundreds of onlookers.

Glossary

Bait of eels Enough for a meal.

Blea Land flooded just enough for the water to be visible through the grass is said to be blea.

Company Collective noun for several wigeon flying together.

'Coy, 'coy birds Short for decoy; locally pronounced "ky".

Dump, to To drive fish towards a lamb net by dumping (splashing) the water with poles.

Drove Road or track which is grass in summer, mud in winter, or in more recent times sometimes gravelled.

Dyke In the fens, a ditch. Originally a Dutch word, dijk, meaning a raised embankment.

Eel sett A series of eel nets forming a single trap.

Eel scissors Blunt serrated tongs for gripping eels when transferring them from one receptacle to another.

Eel trunk A large wooden box perforated with many holes, moored in a river for the storage of live eels.

Flighting Shooting of wildfowl as they flight from roost to feeding grounds and *vice versa* at dawn or dusk, or under the moon.

Fyke net A net, usually set across the stream, with a long skirt of straight net to funnel eels towards the entrance and traps knitted in.

Gleave Eel spear with three to five broad serrated tines which grip rather than stab the fish.

Gunning boat Punt built for gunning. The Washland type was usually 16–18 feet long with a beam of 3 feet, open and undecked.

Grigg Large willow basketwork eel trap. It was not baited.

Grounds Individual fields on washland; "Holland's bullocks are three grounds down from Jacobs' Hovels." At Welney, however, individual fields are called washes.

Gull A horseshoe-shaped bend in a river where the banks have been repaired after a breach. Probably derived from "gullet", the deep hole worn by water rushing through the breach.

Hand gun A shoulder gun, usually a 12-bore, kept in the punt when punt gunning and used to pick off wounded birds.

Herd	Collective term for a gathering of swans or curlew.
Hive, eel	Willow basket eel trap, usually baited.
Jet	A basin-shaped pail fitted with a long wooden shaft used for filling cattle drinking troughs with water from the dykes, especially when water levels are low.
Lamb net	A large round net with valve traps knitted into it. Fixed to a long pole, the net was held in a river or in a large dyke while helpers beat the water to drive fish into it. See dump.
Panny	Soft ground very shallowly flooded.
Pantion	A large earthenware bowl, narrow at the base with a sloping side extending to three feet in diameter, used for holding milk for skimming when making butter. Also used when salting down pork and bacon. Pronounced "panshun".
Pattens	Fenland term for skates, believed to be derived from the French.
Pilger	A pike spear.
Plover	The green plover, lapwing or peewit, known locally as the black plover, caught in their hundreds by the plover catchers.
Scradge (or cradge) bank	The lower bank of a washland river, designed to be overflowed when water levels endanger the outer barrier bank. Rather like an electrical fuse, it is deliberately included as the weakest link in the system.
Slipper or bootjack	A board hinged with a bolt to the stock of a punt gun to absorb the recoil of the gun. The board supports the chest of the gunner, and the other end rests on the bottom boards of the punt; the recoil is taken by the punt. This method was used by the gunners at Cowbit (Cubbit) Wash.
Slubbing out	Removing weeds and mud from a dyke, a normal part of dyke maintenance.
Spring	Collective noun for a number of teal.
Totting or babbing	A method of fishing for eels in which worms are threaded on to about three feet of worsted or crochet cotton, tied into a loose skein and attached to a weighted line fixed at one end to a stick; the whole is known as a tot.
Tomkin cut	A short dyke off a river ending at a culvert under the bank; about 20 feet long and 9 feet wide, such a cut provides ideal moorings for a punt.
Watch line	A line pulled to spring over a lark net.

Opposite page: A bill advertising a race at Thorney in 1879 "should the frost continue".

NATIONAL SKATIN[G]

THE DUKE OF DE[VONSHIRE]
THE EARL OF LE[ICESTER]
C. W. TOWNLEY, E[SQ.]

The Committee of Management of the National Skating Associa[tion]
announce, that the First Race for the

SKATING
CHAMPIONSHIP OF ENGLAND,

Will take place, should the frost continue,

On MONDAY, December 8, 1879,

ON THE

RIVER AT THORNEY,
Near the Railway.

Course--ONE MILE AND A HALF.

The winner of the Final Heat will be entitled to rank as the "Skating Champion of England," he will also receive and hold so long as he retains the Championship, the Champion Scarf, silk and silver mounted, on which the names of the successive Champions shall be engraved, he will also receive a silver-mounted badge with his name and the year he won engraved thereon, also a superior Pair of Skates presented by Messrs. Marsden, Bros. and Co., of Sheffield, the sum of Ten Pounds, and such portion of the interest of the sum invested, as an annual income, as may be hereafter fixed.

The Second Man will receive £5.

The Third and Fourth £2 10s. each.

All other winners shall receive amounts to be announced at the time of the Draw, so that each shall derive some pecuniary advantage, and all Starters shall receive back their entrance fee unless in the opinion of the Judges they wilfully lost.

Entries to be made to Mr. JAMES D. DIGBY, the Honorary Secretary, at 4, Mortimer Villas, Parker's Piece, Cambridge, before SUNDAY, or care of Mr. W. J. HURRY, Thorney, before 10 o'clock on MONDAY, and the Draw to take place at Eleven o'clock precisely. The first Race to take place at Twelve o'clock punctually. The Entrance fee, Five Shillings, must accompany the Entry; should the frost break up so that the Race does not take place, the Entrance fee will not be forfeited, but the Entry will hold good to a future day.

Rule 23.--" That no person shall be eligible to compete for the Championship, or at any meetings under the National Skating Association Rules, who to receive any reward from the Association, or from the promoters of such meetings, who shall be proved to the satisfaction of the Committee to have bought, or sold, or vitiated a race by any unfair conduct since the establishment of this Association."

Naylor and Smith, Printers, " Chronicle ", Office, Cambridge.

Index

Illustrations in bold type

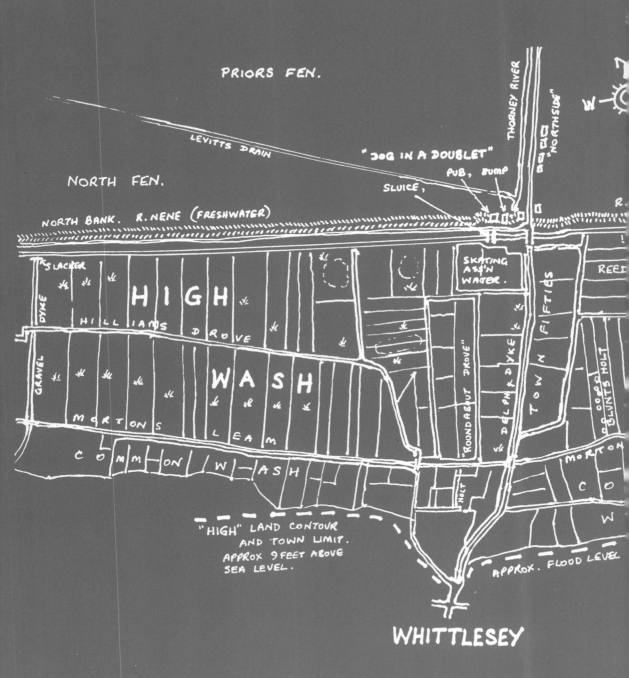

PRIORS FEN.

LEVITTS DRAIN

THORNEY RIVER

"JOG IN A DOUBLET"

"NORTHSIDE"

NORTH FEN.

PUB, PUMP

SLUICE,

NORTH BANK. R. NENE (FRESHWATER)

SLACKER

HIGH

SKATING ASS'N
WATER.

REED

GRAVEL DYKE

HILLIAMS

DROVE

"ROUNDABOUT DROVE"

DELPH DYKE

TOWN FIFTIES

BLUNTS HOLT

WASH

MORTONS

LEAM

HOLT

MORTON

COMMON WASH

CO

W

"HIGH" LAND CONTOUR
AND TOWN LIMIT.
APPROX 9 FEET ABOVE
SEA LEVEL.

APPROX. FLOOD LEVEL

WHITTLESEY